#1960
NOW

#1960

Photographs of Civil Rights Activists

NOW

and Black Lives Matter Protests

BY SHEILA PREE BRIGHT

CHRONICLE BOOKS
SAN FRANCISCO

Library of Congress Cataloging-in-Publication Data

Names: Bright, Sheila Pree, Photographer.

Title: #1960now : photographs of civil rights activists and black lives

 matter protests / by Sheila Pree Bright.

Other titles: Hashtag1960now | Hashtag 1960 now

Description: San Francisco, California : Chronicle Books, 2018.

Identifiers: LCCN 2018000975 | ISBN 9781452170725 (hardcover : alk. paper)

Subjects: LCSH: Black lives matter movement—Pictorial works. | Civil rights

 movements—United States—Pictorial works. | African Americans—Civil

 rights—History—Sources. | Documentary photography.

Classification: LCC E185.61 .B85 2018 | DDC 323.1196/073—dc23 LC record available at
https://lccn.loc.gov/2018000975

Manufactured in China.

Design by Brooke Johnson and Spencer Vandergrift

10 9 8 7 6 5 4 3 2 1

Chronicle books and gifts are available at special quantity discounts to corporations, professional associations, literacy programs, and other organizations. For details and discount information, please contact our premiums department at corporatesales@chroniclebooks.com or at 1-800-759-0190.

Chronicle Books LLC
680 Second Street
San Francisco, California 94107
www.chroniclebooks.com

Special Thanks: AJ Favors of Modern Matter; Anne Dennigton of Flux; Michael Simanga, Ph.D.; Nato Thompson; Siri Engberg, Professor; Bridget R. Cooks, Ph.D.; Annette Cone-Skelton of Museum of Contemporary Art Georgia; Likisha Griffin; Deborah Willis, Ph.D.; Aaron Bryant, Ph.D.; Alicia Garza; Eric Luden; Keith Miller; Alesia Graves; Terrell Clark; the Freedom Fighters of now and then; the families of the victims of police brutality; and my husband, Jeryl Bright.

This book is dedicated to the King and Queen, my mother and father, who have nurtured me with their love.

CONTENTS

INTRODUCTION

THERE ARE MOMENTS THAT CHANGE THE COURSE OF HISTORY FOREVER.

The 1960s are widely recognized as a tumultuous, painful, and inspiring period in the history of the United States, where significant social upheaval occurred as a result of Black people waging a catalytic fight over civil rights. During the height of the Civil Rights Movement in the 1960s, America was challenged to live up to its promise of liberty and justice for all.

Of course, like most movements, history is often distorted, bent to accommodate the interests of the powerful. The events of the 1960s are not exempt from such revisions, silencing the voices and the contributions of many who helped to shape the period and the popular consciousness. The Civil Rights Movement was not one period in history, but in fact, several periods, and the upheaval that occurred in the 1960s was catalyzed by the twenty-year period which preceded it. From sharecroppers in Alabama and throughout the South who organized in the 1930s and 1940s, to the Harlem Renaissance that awakened the imagination of thousands and gave contours to the conditions of Black people from the plantation to the city, the struggle for justice, freedom, and equity has been in motion ever since enslaved Africans set foot on the shores of what was to become America.

Similarly, the Civil Rights Movement was not merely a collection of heterosexual male religious leaders leading their congregations toward freedom. In fact, the Civil Rights Movement was advanced in large part by Black women and queer people who were strategists, community organizers, and visionaries.

Popular narratives of this period in history depicted key figures like Rosa Parks, who led the catalytic Montgomery bus boycott in 1955–56, as a woman who was too tired after a long day of work to move to the back of the bus, and the boycotts as spontaneous action that occurred in response to the mistreatment of Parks, rather than as a strategic economic intervention in the pattern and practice of segregation.

Lunch counter sit-ins and voter registration drives in the South were seen as having been designed and implemented by well-known figures such as Medgar Evers and Dr. Martin Luther King Jr., when in fact, many of those direct actions and strategic interventions in the long legacy of racism and racial terror were designed and implemented by people like Fannie Lou Hamer and Ella Baker and Diane Nash.

The Black Panther Party became known as a movement of Black men with guns, rather than as a political party determined to intervene in the deplorable conditions facing Black communities more than one hundred years after the supposed emancipation of Black people from slavery, led by powerful and visionary women such as Elaine Brown, who became

Cocreator,

Black Lives Matter

Global Network

BY ALICIA GARZA

the first woman to chair the party in the decade following the 1960s; Angela Davis, who was jailed and targeted by the FBI for her affiliation with the party, and hundreds of others who set up community service programs and infrastructure for Black people to be able to live with some semblance of dignity.

In the 1960s, there was no social media to help us counter such depictions of how movements develop, evolve, and impact the political, economic, and social workings of a place. What we do have, however, are pieces of documentation that portray history as it actually happened. Photographs of the events of the 1960s, alongside narratives from those who were involved from different positions and perspectives, are what help us understand the complexity of movements themselves, and rescue said movements from the revisions that allow America to remain firmly locked in its own contradictions.

The movements of now are at the same time impacted by the same dynamics and are challenging those revisions in new and innovative ways. Today's movements are unapologetic about making sure that they themselves write and narrate their own development and progress, and at the same time that they do, challenge others and ourselves to have new problems, rather than rehash the same problems movements have been grappling with forever. The movements of now are faced with the same and worsening challenges that organizers and activists encountered in the 1960s—substandard conditions in Black communities, a lack of political power, and

an amnesia that says that Black suffering is a product of our imagination rather than our lived experiences.

Similar to the movements of the 1960s, today's movements are fueled by a resistance to white supremacy and an economic system that prioritizes profit over people's needs. Today's movements do not just resist, but imagine a new world in which we can all belong. And in response, today's movements face incredible backlash from those who are not willing to cede their power for the good of all of us. The movements of the 1960s faced the Ku Klux Klan, were disappeared at the bottoms of rivers, hung from trees, and surveilled and killed by the same government sworn to protect all of its citizens. Today's movements face the same racial terror—activists in Ferguson found dead in rivers and burned-out cars, hung from jail cells, and surveilled and terrorized under a new regime of law and order—all for daring to be free.

#1960Now captures the complexity, nuances, and resistance of today's movements fighting for dignity across the spectrum of gender, race, class, ability, and citizenship status. Documentation such as this reminds us that the way history unfolds and is shared with those who will come after us is important. Under a new regime, led by a white supremacist project that aims to bend the arc of history in the direction of the powerful and the undemocratic, the project of remembering is more critical than it has ever been.

ARTIST'S STATEMENT

SHEILA PREE BRIGHT
PHOTOGRAPHER

AS A FINE ART PHOTOGRAPHER,

I am interested in the life of those individuals and communities that are often unseen in the world. My objective is to capture images that allow us to experience those who are unheard as they contemplate or voice their reaction to ideas and issues that are shaping their world. In this process, what I shoot creates contemporary stories about social, political, and historical context not often seen in the visual communication of traditional media and fine art platforms. My work captures and presents aspects of our culture, and sometimes counterculture, that challenges the typical narratives of Western thought and power structures.

In my artistic practice, I observe trends and movements in the culture. My focus is always on the idea that it is the people, ordinary people, who are the force behind what is trending and popular. My practice involves close listening, observing, and researching social trends and then an immersion in the communities where those trends are emerging. My approach is to seek the common thread that connects the human condition, to examine what people define for themselves. In my career I have produced several series that are nationally and internationally recognized in the field. It is also important to me that my work become known outside of the art world and academia. My series *1960Who* has been extensively reviewed and written about, and my photographs have also been exhibited and collected.

As major social movements have emerged in the past two years, I've also documented the tensions, conflicts, and responses between communities and police departments that have resulted from police shootings in Atlanta, Ferguson, Baltimore, and Washington, DC. I've observed young social activists taking a stand against continued injustice that closely resembles that which their parents and grandparents endured during the era of Jim Crow. By documenting this emerging social movement, I have been able to invite other communities into the ongoing conversation. In 2013 while photographing under-recognized living leaders of the Civil Rights Movement, I made a connection between today's times and the climate of the 1960s that inspired the *#1960Now* project. *#1960Now* examines race, gender, and generational divides to raise awareness of millennial perspectives on civil and human rights. *#1960Now* is a photographic series of emerging young leaders affiliated with the Black Lives Matter movement.

As an artist it is deeply rewarding to hear that in my work people see the beauty, complexity, and humanity of those I've photographed. I am also inspired by the conversations my photographs have generated. Conversations that have helped us engage each other about our vision for society. I feel art is a form of activism to create awareness and bring shared communities together.

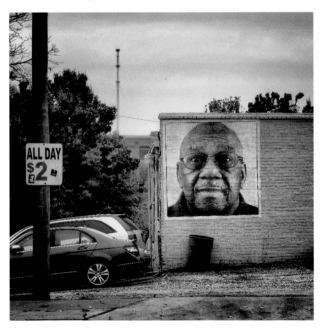

1960Who series, 2013

FACES OF A
MOVEMENT

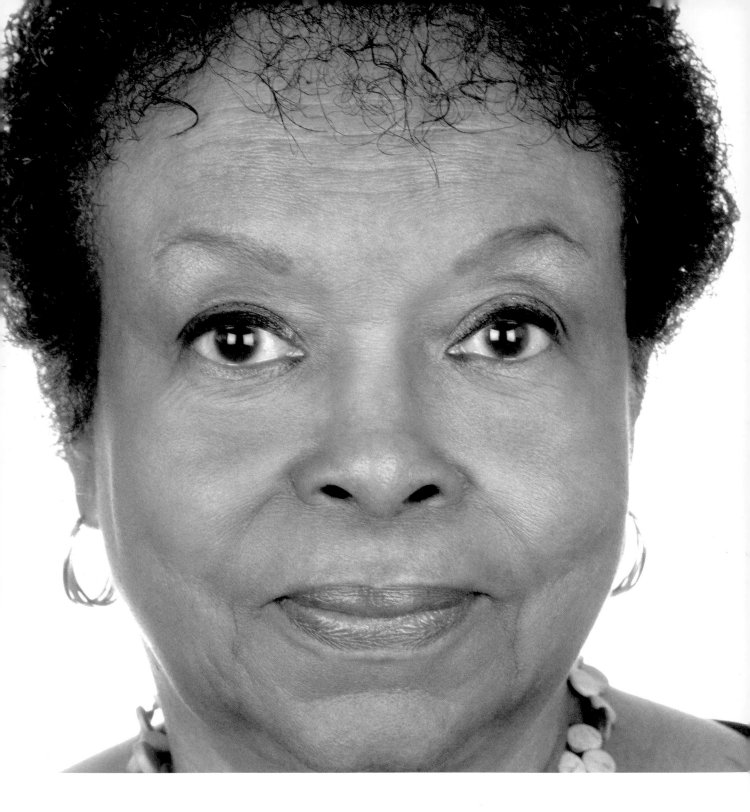

DR. ROSLYN POPE

Member of the Atlanta Student Movement, author of the Appeal for Human
Rights at Spelman College in the 1960s, Atlanta, Georgia, 2013

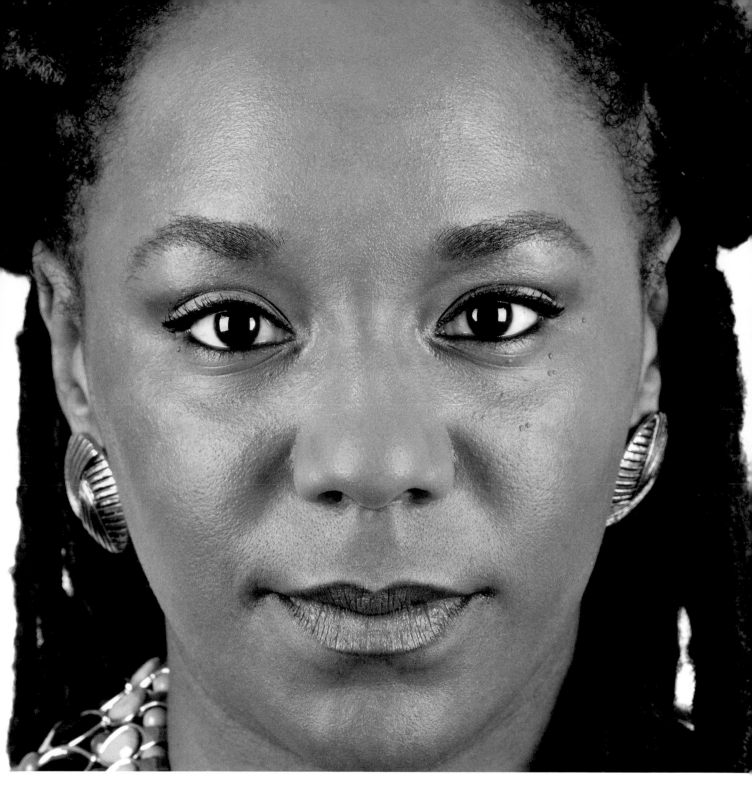

BREE NEWSOME

Activist, artist, and poet who took down the Confederate flag at
South Carolina State Capitol, Atlanta, Georgia, 2015

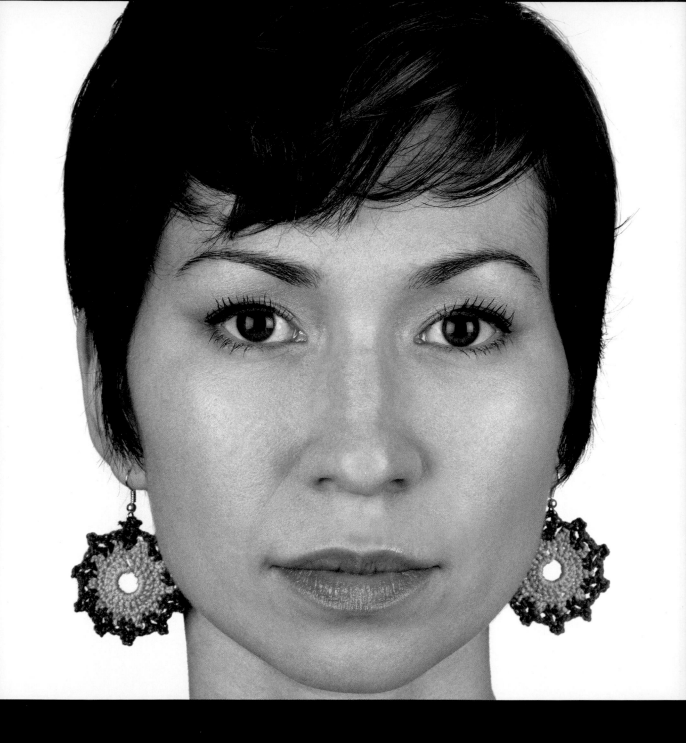

DR. LAURA EMIKO SOLTIS

Activist, organizer, and executive director of Freedom University for
undocumented students, Atlanta, Georgia, 2015

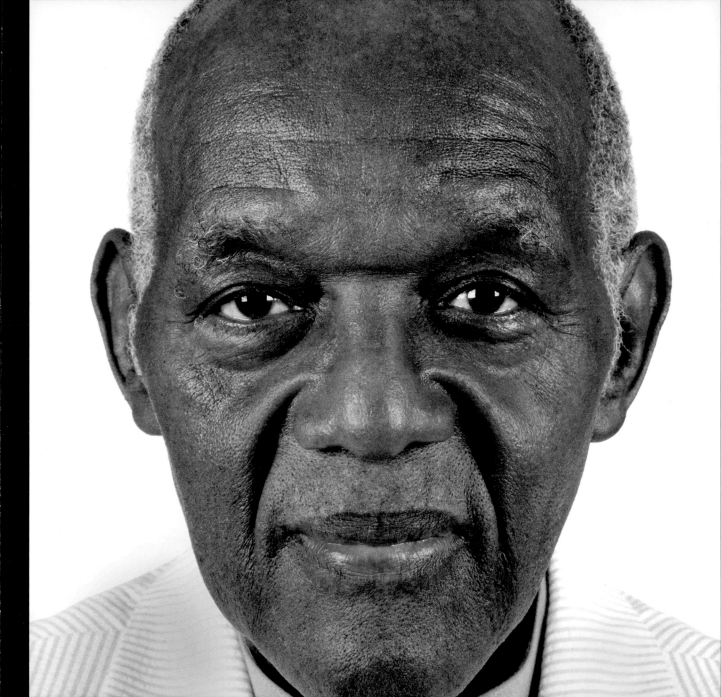

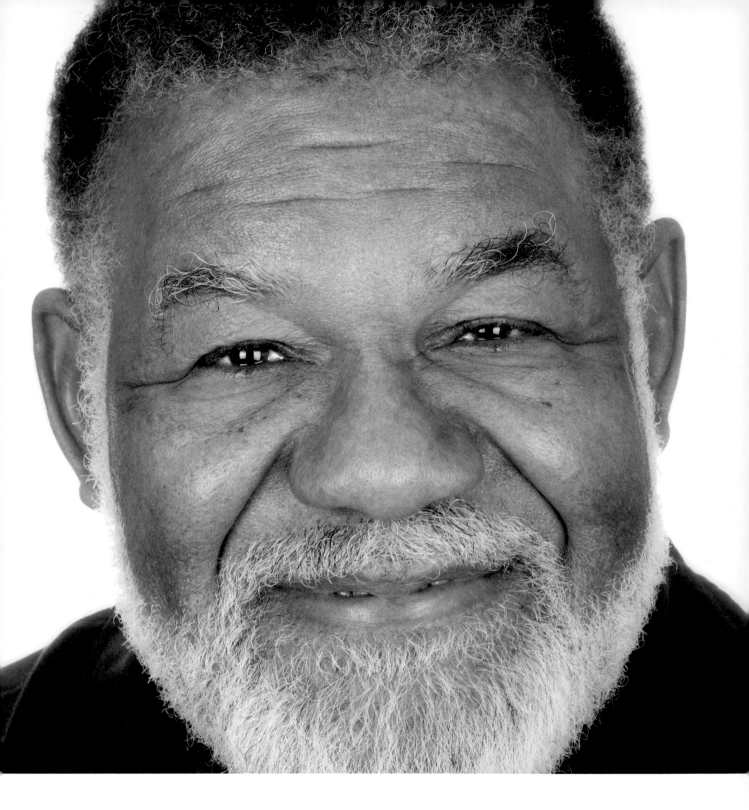

CHARLES BLACK

Organizer and president of the Atlanta Student Movement at Morehouse
College in the 1960s, Atlanta, Georgia, 2013

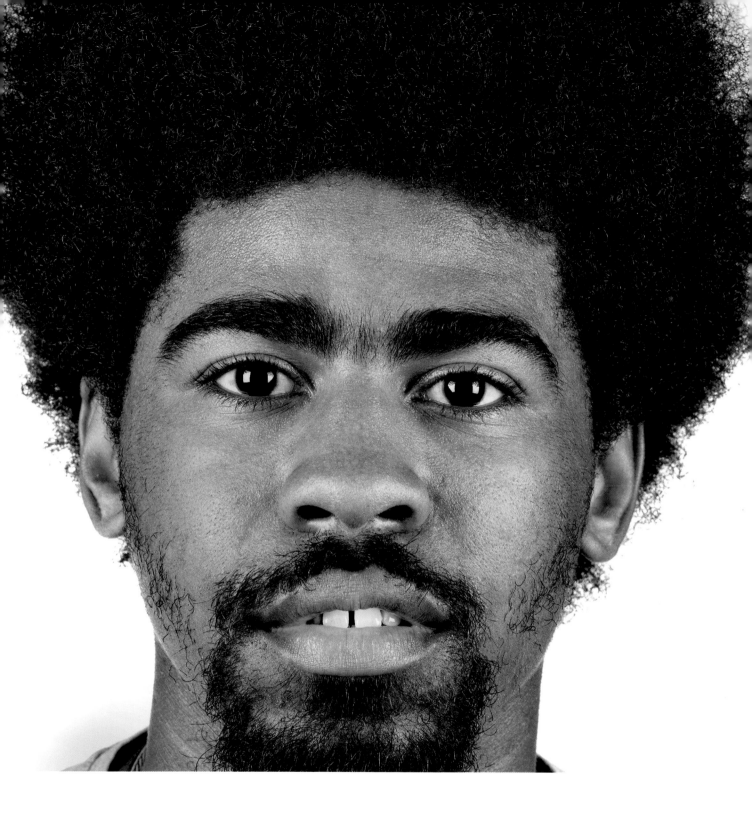

DEVIN ALLEN

Activist and photographer whose image of the uprising in Baltimore graced the
cover of *Time* magazine, Baltimore, Maryland, 2015

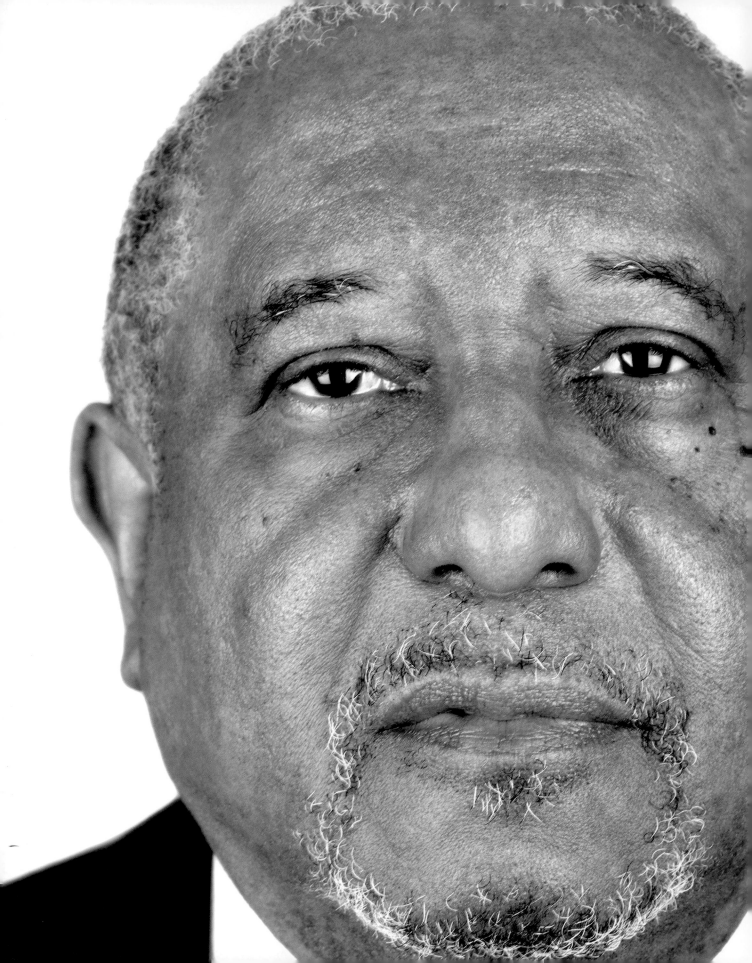

DR. BERNARD LAFAYETTE JR.

Lead organizer of the Selma voting rights movement and member of the Nashville Student Movement and the Student Nonviolent Coordinating Committee (SNCC) in the 1960s, Atlanta, Georgia, 2015

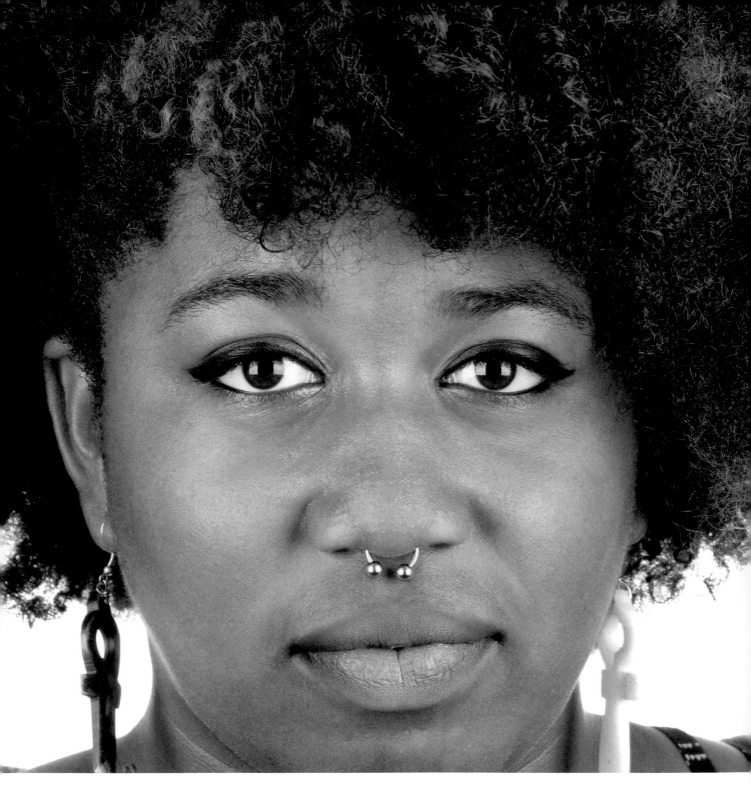

AURIELLE MARIE

Cofounder of It's Bigger Than You and spoken-word artist, Atlanta, Georgia, 2015

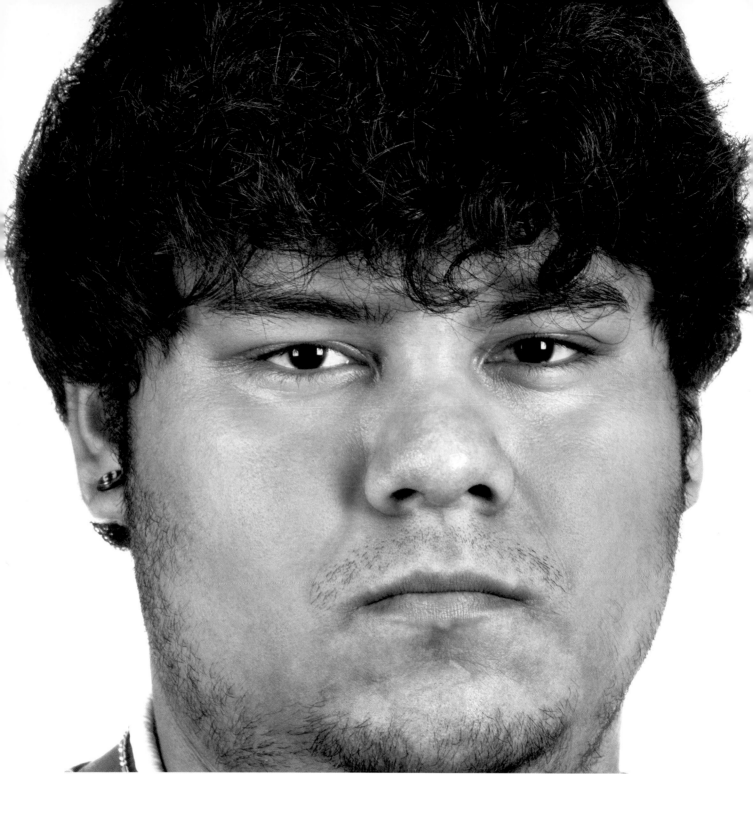

ALDO E. MENDOZA

Activist and protestor for "Dreamers" (undocumented students protected under
the Deferred Action for Childhood Arrivals program), Atlanta, Georgia, 2015

EVA KENDRICK WOLLERT

Civil rights foot soldier and member of the Atlanta Student
Movement in the 1960s, Atlanta, Georgia, 2013

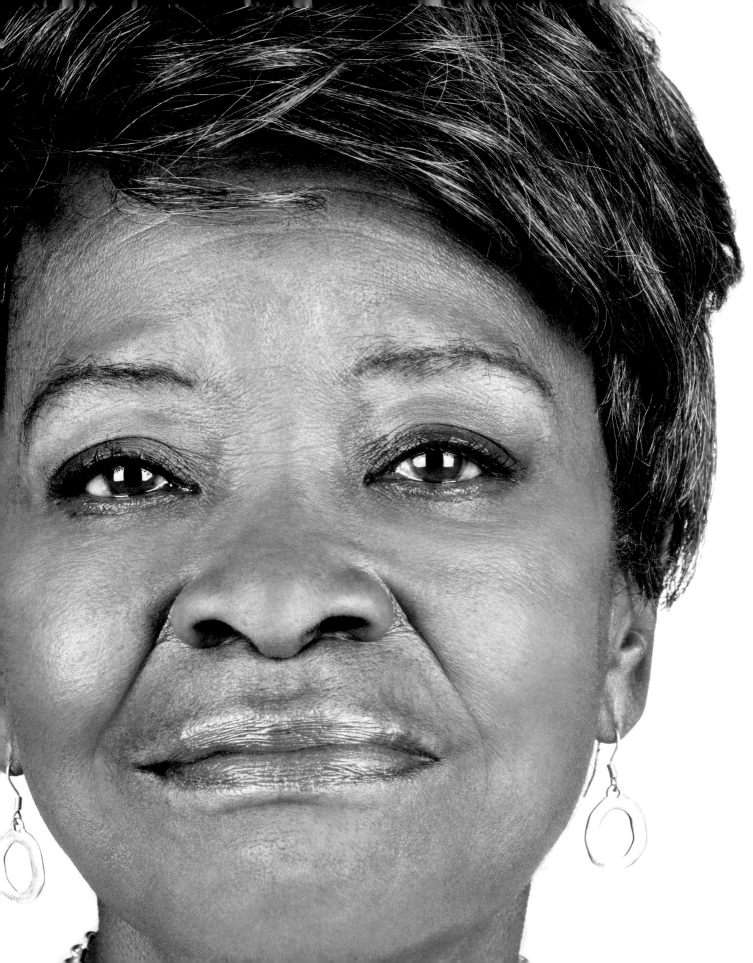

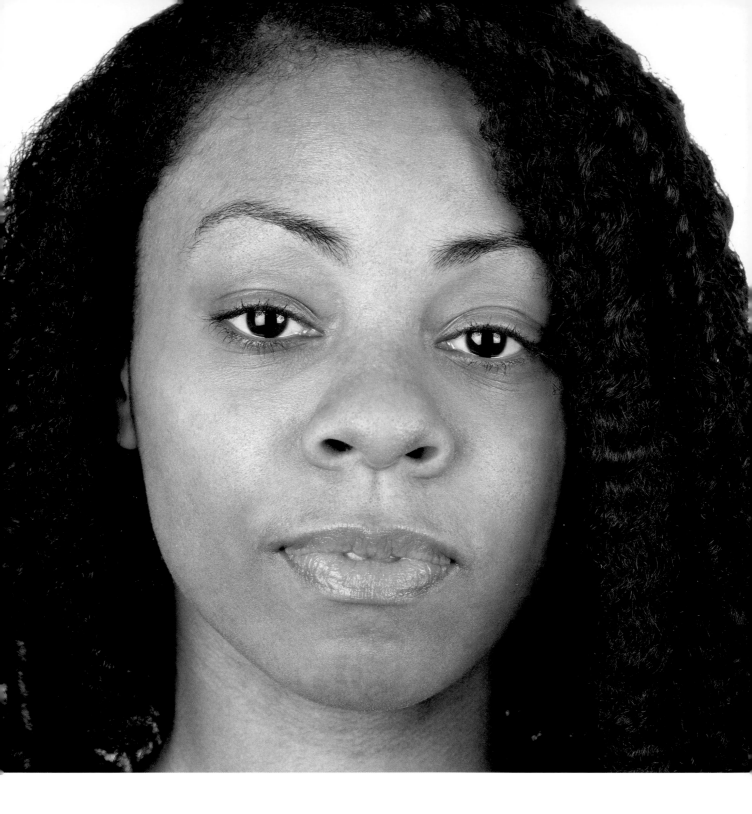

CRYSTAL E. MONDS

Organizer and activist, Black Lives Matter Movement, Atlanta, Georgia, 2015

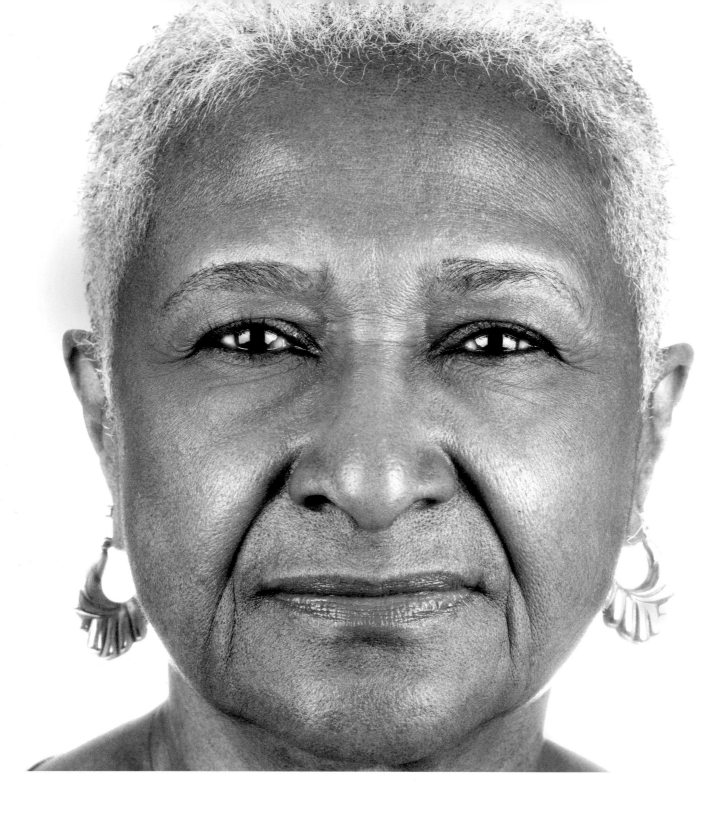

EVELYN HALL

Protestor with the Chicago Freedom Movement in the 1960s, Atlanta, Georgia, 2015

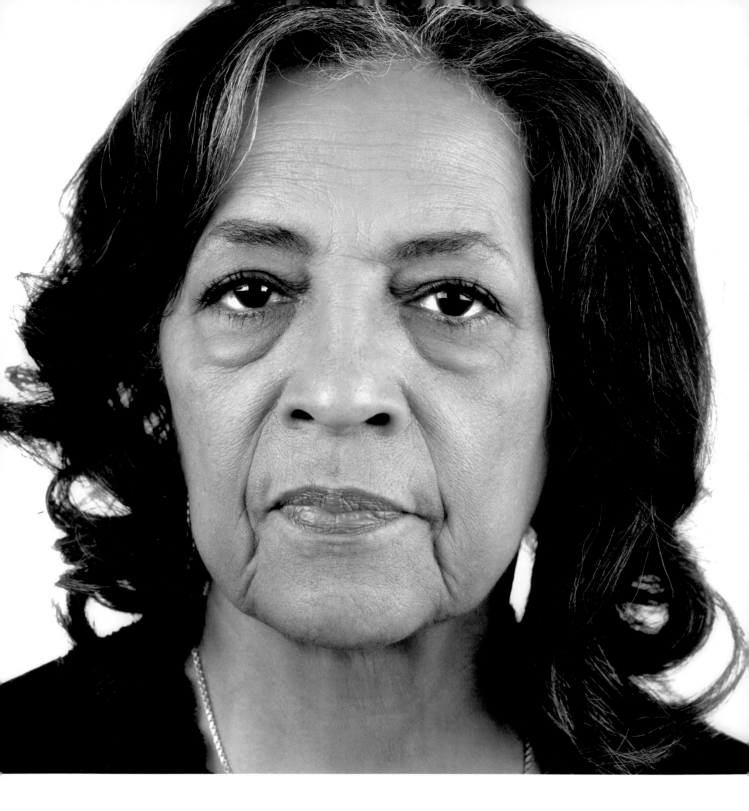

GWENDOLYN MIDDLEBROOKS

Member of the Atlanta Student Movement in the 1960s, Atlanta, Georgia, 2013

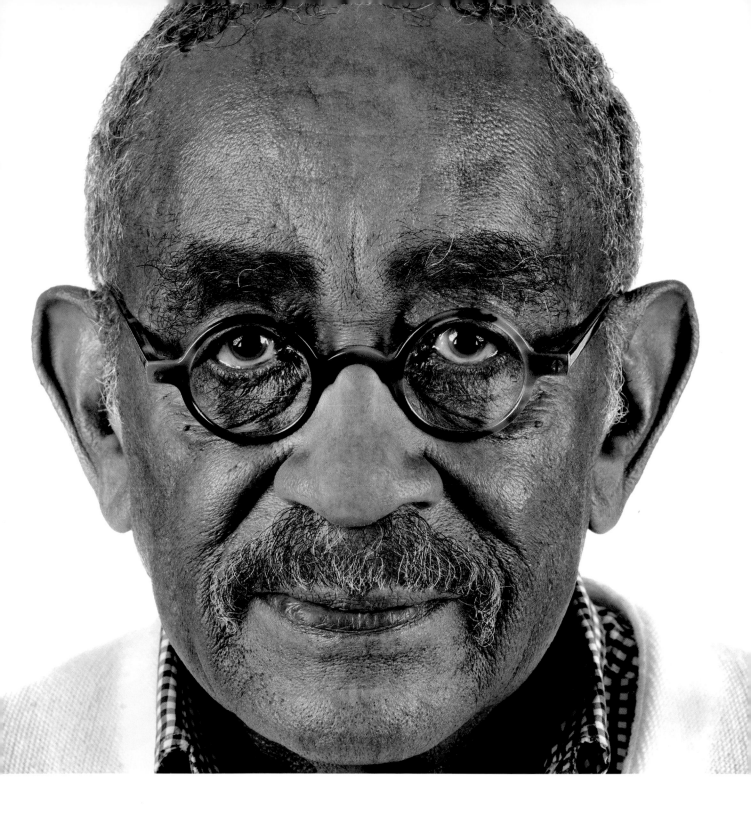

ROBERT HOUSTON

Civil rights photographer for the Poor People's Campaign led by Dr. Martin
Luther King Jr. in the 1960s, Baltimore, Maryland, 2015

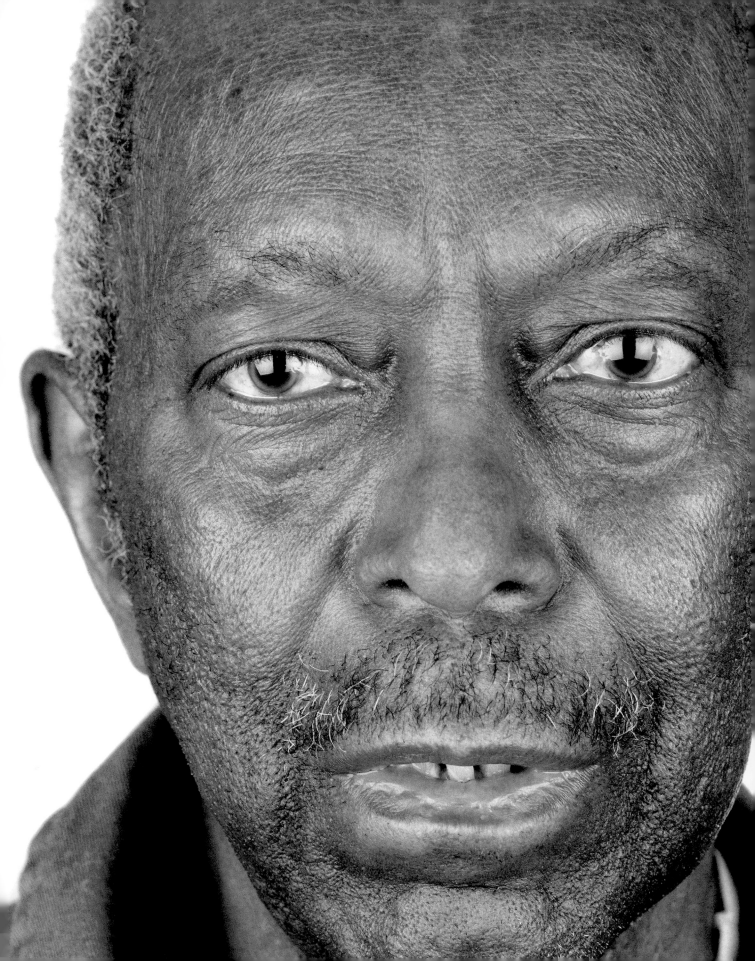

JOSEPH BLACK

Protestor in the Birmingham Children's Crusade campaign in the 1960s,
Birmingham, Alabama, 2013

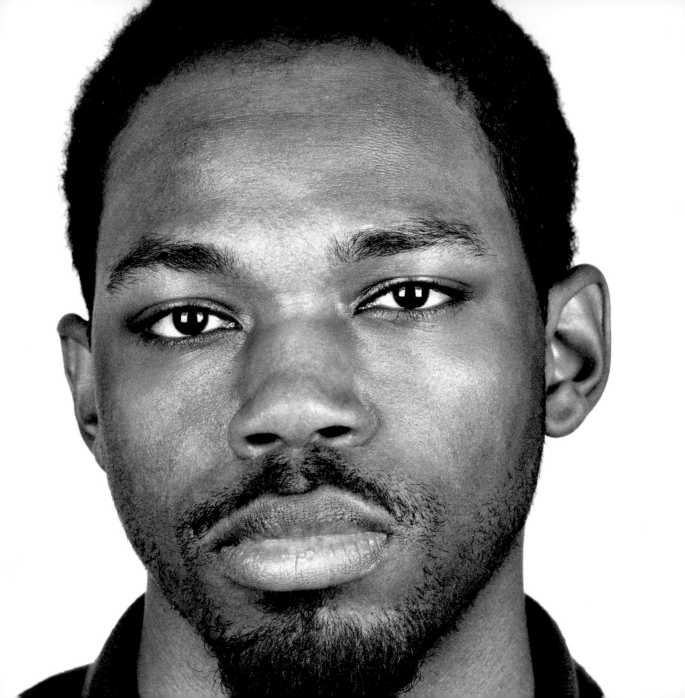

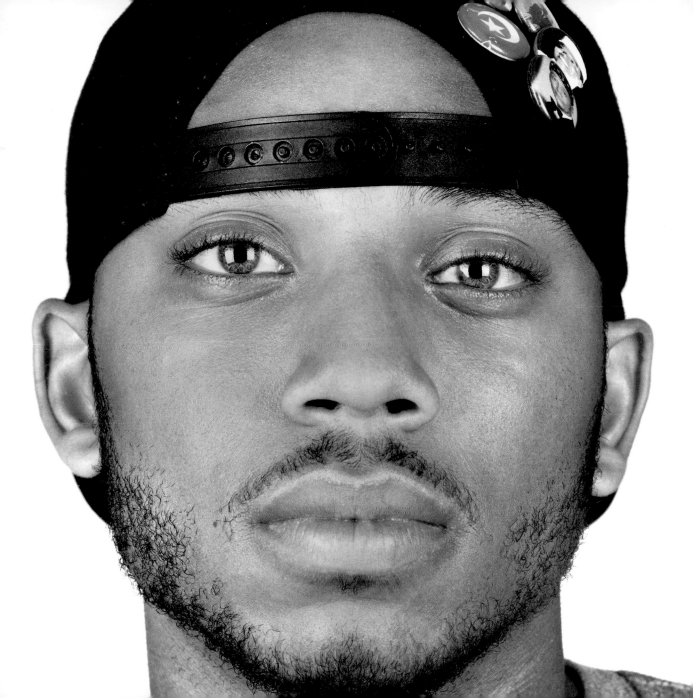

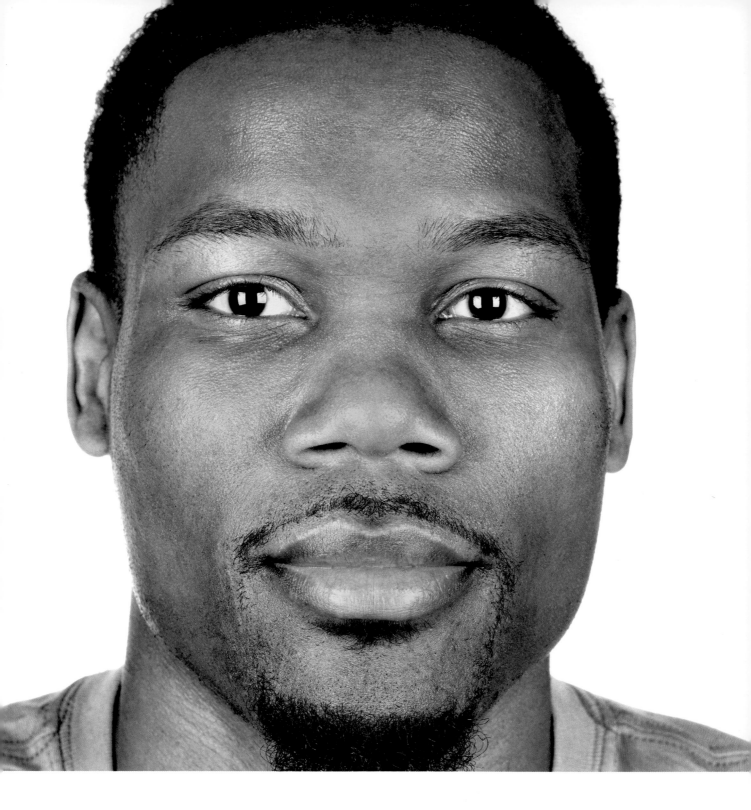

WESTLEY WEST

Known as "Pastor West," organizer and protestor, Baltimore, Maryland, 2015

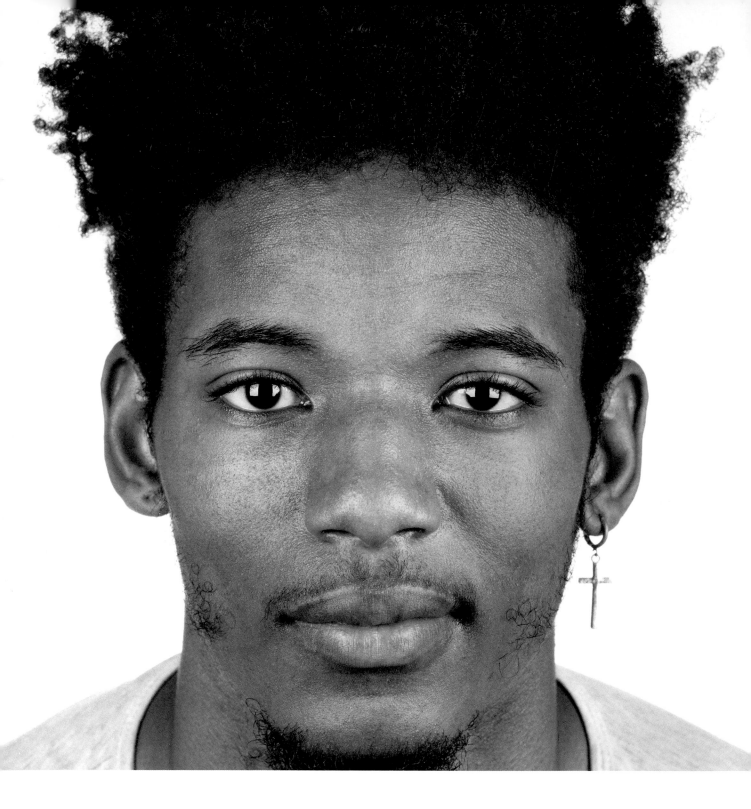

JULIAN PLOWDEN

Photographer and activist, Atlanta, Georgia, 2015

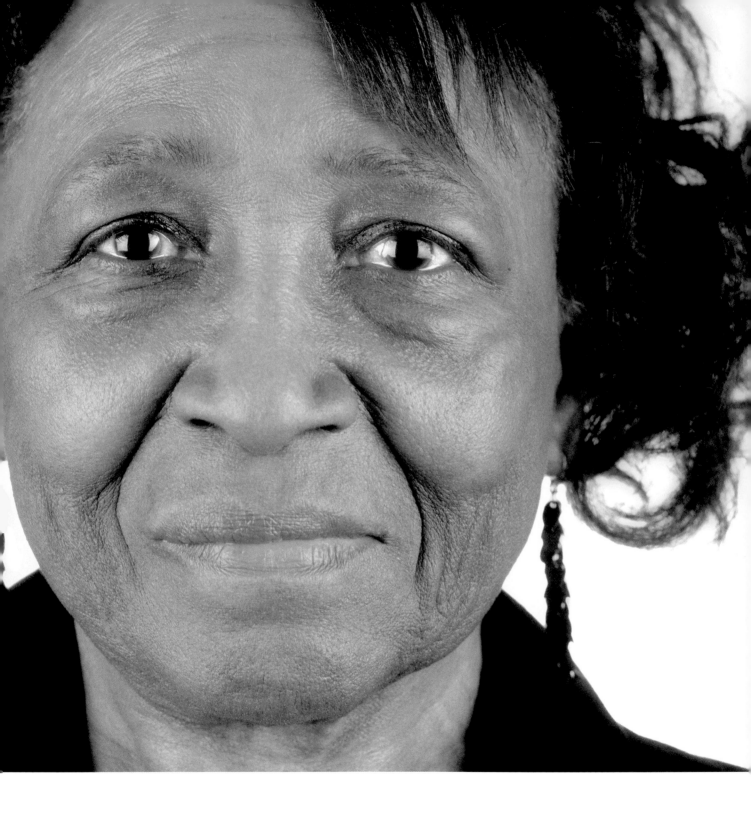

LILLIE AVERY SIMMONS

Member of the Atlanta Student Movement in the 1960s, Atlanta, Georgia, 2013

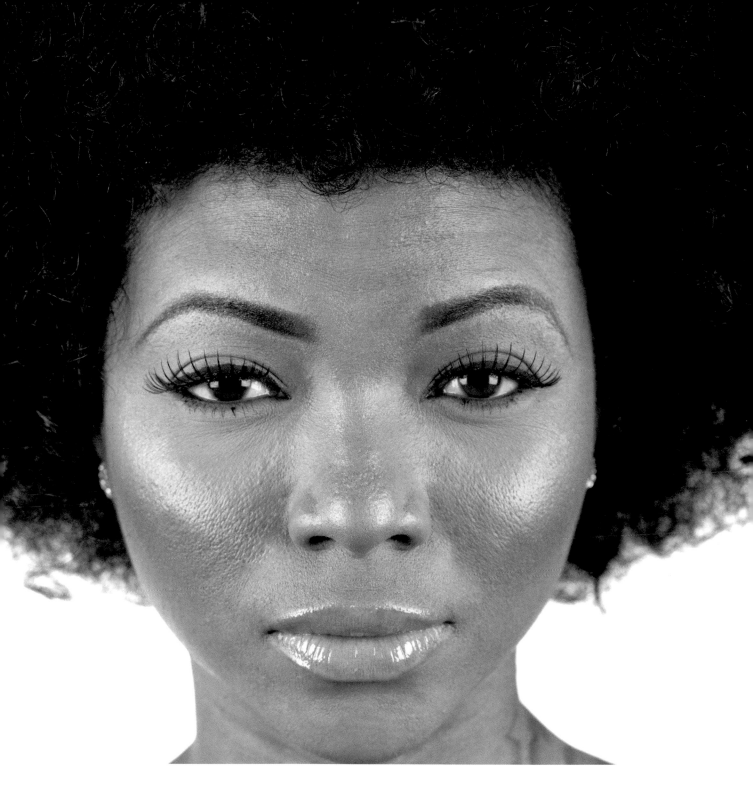

MALACKA REED EL

Activist and cofounder of 365 Empress Movement, Baltimore, Maryland, 2015

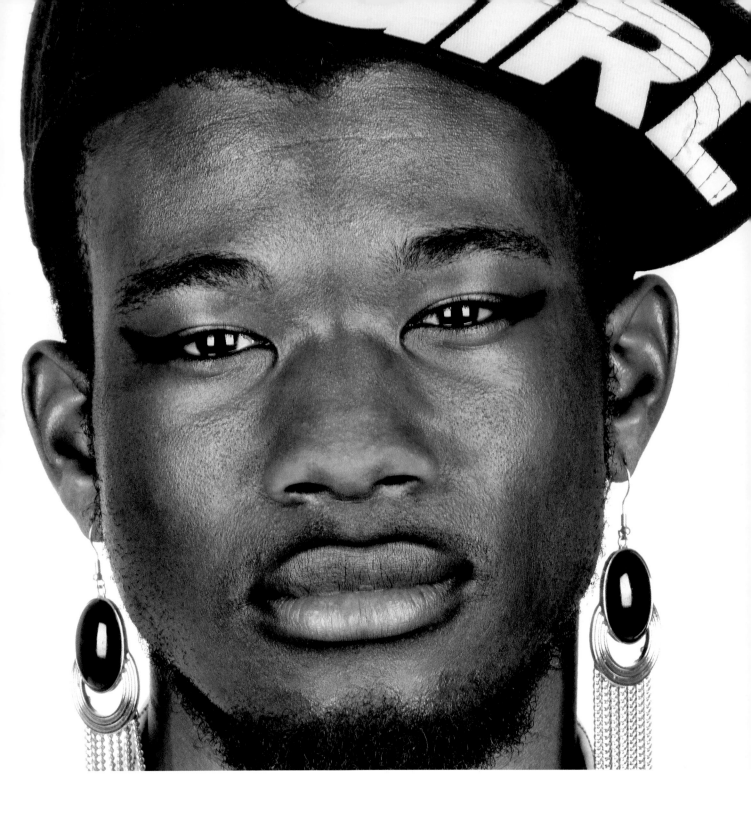

MICKEY BRADFORD

LGBT activist and protestor, Black Lives Matter movement, Atlanta, Georgia, 2015

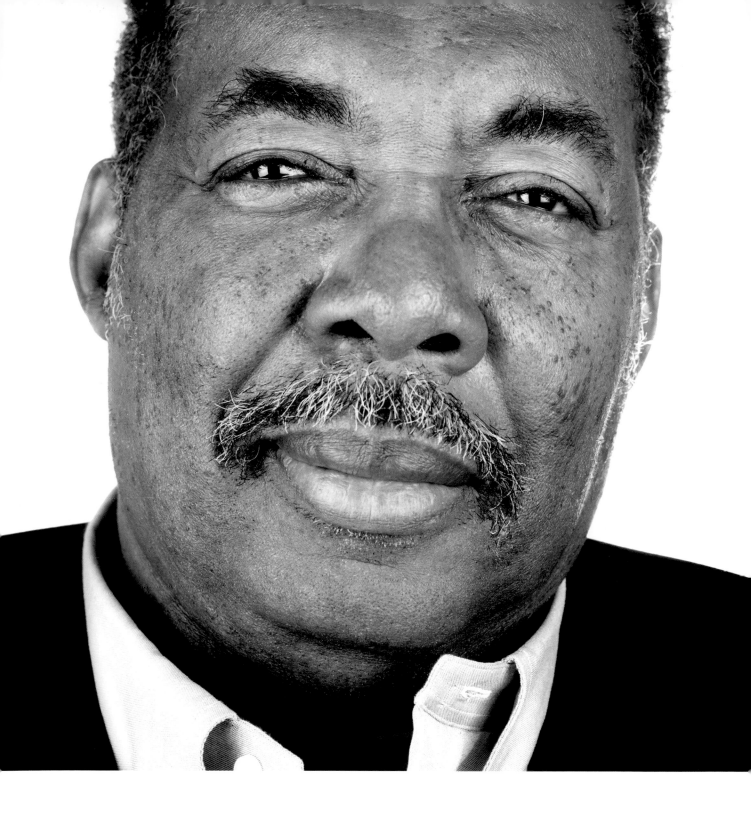

HANK THOMAS

Freedom Rider in the 1960s, Atlanta, Georgia, 2013

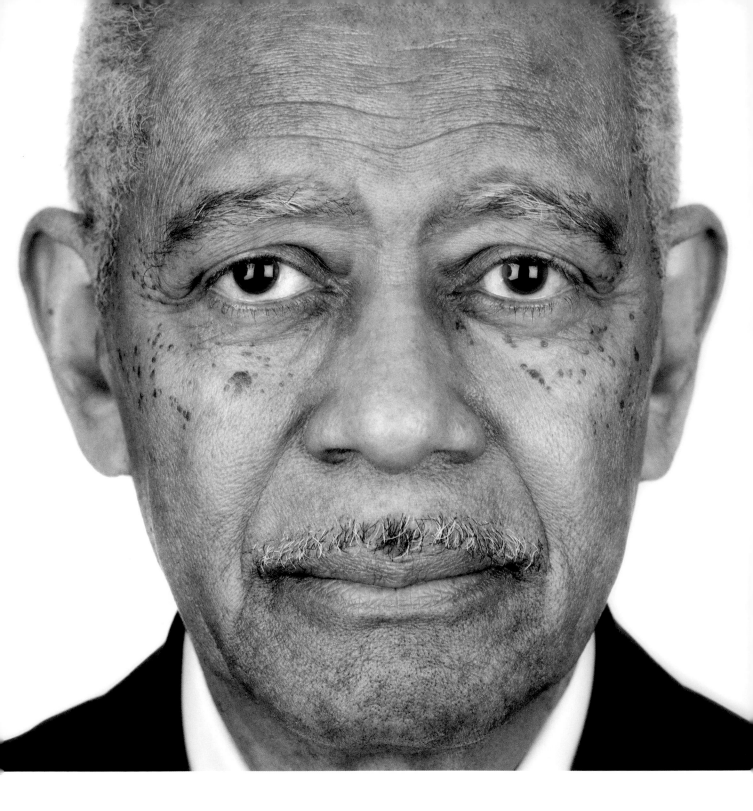

OTIS MOSS

Member of the Atlanta Student Movement in the 1960s, Atlanta, Georgia, 2013

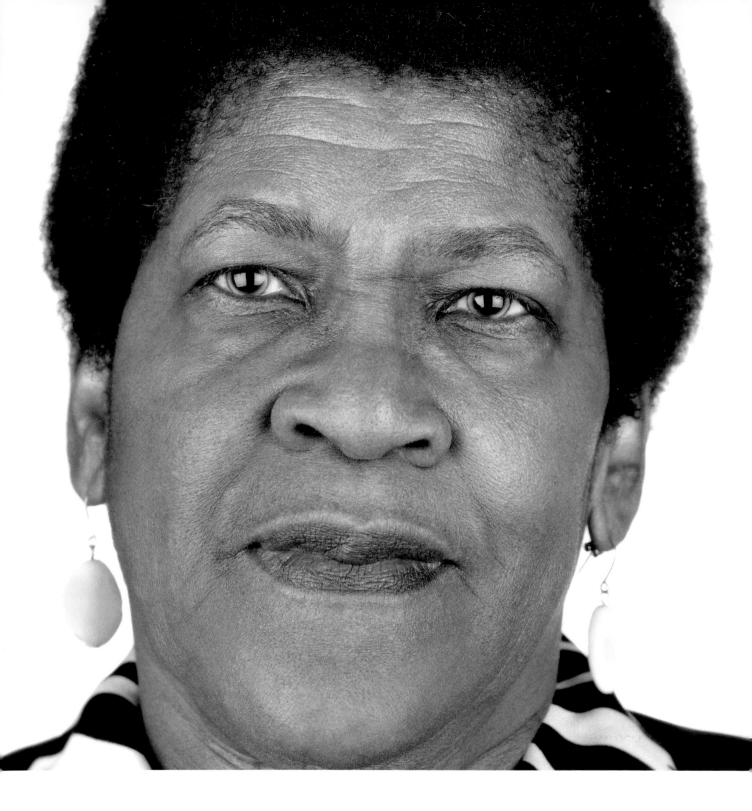

MAMIE KING-CHAMBERS

Civil rights activist/Birmingham Children's Crusade; she is in the
iconic Birmingham photograph by photographer Charles Moore being
hosed by the police up against the wall (1963), Birmingham, Alabama, 2013

RAQUEL WILLIS

Activist and organizer for transgender rights and Black Lives Matter, Atlanta, Georgia, 2015

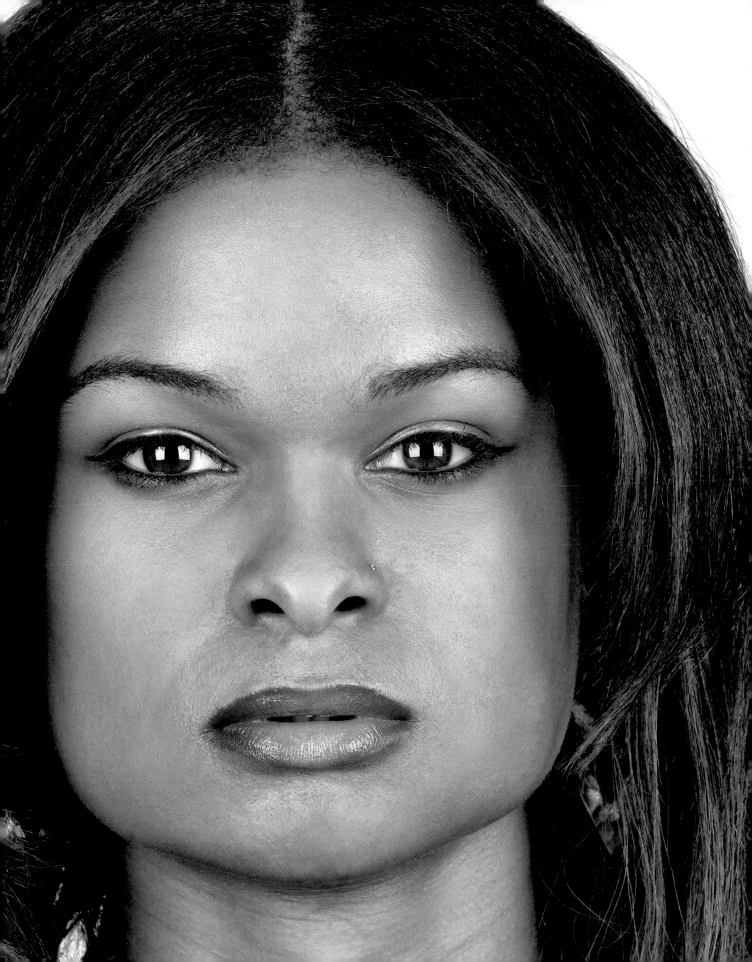

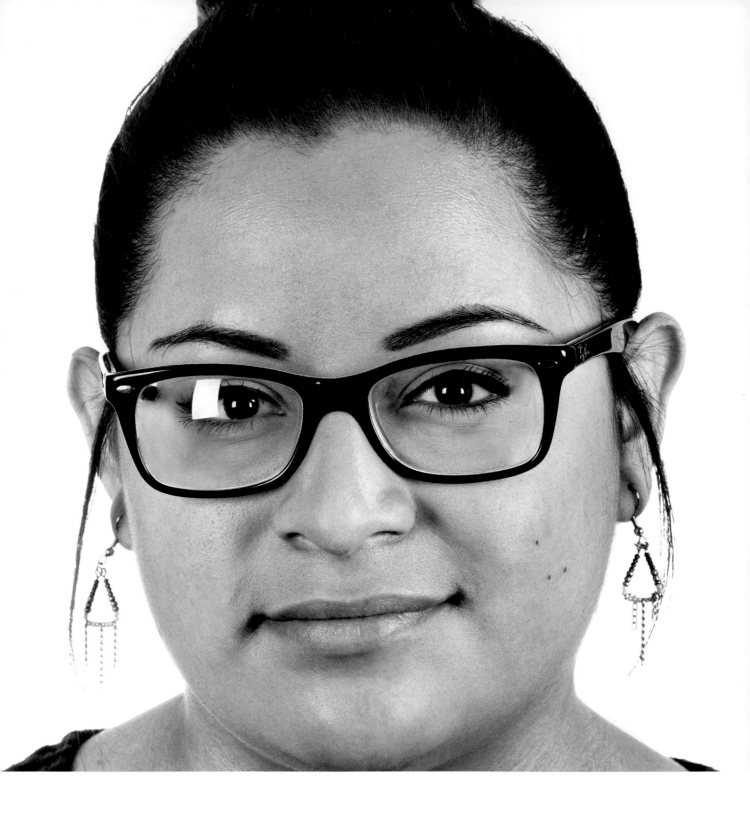

MELISSA RIVAS-TRIANA

Activist and protestor for "Dreamers" (undocumented students
protected under the Deferred Action for Childhood Arrivals
program), Atlanta, Georgia, 2015

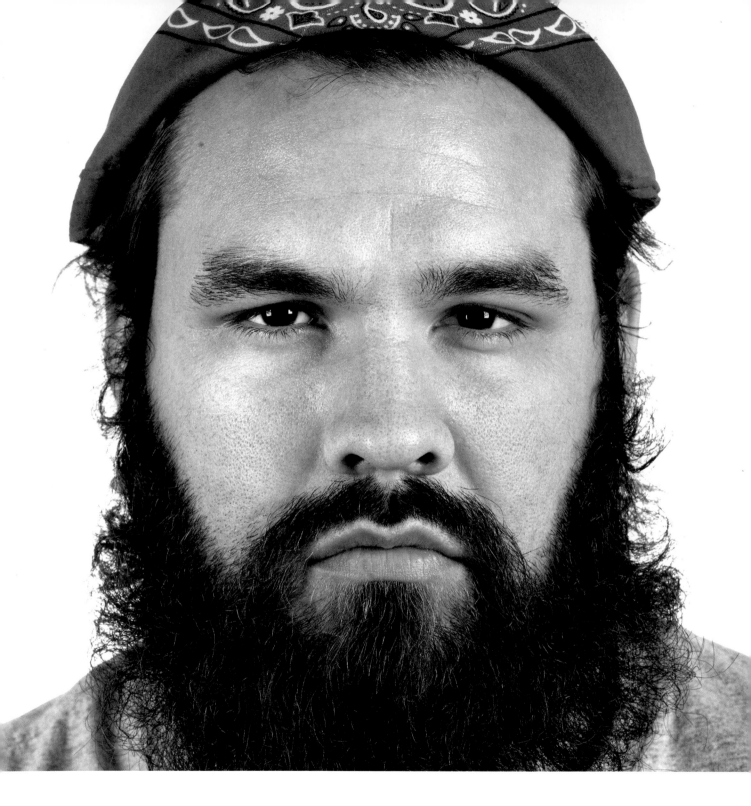

THOMAS DIMASSIMO

Filmmaker, activist, and protestor, Atlanta, Georgia, 2015

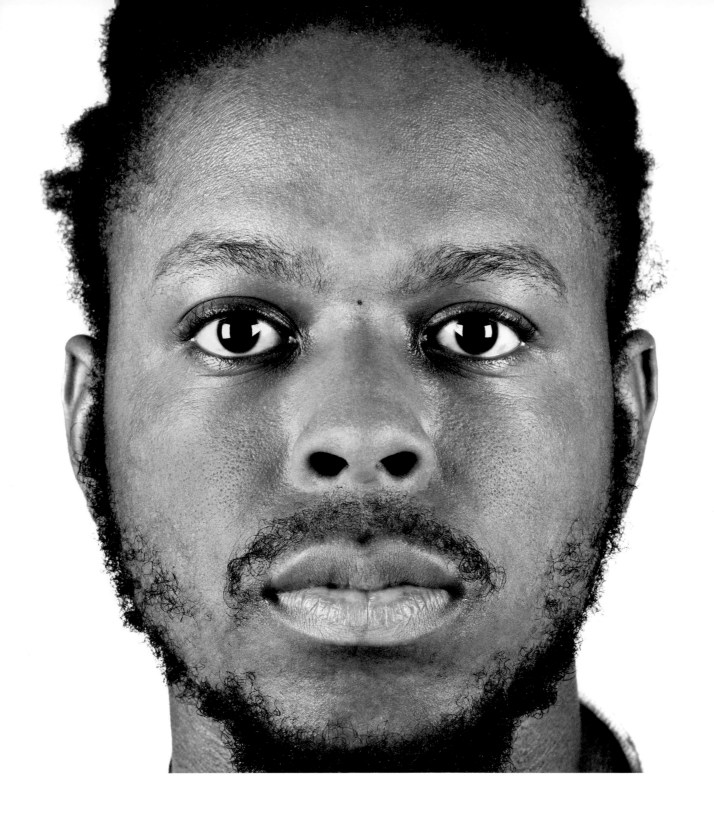

YOEHZER BEN YEEFTAHK

Organizer, activist, spoken-word artist, and founding member of
It's Bigger Than You, Atlanta, Georgia, 2015

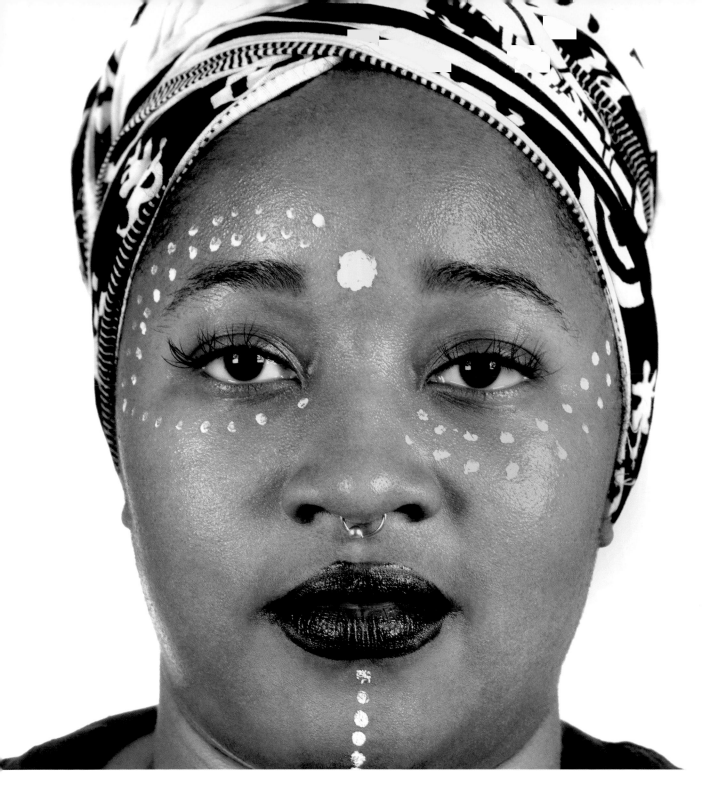

TALIBA OBUYA

Organizer, activist, and member of the Malcolm X Grassroots
Movement, Atlanta, Georgia, 2015

#1960NOW
THE PHOTOGRAPHS AND VISION OF SHEILA PREE BRIGHT

SHEILA PREE BRIGHT IS A PHOTOGRAPHER AND ACTIVIST-ARTIST who continues to express herself through the visual experience. She makes engaging photographs and creates provocative installations while creating a series of critical images of what it means to be an American. For Bright, creativity is part of a collaborative process. She contextualizes the voices of young protesters by weaving their words and faces into her portraits. She brings the same passion to her documentation of today's social protest movement from Atlanta to Baltimore to Ferguson to Washington, DC, as did her predecessors who made photographs in the 1960s civil rights protests for equal rights. Whether it's the right to free speech or the desire to have a sound education or the right to fair housing opportunities, Bright champions the right of all Americans to a full participation in the American democratic process. It is encouraging to see Bright's contemporary photographs connect to these historic events, hence the title of her series *#1960Now*.

Bright herself was not yet born when young civil rights activists took to the streets, boarded buses, and entered into spaces that would possibly harm them and/or end their lives.

Always interested in documenting moments and telling visual stories through her projects, she recently wrote, "As I observe the state of our country, I feel art can assist in creating cultural and neighborhood awareness for social good." Bright frames the ideas of the Black Lives Matter movement as it is reflected in the faces of the people who live in and those who travel to cities such Ferguson and Baltimore to support the local activists—from young women to young men, to mothers and fathers who walk the streets carrying the message on banners that "Black Lives Matter." The powerful moments depicted in the photographs portray Bright's empathy and support as both participant and observer. The beautifully rendered images are stark and direct. With her camera, she homes in on the faces, the T-shirts, and the handwritten placards—"All night, all day, we're gonna fight for Freddie Gray"; "#StolenDreams," with the high school portrait of Michael Brown; "We love our people and we will be here until justice is served." With the photographer's commitment and support of the movement, these words and images equally become portraits of the participants. Bright cares deeply about the young girls and boys, men and women, Black and White, Asian and Latina, Christian and Muslim, who are committed to human rights and civil rights for American citizens. In pondering the past, Bright photographed a banner (#It'sBiggerthanyou ReclaimMLK) that

Chair of the Department of Photography & Imaging at the Tisch School of the Arts at New York University

BY DEBORAH WILLIS, PH.D.

connects to the memory of the martyred civil rights leader Dr. Martin Luther King Jr. following his dream to obtain equal rights for Black Americans. Bright honors the aesthetic of movement imagery, digitally creating black-and-white photographs that memorialize the past and present.

The lyrics to vocalist and songwriter Gregory Porter's hit title "1960 What?" inspired Bright's initial project, *1960Who*, which evolved into *#1960Now*.

#1960Now focuses on policing in Black neighborhoods and questions the use of extreme force resulting in the deaths of young Black men such as Trayvon Martin, Freddie Gray, and Michael Brown, among others. Bright's work as a photographer and as a woman is significant in making visible the voices and images of women who are prominent in her photographs. Rarely are the voices of mothers and women highlighted in American social protest imagery. There is a powerful presence of women in the Black Lives Matter movement. As cultural worker, artist, and cocreator of the Black Lives Matter Global Network, Alicia Garza writes in her essay *A Herstory of the #BlackLivesMatter Movement:* "I created #BlackLivesMatter with Patrisse Cullors and Opal Tometi, two of my sisters, as a call to action for Black people after 17-year-old Trayvon Martin was posthumously placed on trial for his own murder and the killer, George Zimmerman, was not held accountable for the crime he committed. It was a response to the anti-Black racism that permeates our society and also, unfortunately, our movements. Black Lives Matter is an ideological and political intervention in a world where Black lives are systematically and intentionally targeted for demise. It is an affirmation of Black folk's contributions to this society, our humanity, and our resilience in the face of deadly oppression."

As mentioned previously, memory is central to Bright's social practice in making artful documentary images. These images powerfully expose the complexities in photographing social movements. For example, the American flag is an iconic object in Bright's work. Throughout *#1960Now* the flag functions as a symbol, a banner for marginalized individuals claiming an identity in the fabric of America. This is critical today as it connects to the *#1960Now* project, which includes portraits of young people in Black Lives Matter movement groups throughout the country. Bright defines the project as "generations of young people who have committed their lives for social good."

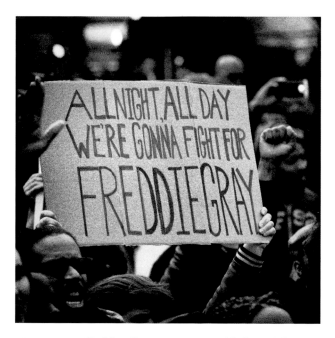

2015, protest, "All Night, All Day, We're Gonna Fight for Freddie Gray," Baltimore, MD

This page to page 65:

2015, National March on Ferguson, "We Can't Stop Now,"
protesting police violence and the murder of Mike Brown

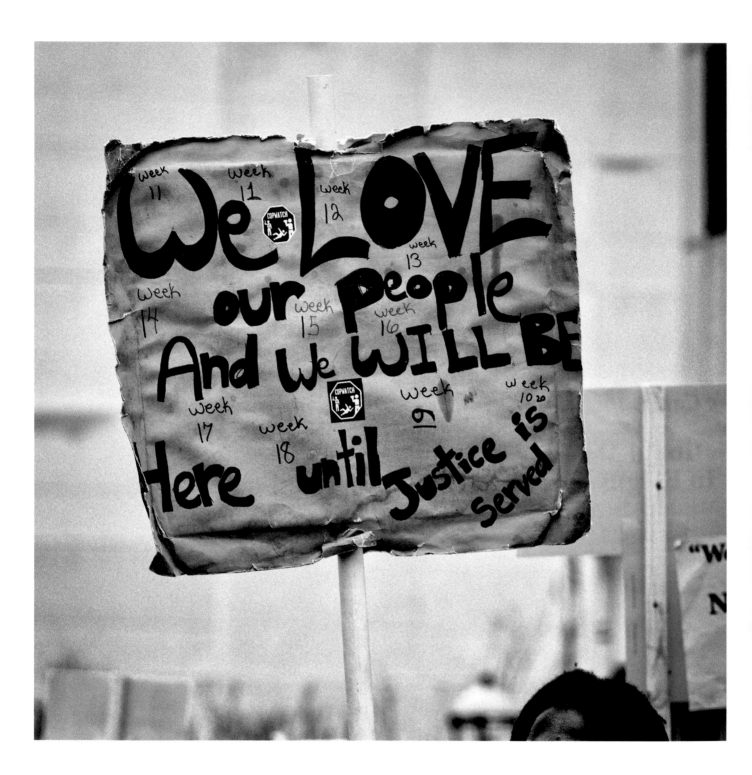

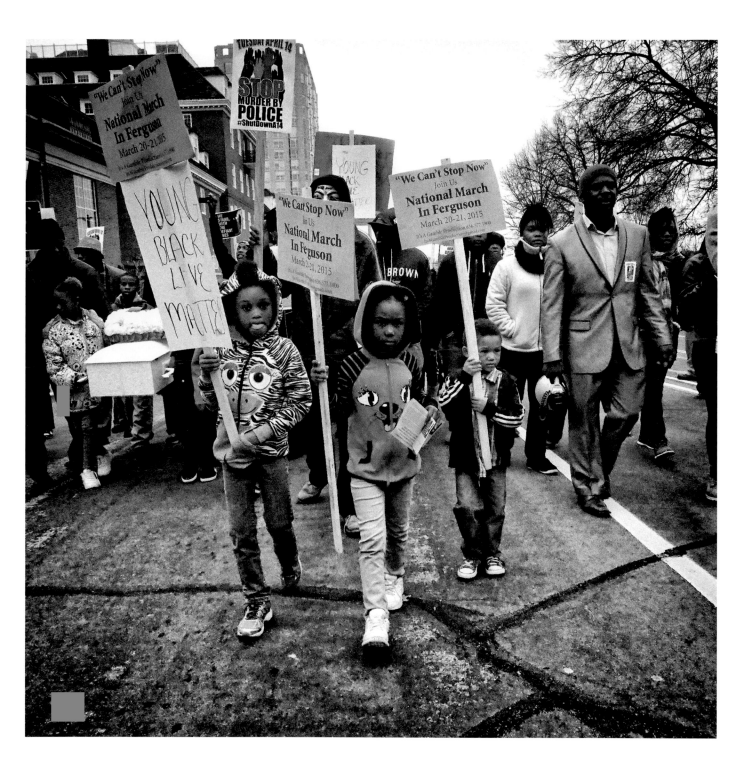

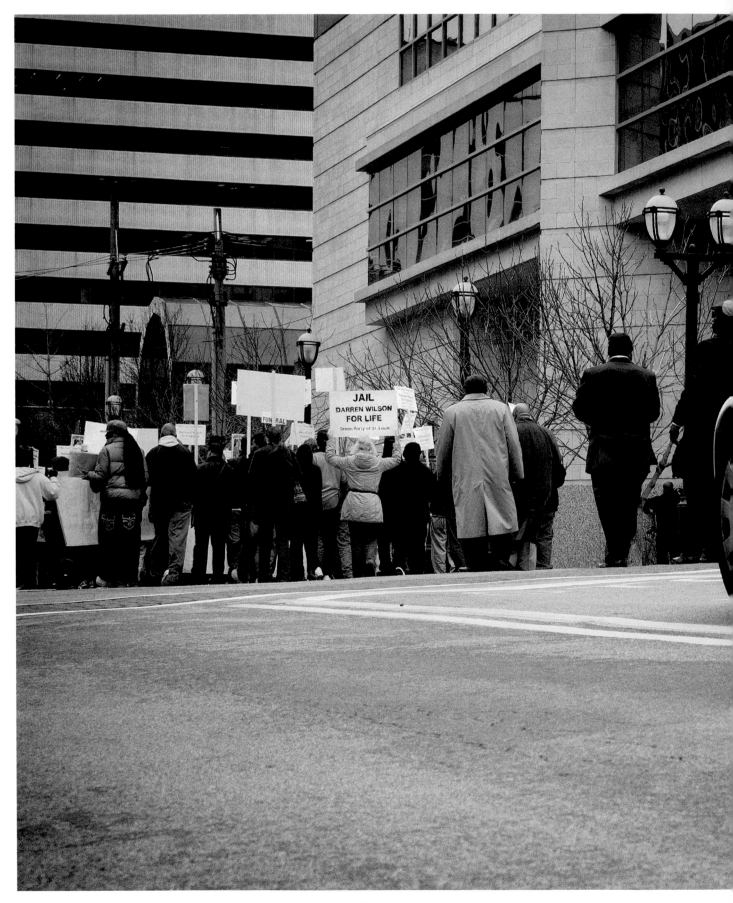

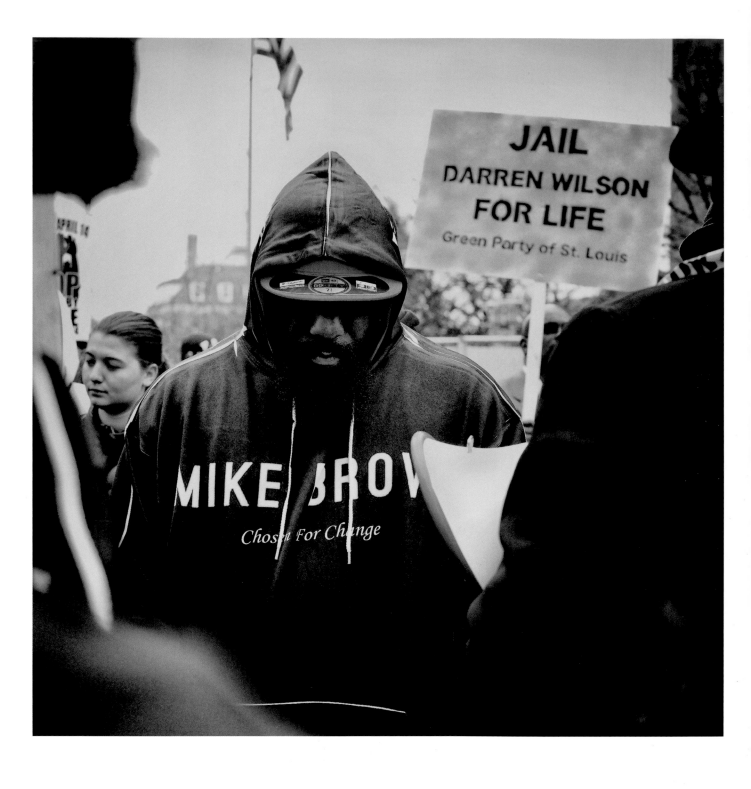

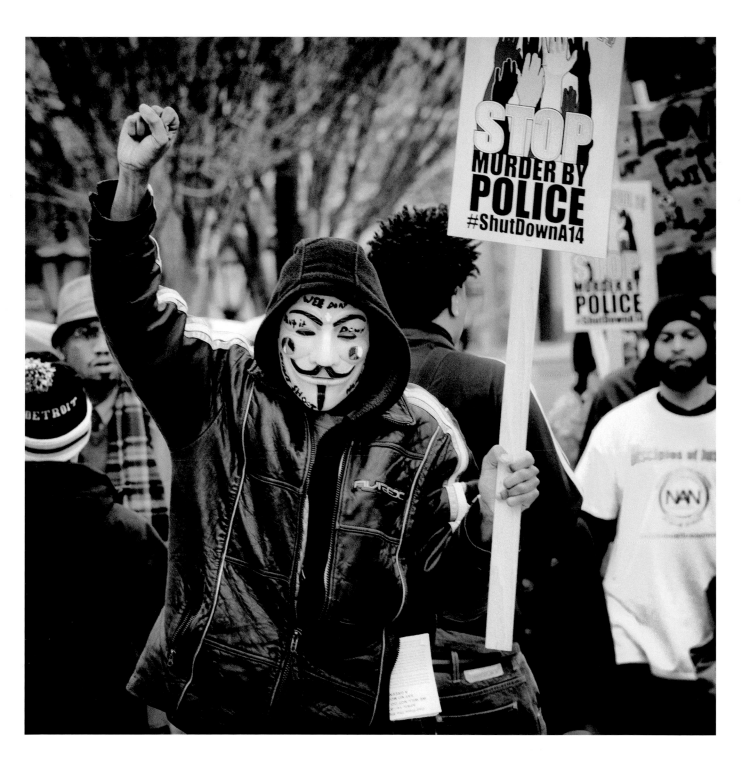

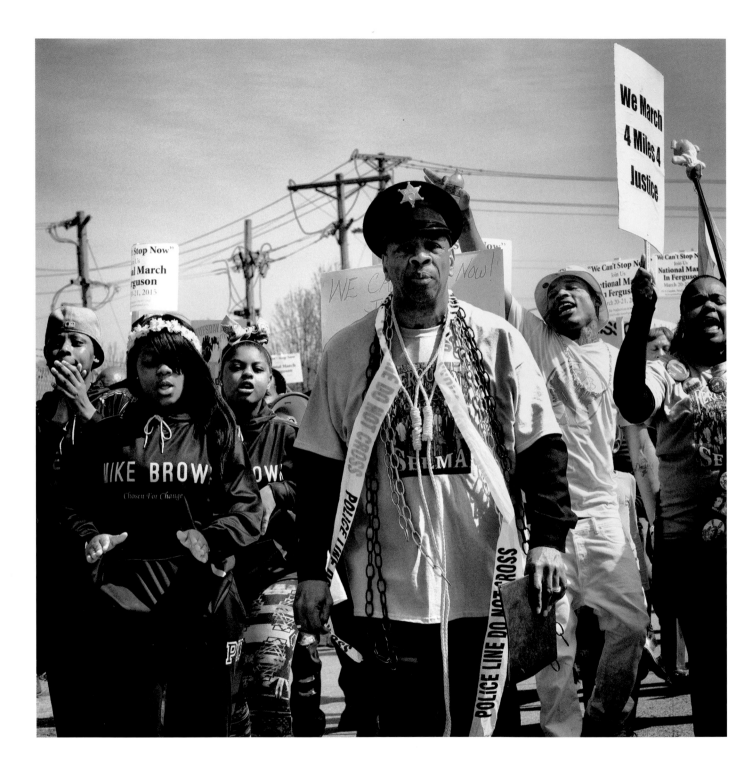

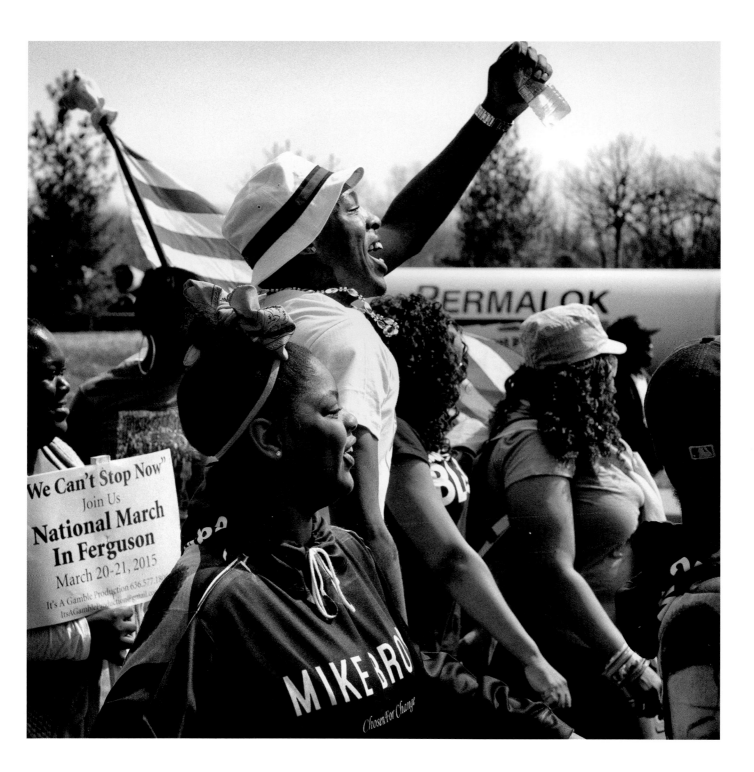

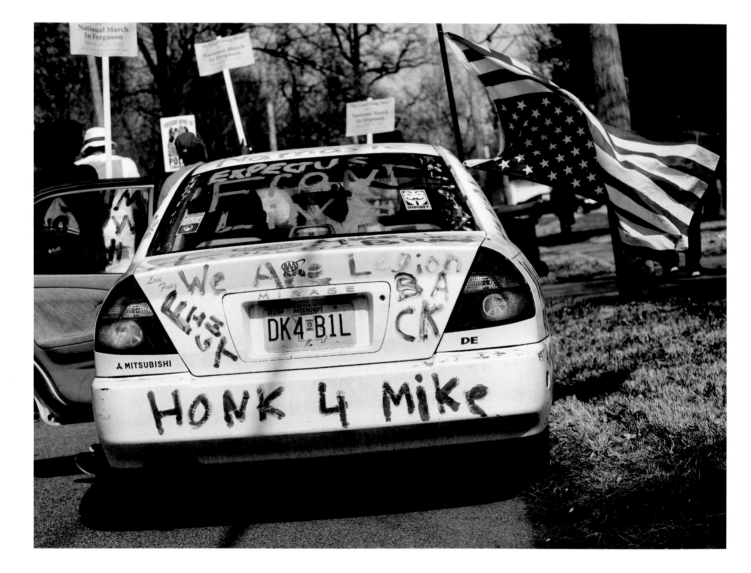

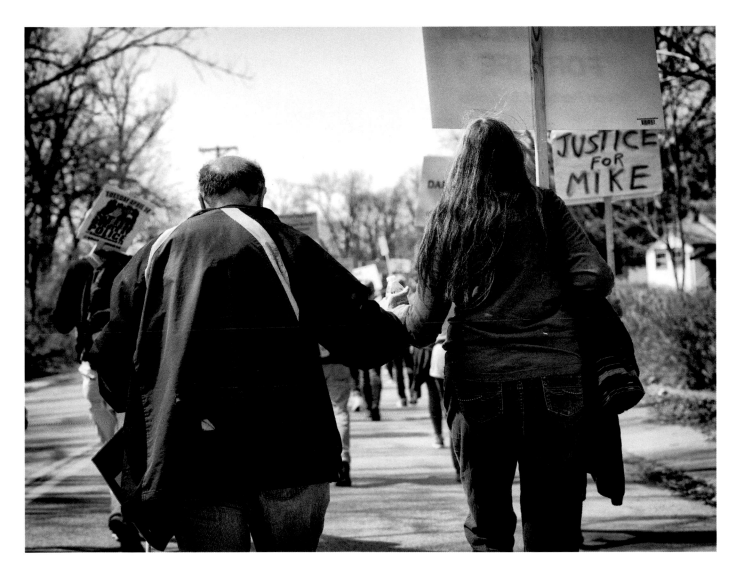

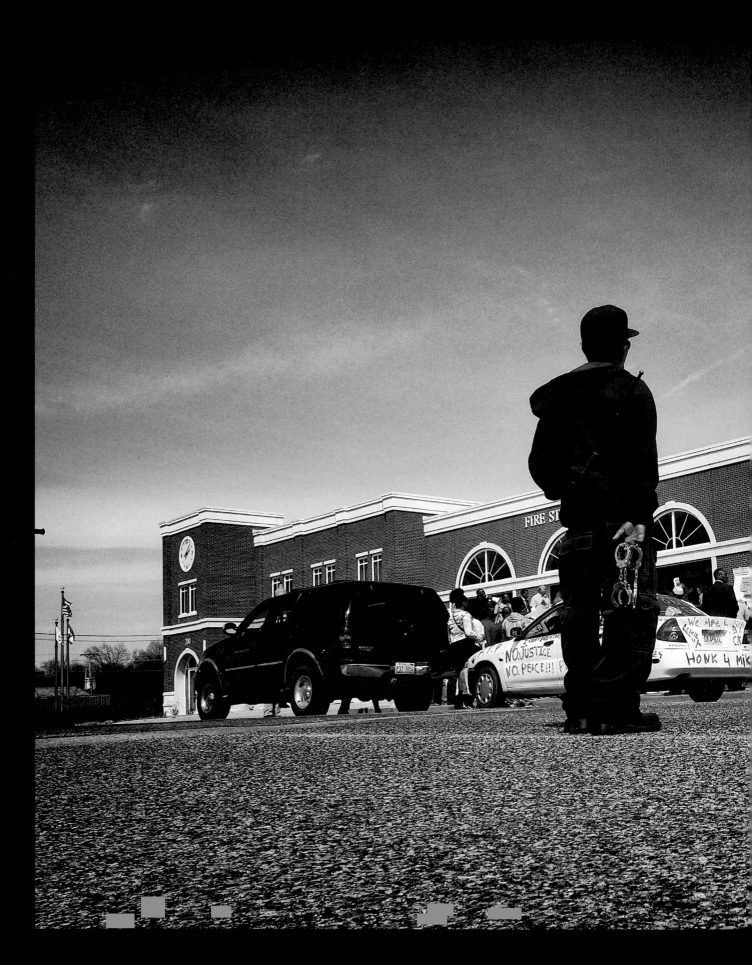

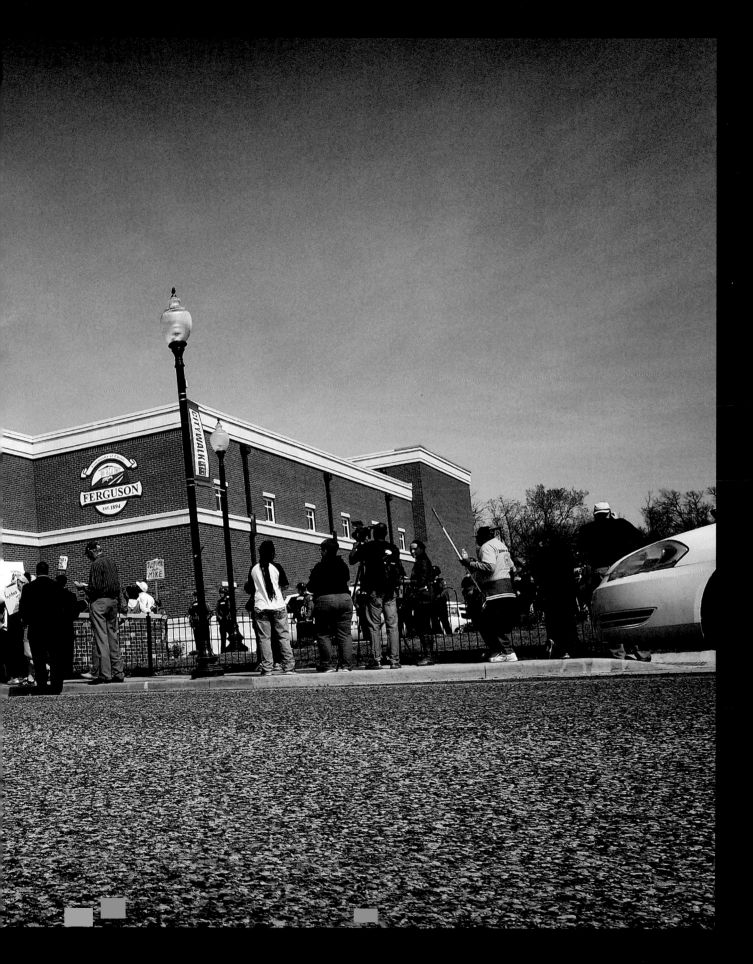

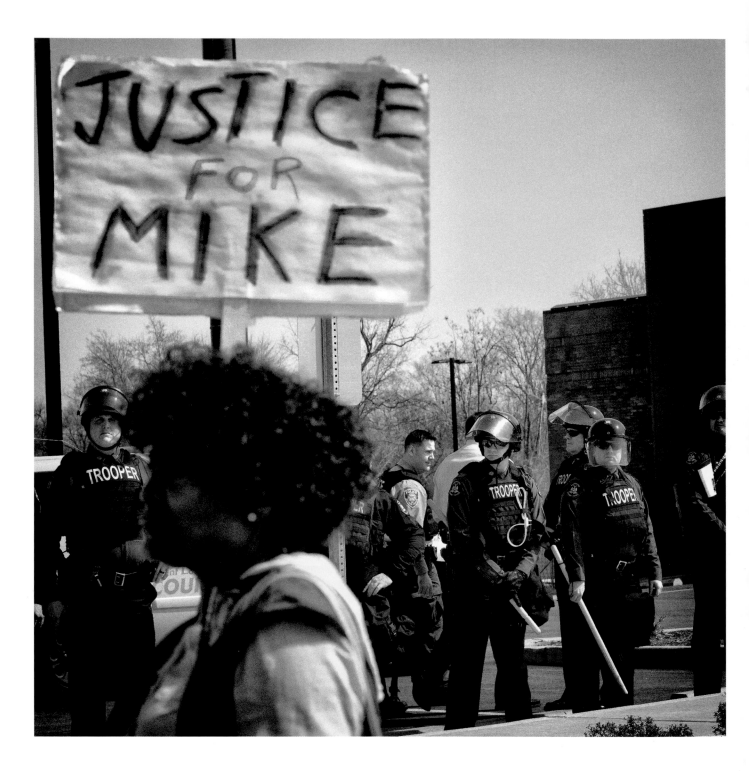

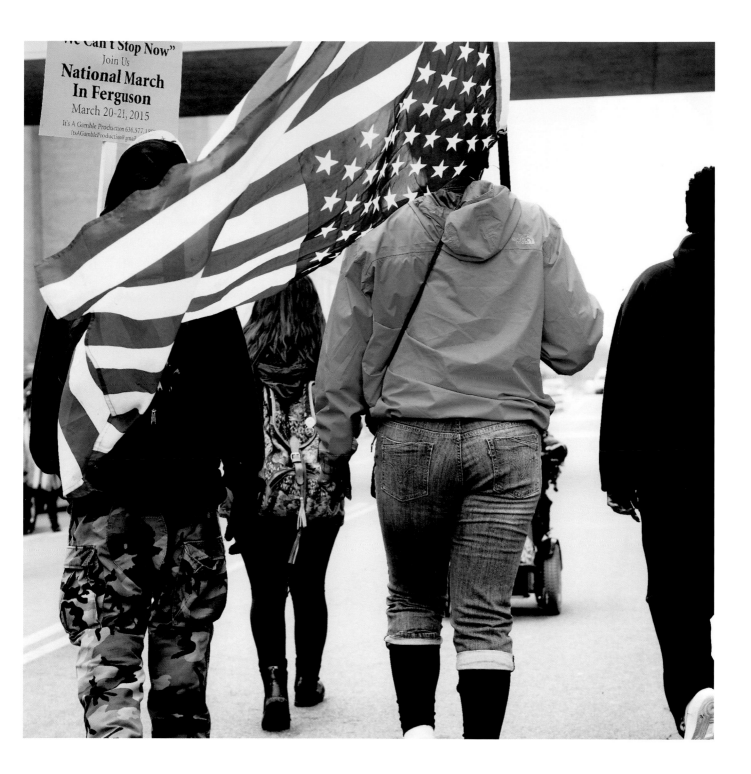

1960NOW: ART+INTERSECTIONS
BY KICHE GRIFFIN
Creative Consultant

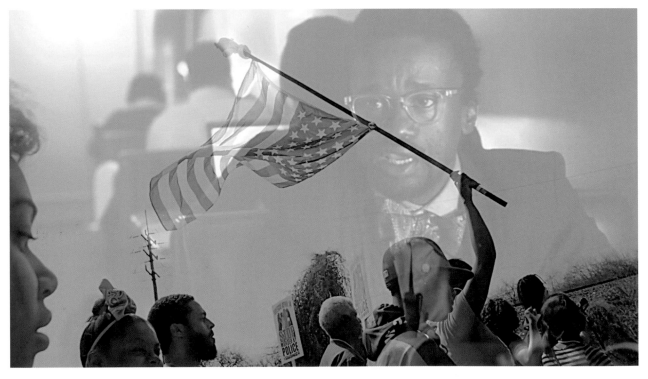

1960Now Art + Intersection *film still*

SHEILA PREE BRIGHT'S PROTEST FOOTAGE OF THE BLACK LIVES MATTER MOVEMENT

in Atlanta, Ferguson, and Baltimore is a compelling documentation that echoes content of the Jim Crow era. As each generation has its social values, music, fashion, and trends, the *1960Now: Art + Intersections* video depicts intergenerational correlations between critical thinkers noted in history and the emerging new leaders around the nation. Dr. Martin Luther King Jr., Stokely Carmichael, James Baldwin, and Nina Simone represent a collective muse, revealing an intersection in which church, rebellion, philosophy, and music proclaim a call to action.

As black churches were the spaces where the Civil Rights Movement emerged in the '60s, the relationship between religious practice and activism represents a crossroads at which the foundational voice of "the ground" can be expressed and heard by those who are respected as having community experience. In Bright's films for the *1960Now: Art + Intersections* exhibition, Reverend Osagyefo Uhuru Sekou of Ferguson discusses his observations on intergenerational and shared-community "safe" places after the police shooting of Michael Brown. Bright's footage of Pastor West, a young minister from Baltimore, also shows connections between church traditions and his experience as a black male from the city's streets during the Freddie Gray uprising.

Protest songs throughout Bright's footage symbolize a united call for action. In the '60s, protestors sang spirituals in the streets. As soul music—which has evolved into R&B, hip-hop, and rap—represents voices for freedom, Kendrick Lamar's music video *Alright*, featured in Bright's work, reveals a poetic message connecting the dilemma of Black lives falling by violence to the will to live against odds. The repetition of Lamar's falling body reinforces themes by contemporary authors, such as Ta-Nehisi Coates and D. Watkins, who both discuss what it means to survive "living in a black body" in American inner cities. Footage of the #HYTB (Hell You Talking 'Bout) chant by Wondaland recording artists Janelle Monáe, Jidenna, Deep Cotton, and St. Beauty explores the role of celebrity culture, proving that the street's call for action reaches beyond neighborhood blocks as the Wondaland artists joined the community in protests around the country.

In 1965, Bloody Sunday created global awareness as television broadcast the violence against Black Americans as a result of white supremacists of that time. Bright continues the tradition of showing the truth of community struggles through a collective video history of racial profiling, examining intergenerational responses to policing in America as a result of shootings across the U.S. targeting black bodies. Today, citizens use their smart devices to document police brutality, narrating details as real community witnesses in order to counteract fake news. In one video clip, Kwame Rose, who is included in *#1960Now*, debates Fox news journalist Geraldo Rivera, exposing the intent of the predatory media to exploit negative stereotypes of the people of Baltimore for news ratings. Social media allows communities to tell their stories, owning their truths and revealing relevant story angles often misinterpreted by outsiders. Overall, Bright's *1960Now: Art + Intersections* provides an informative observation of real experiences on the ground and a critical look at leaders of the past and present who call for change.

BALTIMORE, MD

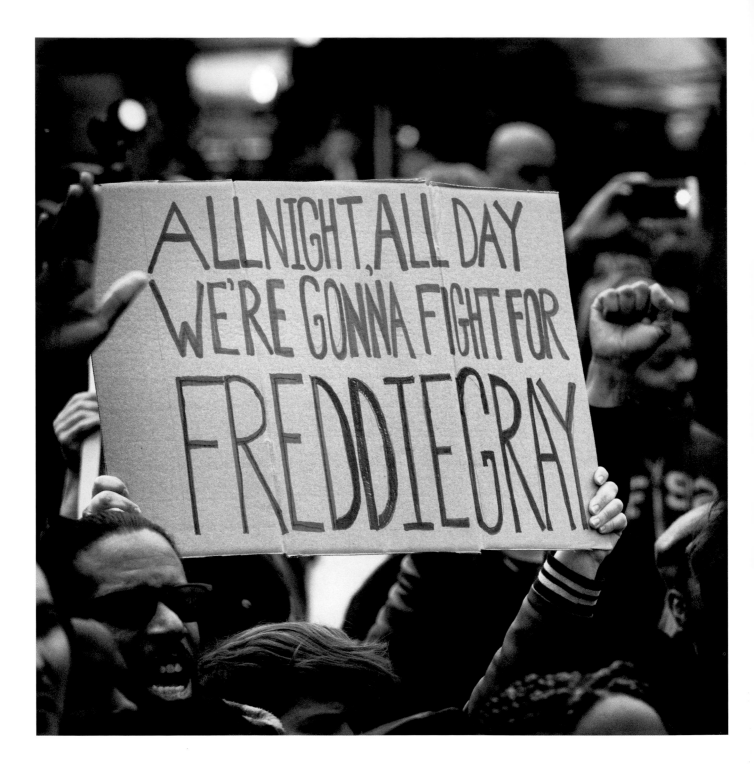

This page to page 83:

2015, Protest, "All Night, All Day, We're Gonna Fight for Freddie Gray"

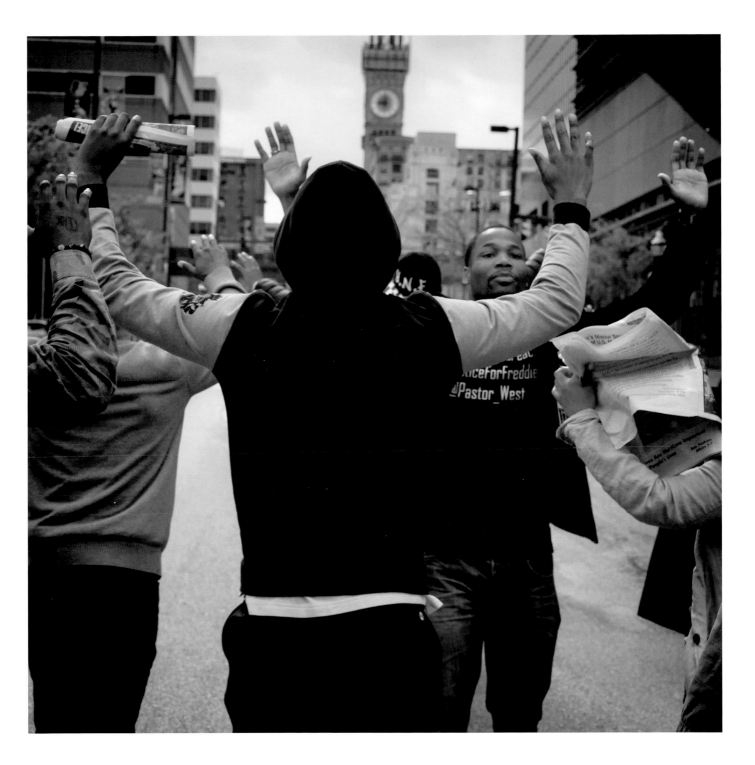

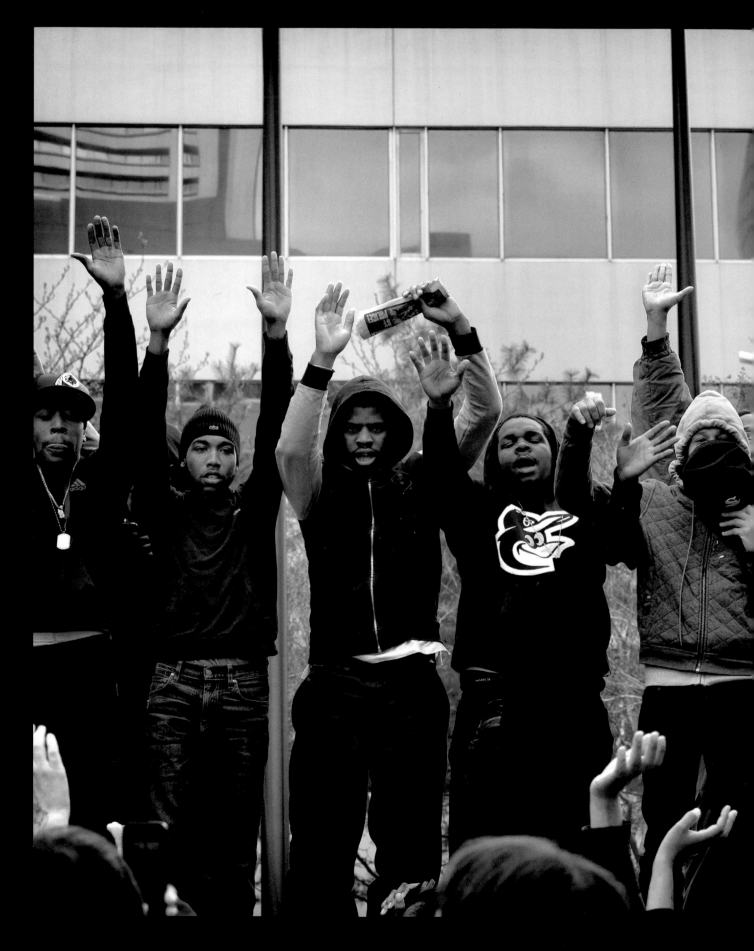

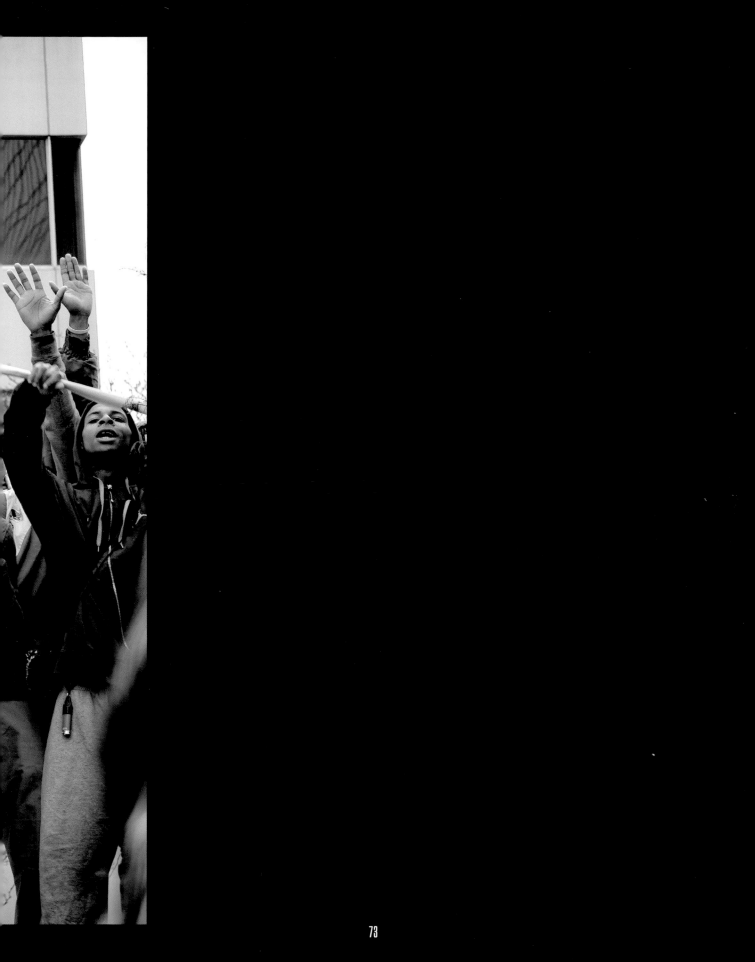

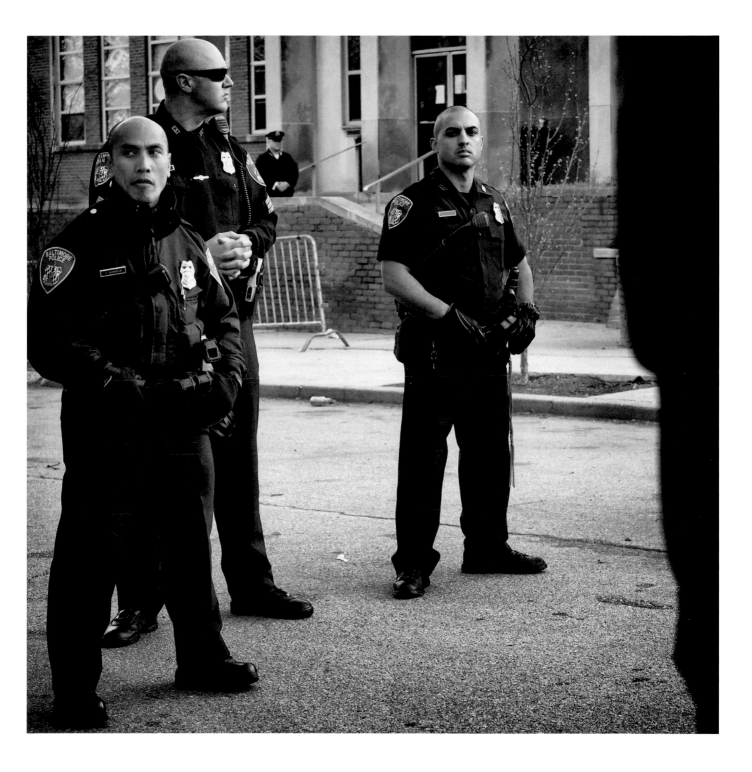

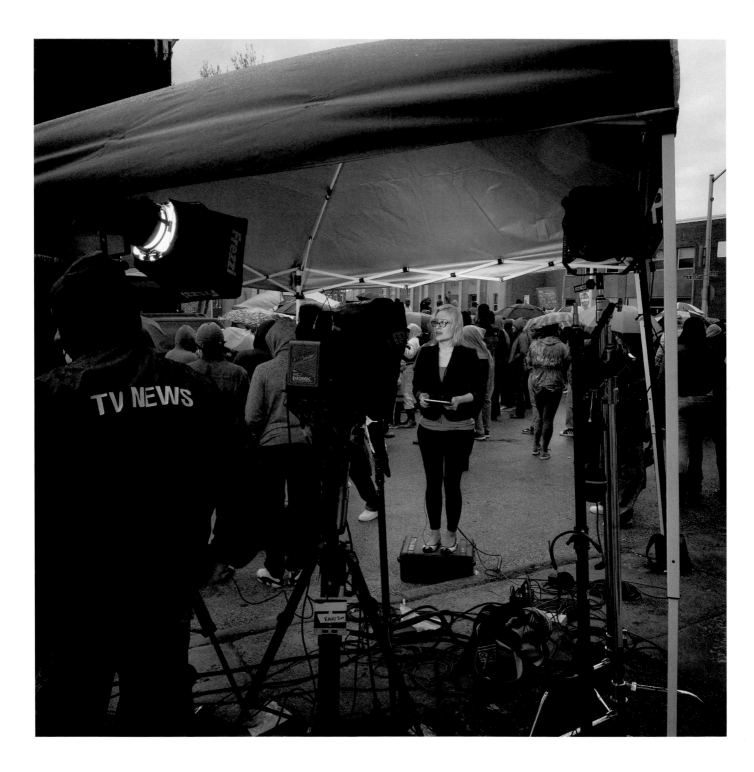

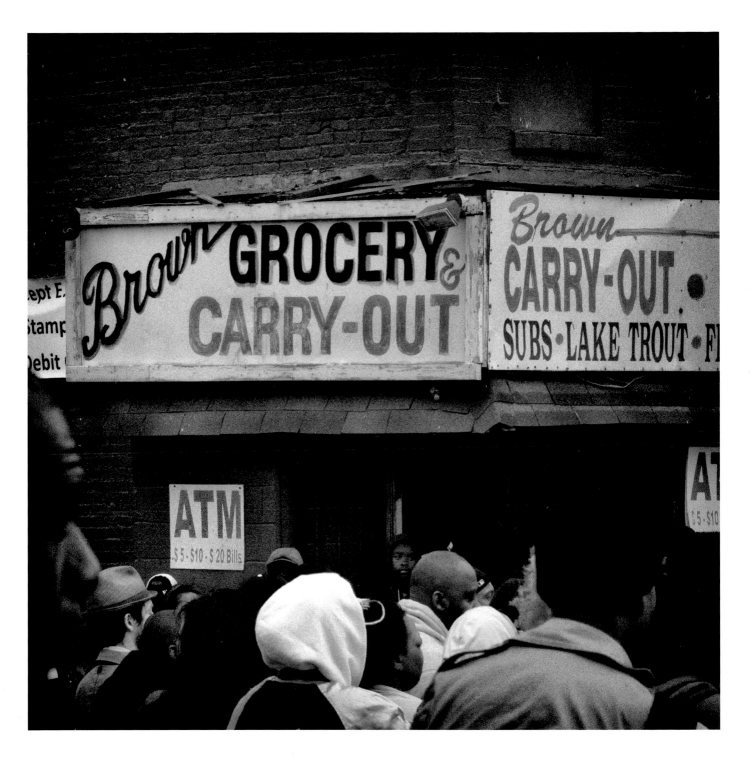

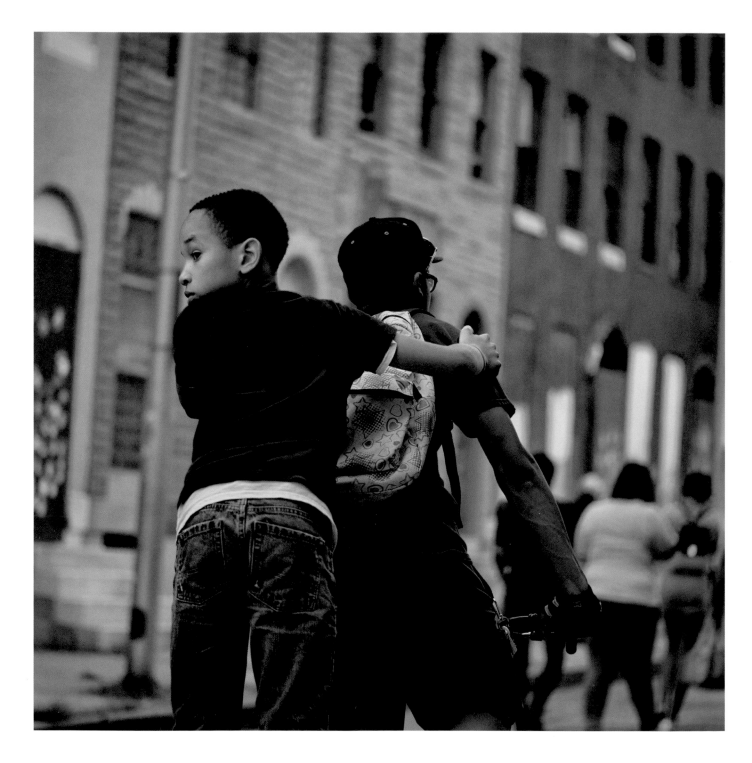

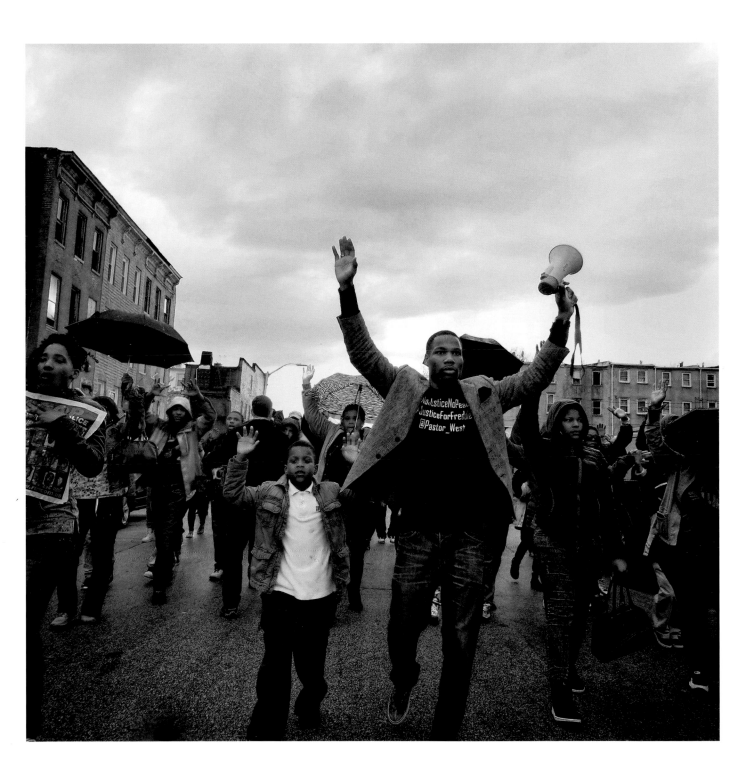

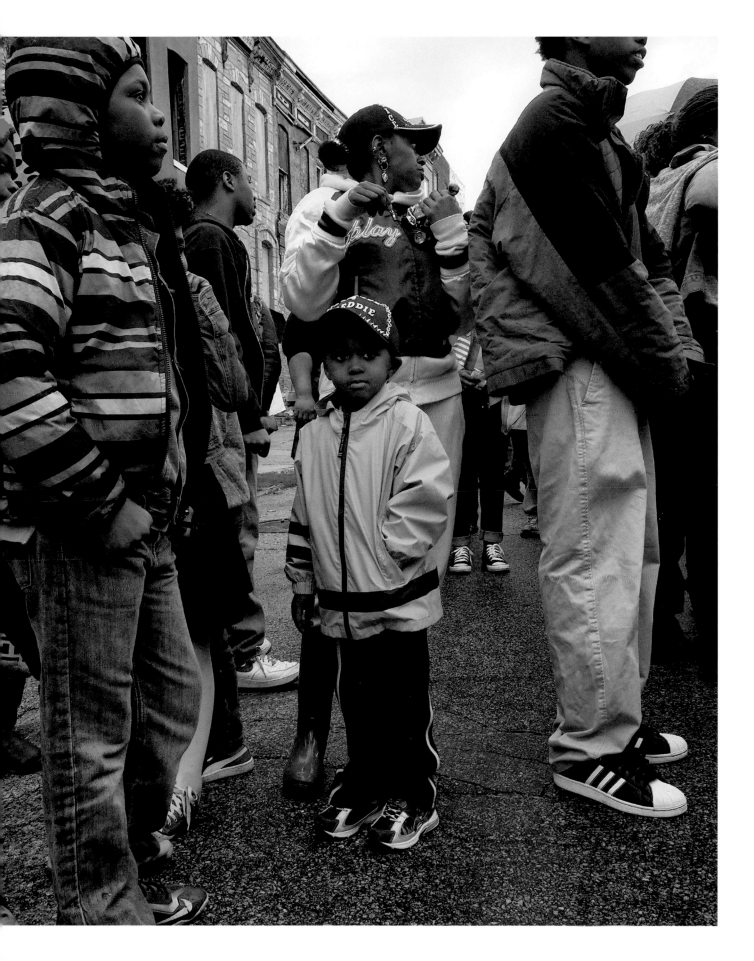

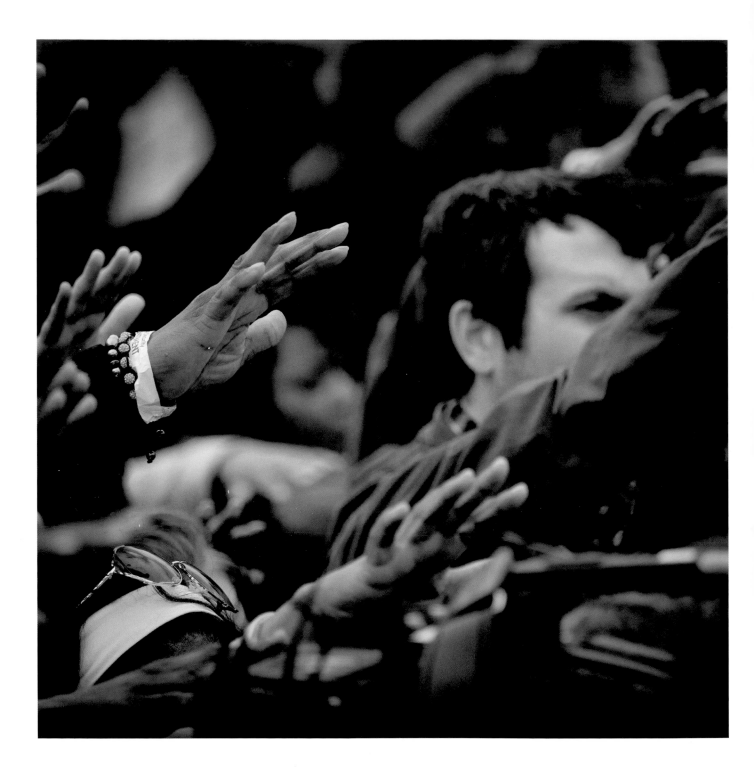

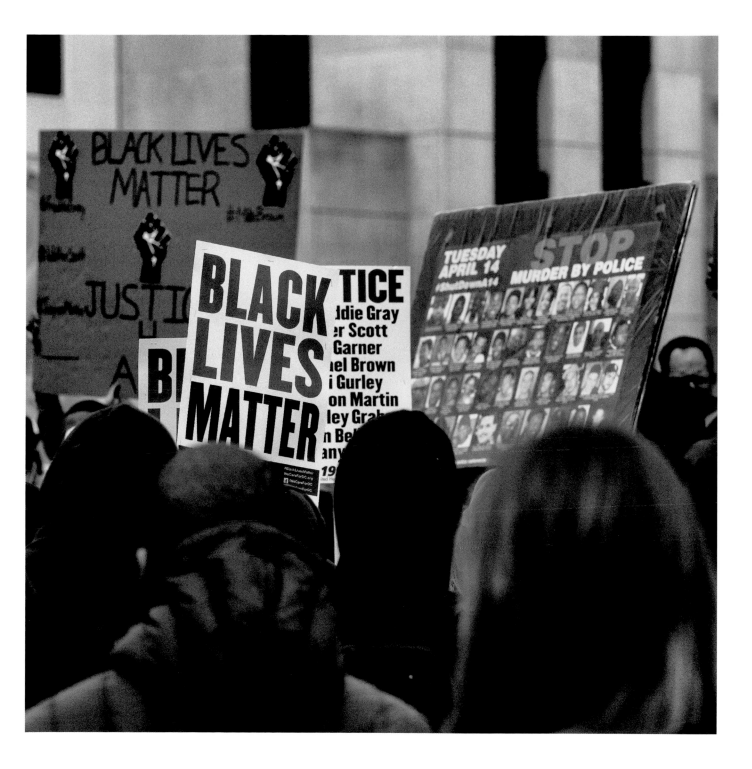

FRuM 1y6U Tu NuW!

SHEILA PREE BRIGHT IS BOTH A PHOTOGRAPHER AND AN URBAN ANTHROPOLOGIST.

She is an "ethnograph-photographer" who is a participant-observer in the communities that populate her images. Documenting histories and cultures of everyday life, Bright offers visual accounts of the ways in which ordinary people accomplish extraordinary things. The subjects of Bright's images dare to challenge hegemonies, empower themselves, and define their place in the world as individuals representing a community. Bright does the same. While celebrating the agency of her subjects, the photographer confronts and interrogates the assumed validity of institutions that legitimate their own power while marginalizing the agency of others. Bright responds by authenticating grassroots knowledge and truth. In the world that she portrays, people act to produce their own realities, truth, and meaning. Her *#1960Now* series is the perfect example of this.

In *#1960Now*, as in her *1960Who* series of portraits, Bright has created images of the sometimes anonymous and often unsung heroes of grassroots social change, to construct an alternative lens on civil rights history and contemporary protest movements. This particular portfolio engages Black Lives Matter and the symbolic interaction that has shaped Black Lives protests as culture and ideology. Through images of mobilization, Bright visually articulates the structures of cultural knowledge through symbols of social consciousness that have meaning to multiple generations. Symbols of protests captured by photographs that reflect the meaning, truth, and realities of a culture become knowable through the signs and representations that Bright shares. Seconds split by the click of an aperture capture voices raised in prayer, chant, or song. Extended fists punctuate the sky in solidarity, and elevated protest signs give shape, form, and compositional movement to the photographic canvas, while expressing the voice and language of the unrecognized and unheard. Sheila Pree Bright gives her subjects language, agency, and recognition, while creating a subjective understanding of Black Lives Matter as a culture, an ideology, and a crusade.

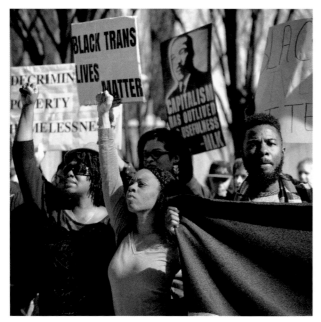

2015, #ReclaimMLKDay, Black Lives Matter disrupts MLK Day parades across the country, Atlanta, GA

BY AARON BRYANT

Curator of Photography, Visual Culture, and Contemporary Political History at the Smithsonian National Museum of African American History and Culture

Along these lines, the symbolic interaction inherent in Bright's photography positions the cultural and political perspectives of Black Lives Matter within the larger context of the Civil Rights Movement. This is evident in the photographer's choice to title the series *#1960Now.* Protests in Ferguson and Baltimore, for example, some of which shifted from peace rallies to riots, raise questions today that are similar to those posed by commissions during the 1960s on America's riots and civil disorder. The Kerner Commission, fifty years ago, drew conclusions that are shocking to consider now because they seem too familiar to us today. From Watts to New Brunswick, many riots of the period were sparked by confrontations with police officers. Reports also cited racial discrimination, economic injustice, and quality-of-life disparities as incubators for repressed resentment that eventually erupted in cities across the country.

Bright suggests similar issues in her photography. However, she focuses on solutions and on communities mobilized for peace, action, and change. One image taken in Atlanta, in particular, renders a crowded group of protesters, and to the far left are two women with their fists raised. Behind them are people carrying protest signs. The sign to the far right reads in large, handwritten letters, "Black Lives Matter." Another sign declares "Black Trans Lives Matter." Then two different signs speak directly to quality of life and economic justice: The first simply states "Discrimination, Poverty, Homelessness"; while the second features an image of Martin Luther King Jr. and his observation that "capitalism has outlived its

usefulness." The quote is taken from a letter that King wrote to his wife, Coretta Scott King, on July 18, 1952, when the couple had been dating for only a few months and refers specifically to King's thoughts on collectivism and the social gospel.

More than ten years later, King would argue that the inhumanity of poverty was the root cause of the violent backlash in America's cities, and until his assassination in 1968, the civil rights leader saw riots of the period as a consequence of legislatively supported racial discrimination that created economic disparities between White and Black communities. King maintained that peaceful but disruptive mobilization to force changes in government policies would be the only solution to civil unrest. With that in mind, the Baptist minister organized the Poor People's Campaign. Today, we mobilize around similar issues through Black Lives Matter and other issue-specific protests.

Like other documentarians before her, Sheila Pree Bright has committed her art to social justice and change. She positions her photography as a public sphere in which viewers become a discursive part of an idioculture and movement. Each image serves as a photographic space of cultural exchange and symbolic interaction in which Black lives, Trans lives, and social justice matter. Within this sphere, not only are individuals as subject positions discursively produced, as part of a cultural dialectic, they shape and reshape the discourse and thus, their own subjectivity, through images that capture the traditions and ideas of generations from the 1960s to now and into the future.

WASHINGTON, DC

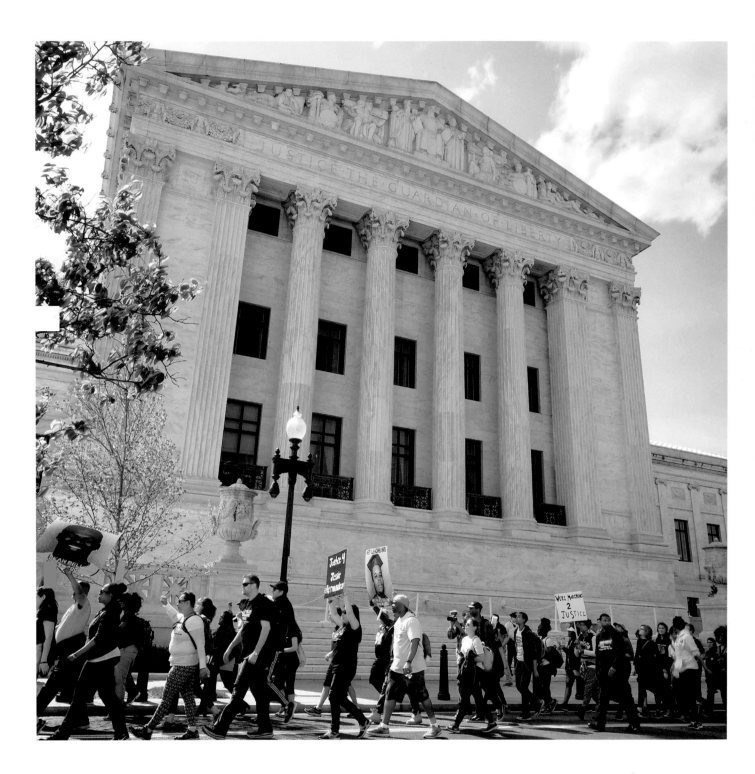

This page to page 101:

2015, Justice League NYC's "March 2 Justice" from New York to
Washington, DC, in protest of police brutality

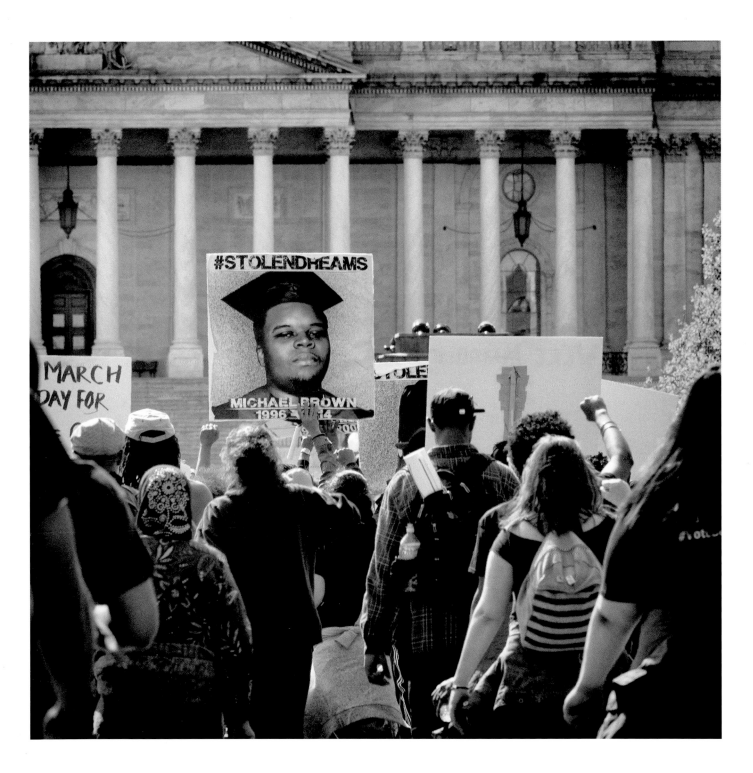

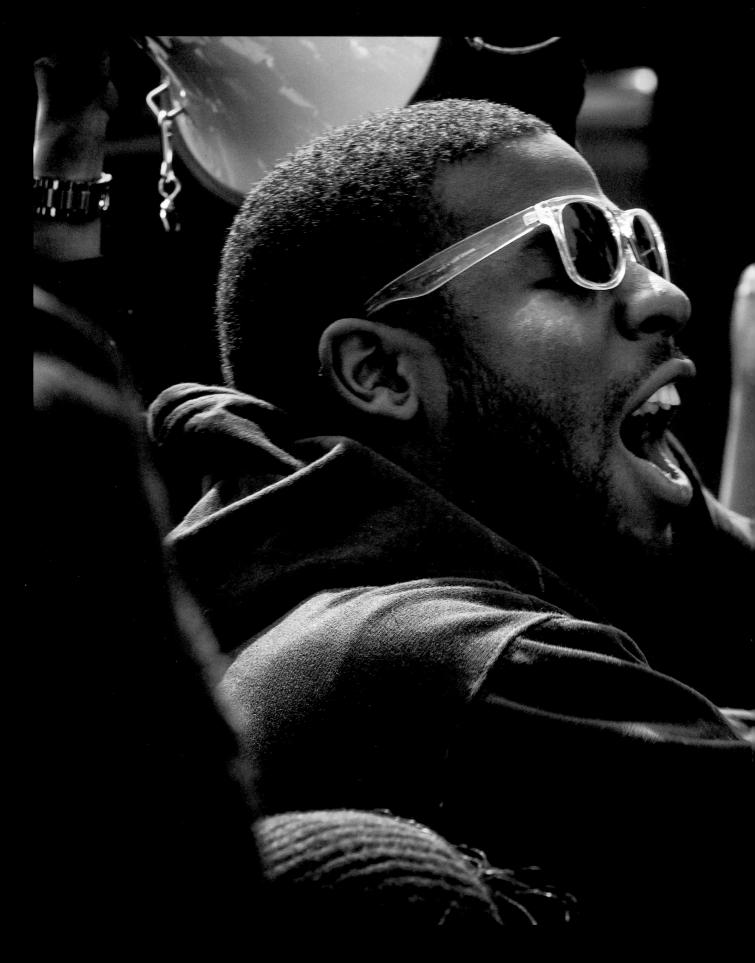

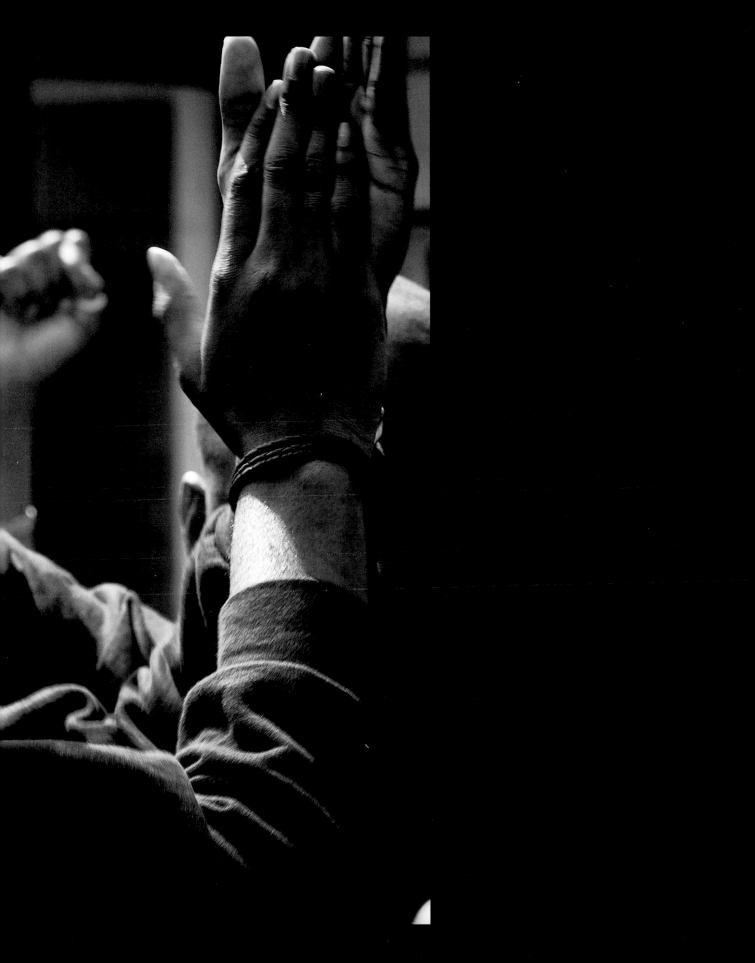

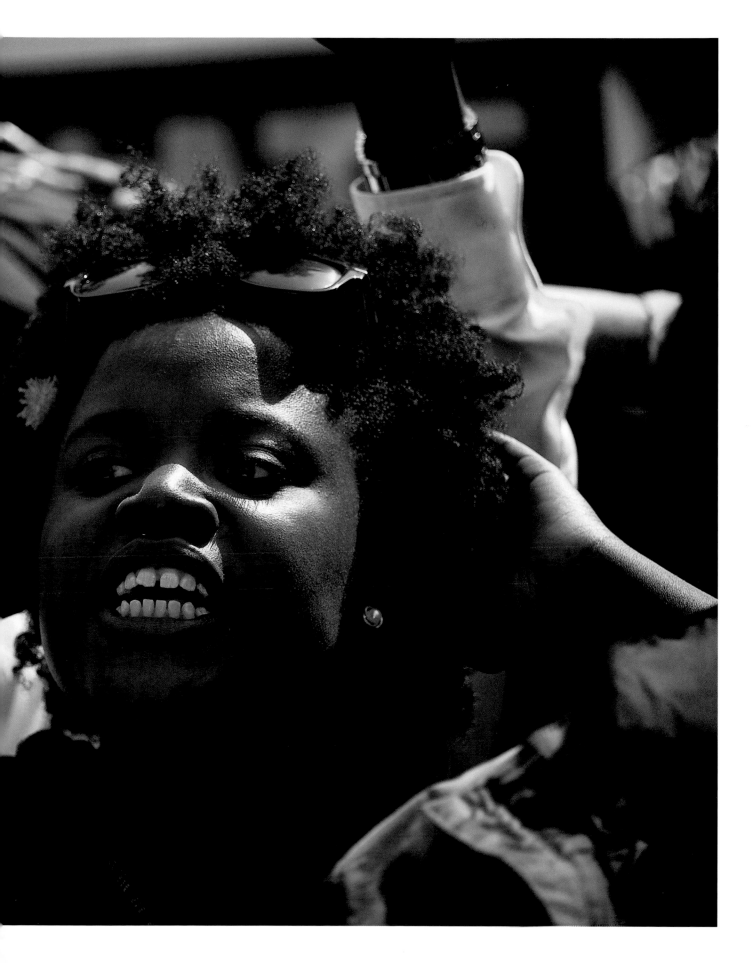

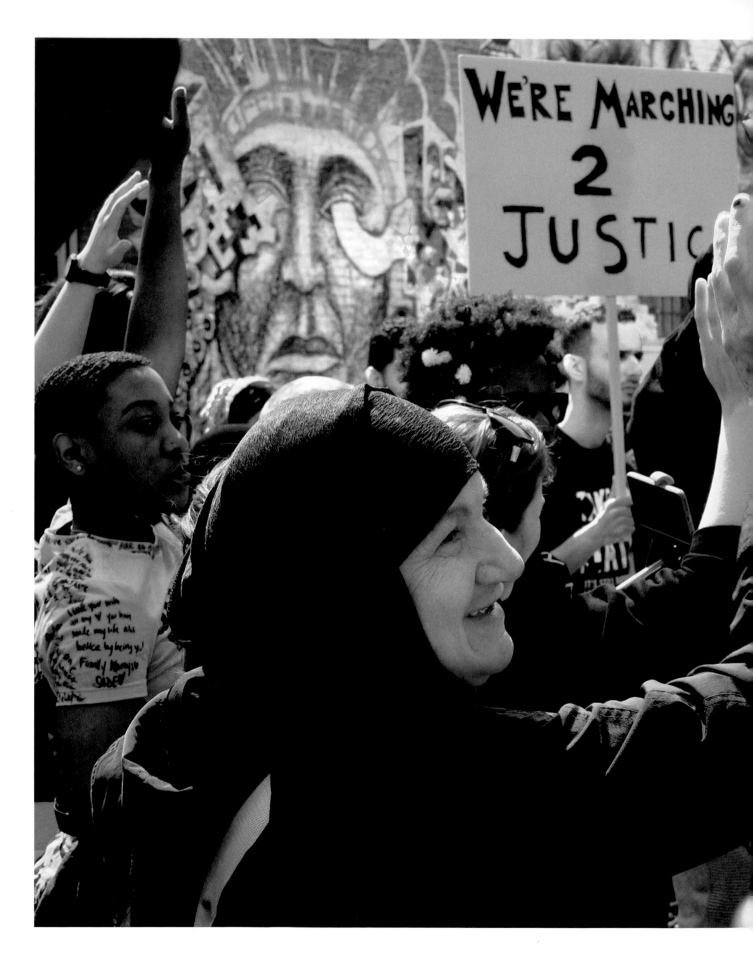

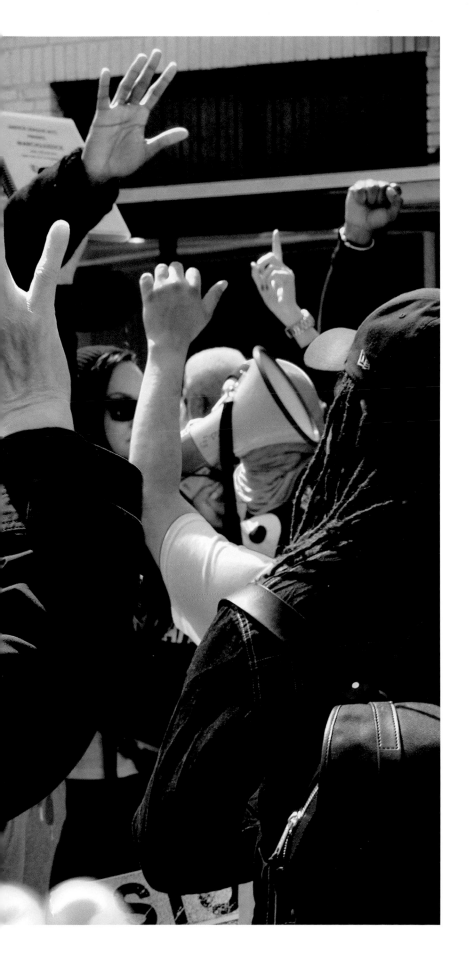

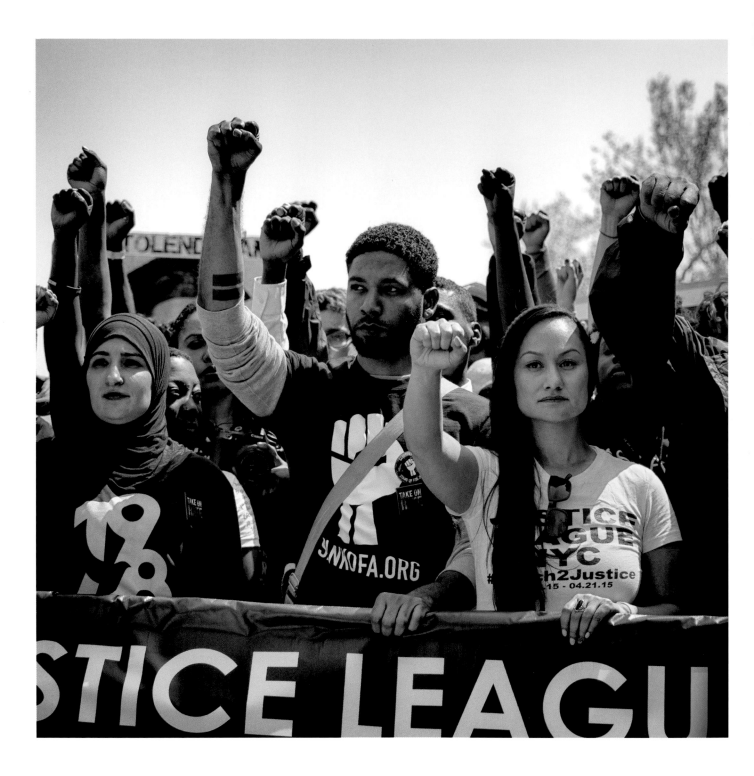

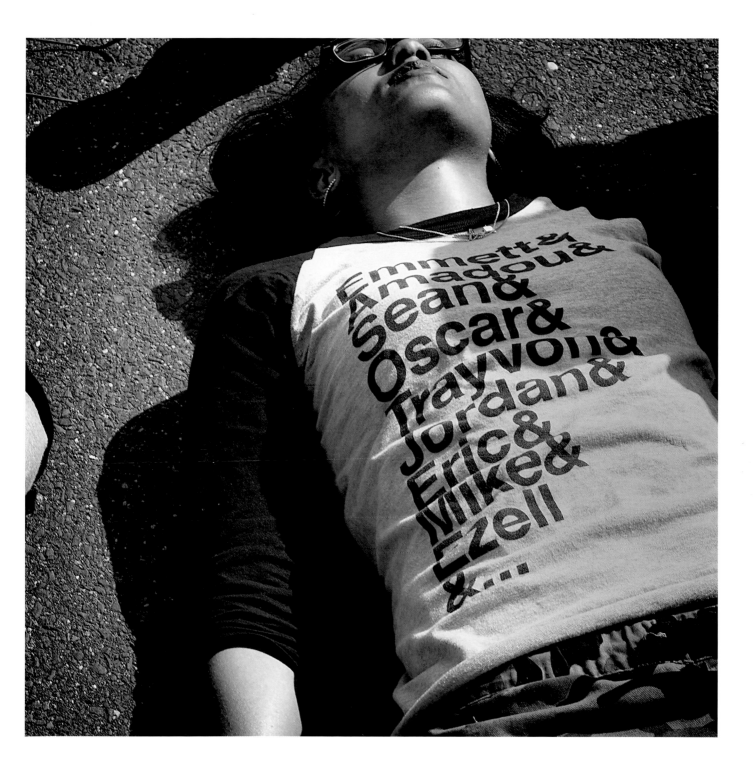

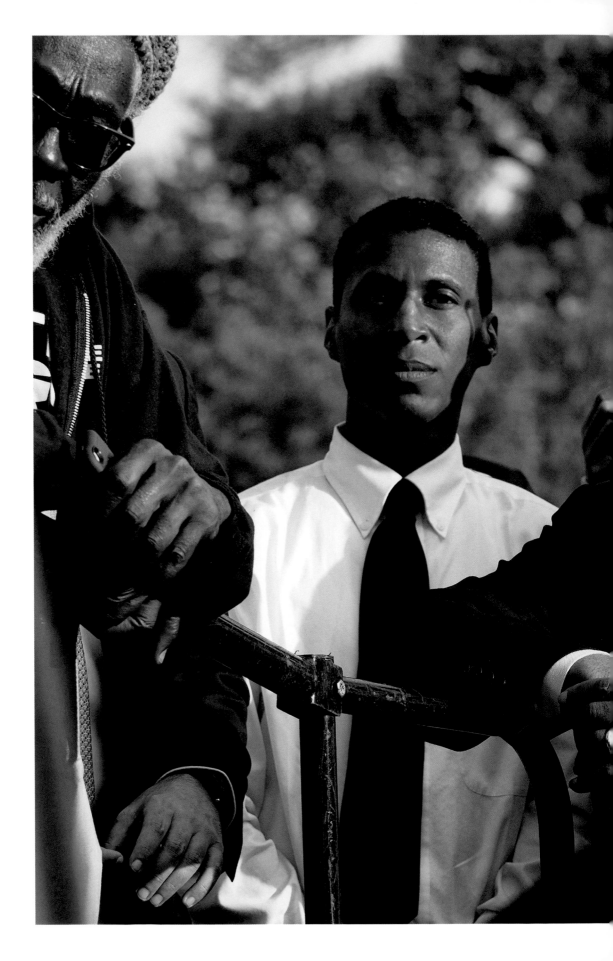

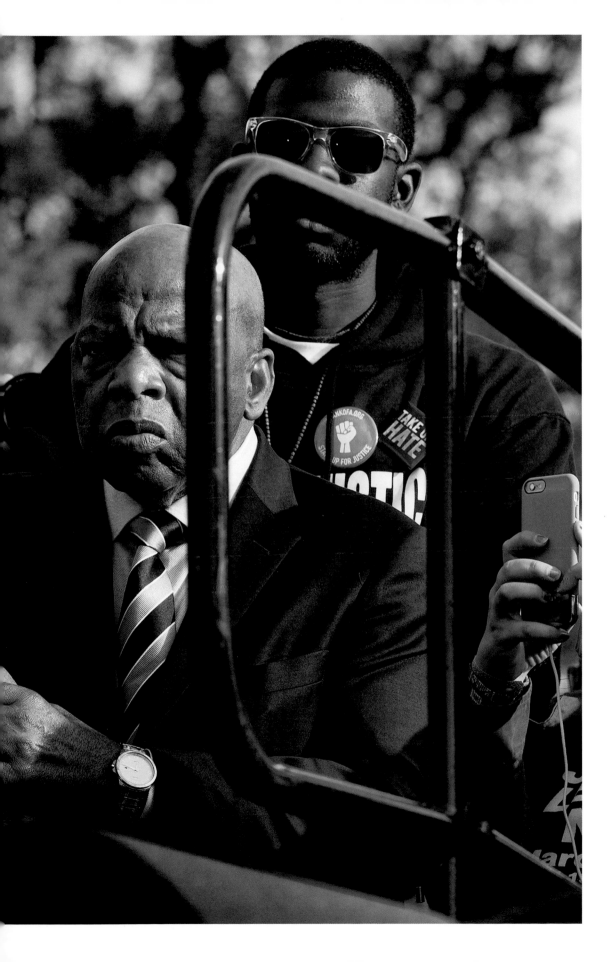

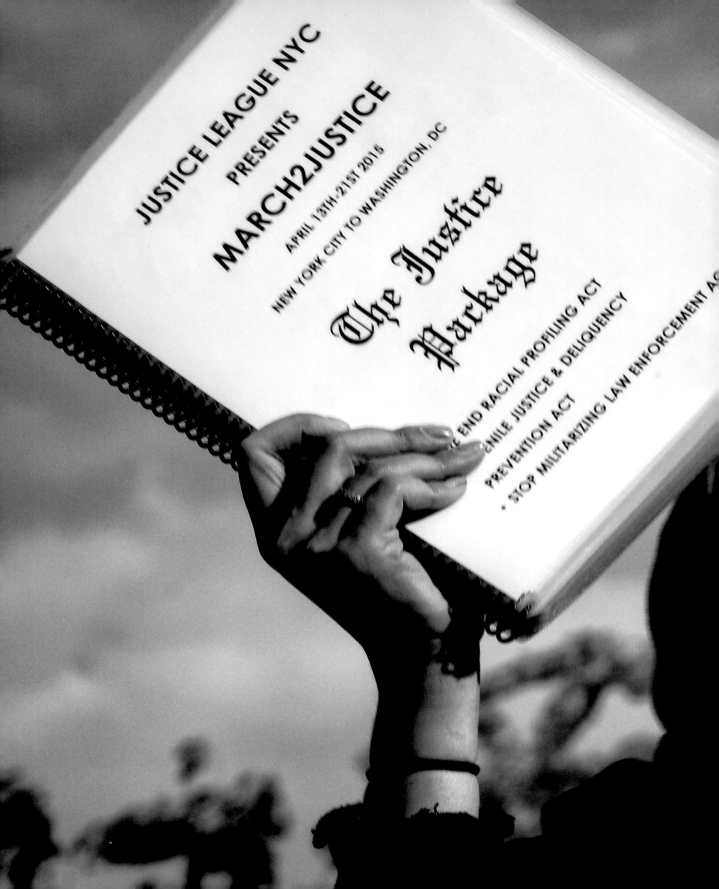

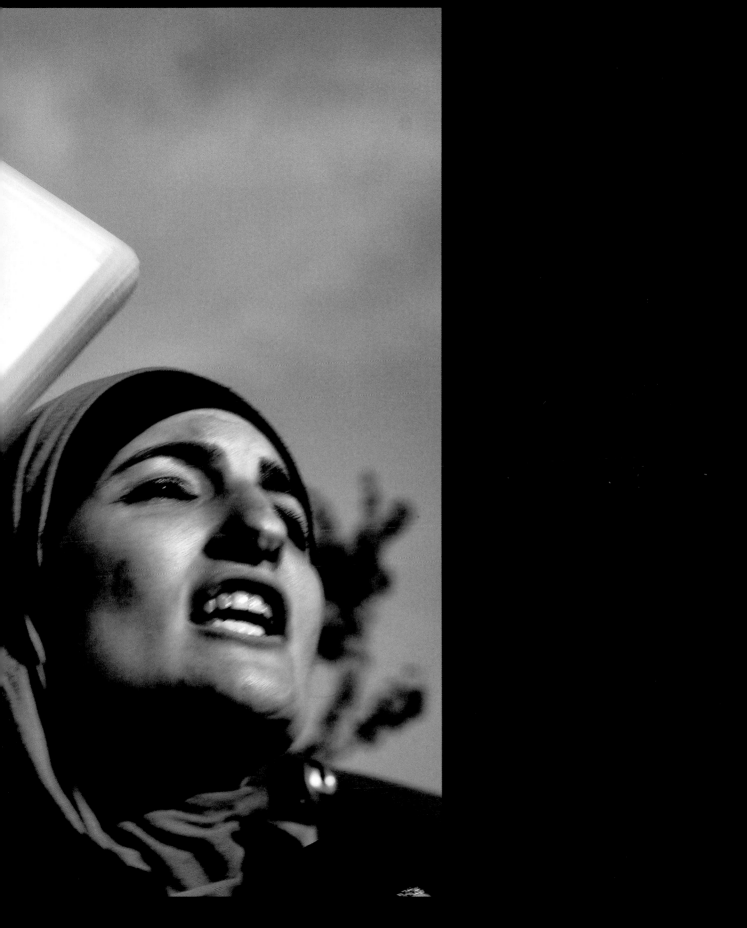

HEROES, VICTORIES, AND TRIUMPHS

SHEILA PREE BRIGHT IS ENGAGED IN A QUEST TO CHANGE

the way Black bodies are seen, represented, and conceptualized. For her, social- and racial-justice struggles are points of departure to investigate, educate, and explore. Bright's work demonstrates the participant eye of an activist who is unwilling to sit on the sidelines as history is made. Her exhibition *Heroes, Victories, and Triumphs* shows the ongoing fight against injustice and, in particular, the photographer's celebration of the beauty of individuals and the hopes and dreams of the people.

The ongoing series *#1960Now* shows an intimate view of demonstrations and marches in which deep and empathetic humanism resists simple categorization. The large-scale portraits come directly out of the tradition of the great portraitists, from Richard Avedon to Dorothea Lange, who capture people who might otherwise be no more than a passing news image. Equal parts documentary and homage, Bright's work matches the formal qualities with the sense of respect for the changing tide of history and those who play central roles in it.

Bright's work challenges what we see and how we see it. Within the current context of momentous changes that surround us, her work refreshes our sense of the possible and expands our notions of what is beautiful.

BY KEITH MILLER

Curator of the Gallatin Galleries
at New York University

2015, Protest, "All Night, All Day, We're Gonna Fight for Freddie Gray," Baltimore, MD

This page to page 115:

**2015, #ReclaimMLKDay, Black Lives Matter disrupts MLK Day
parades across the country**

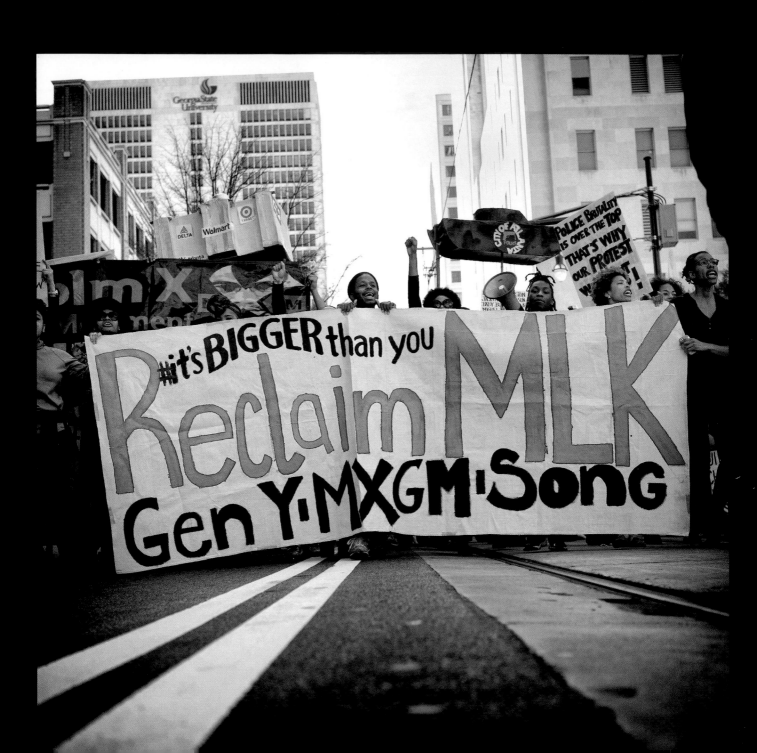

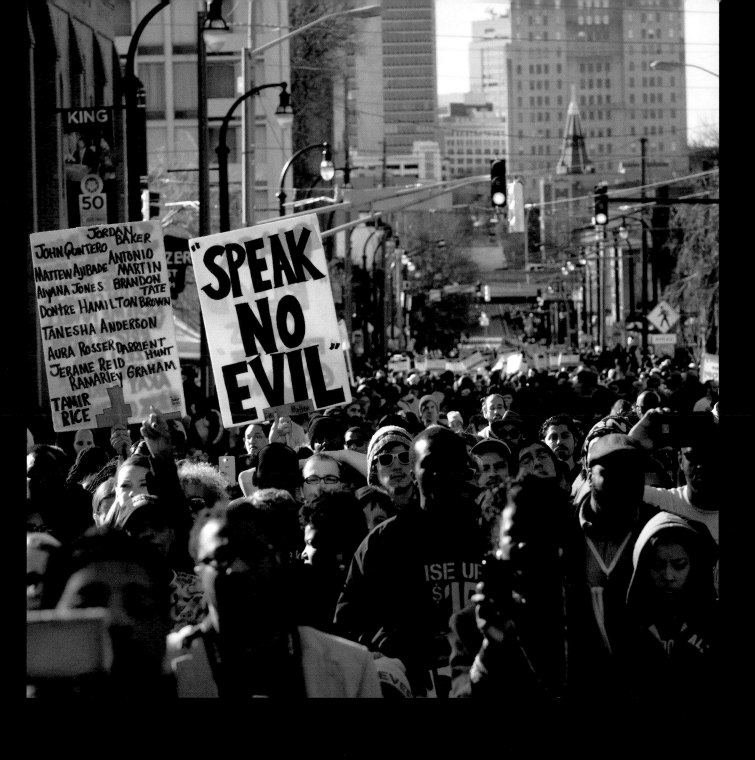

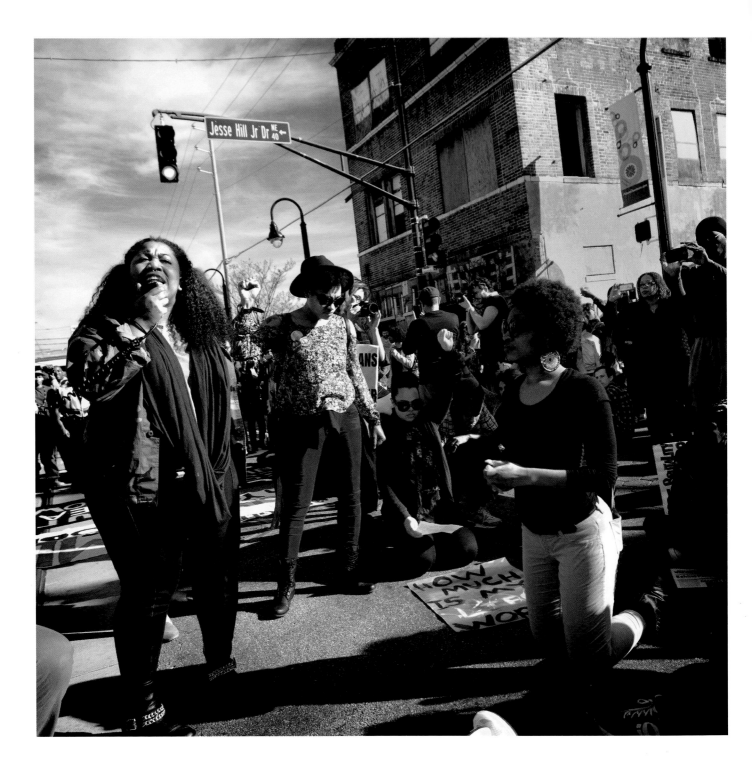

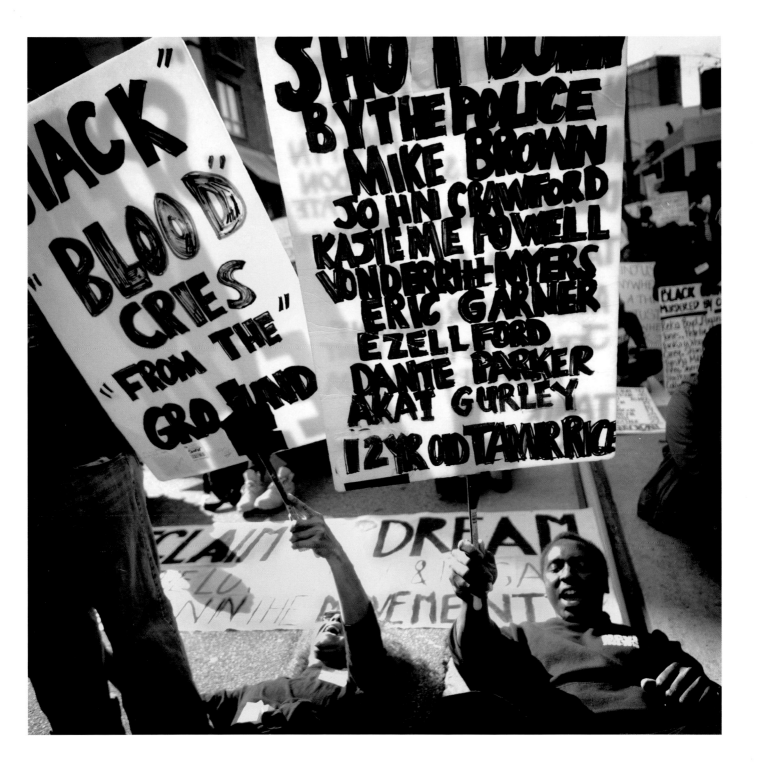

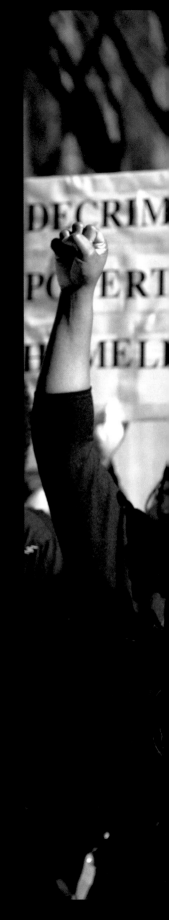

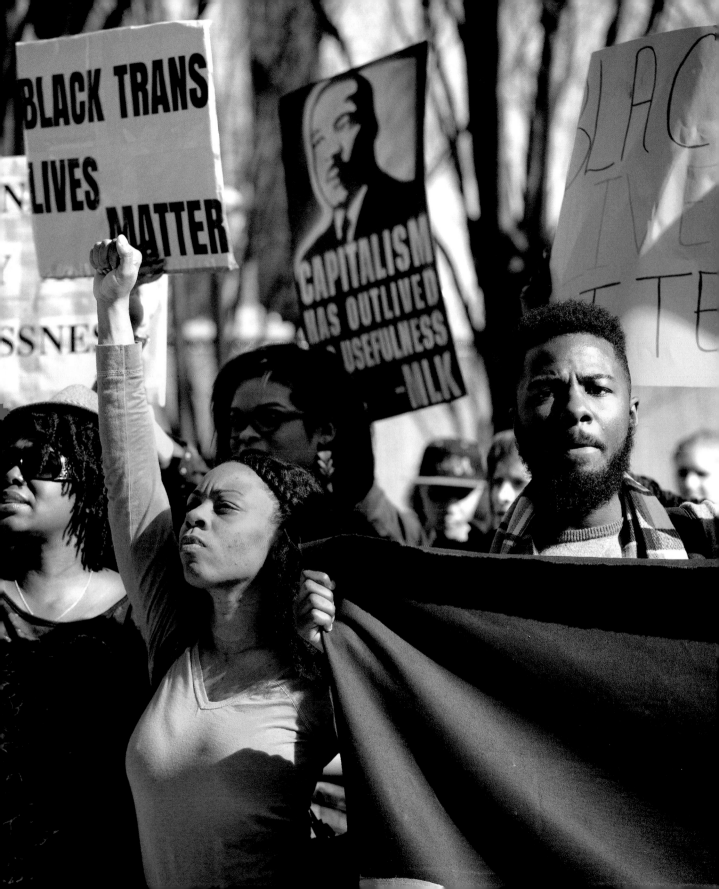

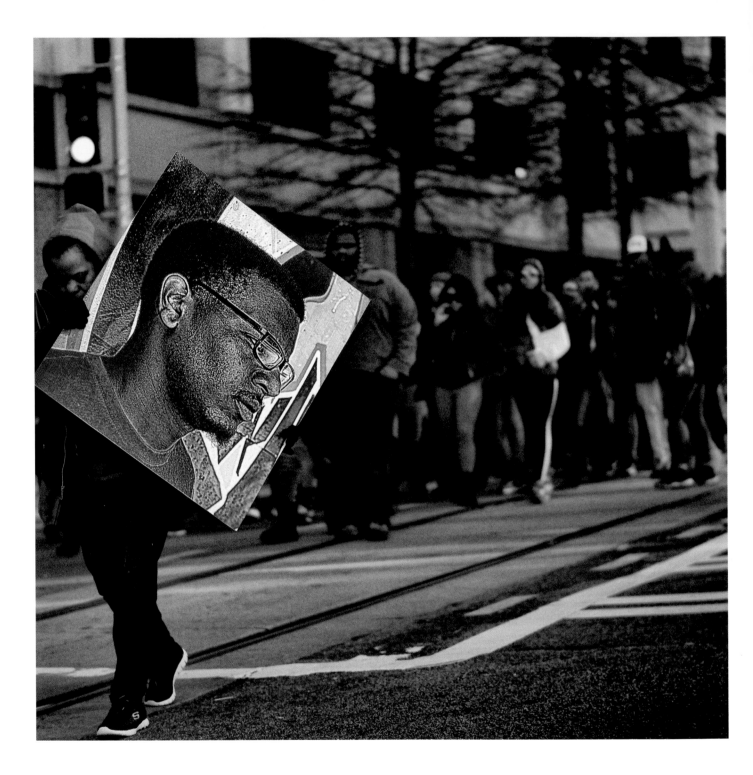

This page and the next:

2016, Martin Luther King Day Parade, Black Lives Matter Atlanta Chapter

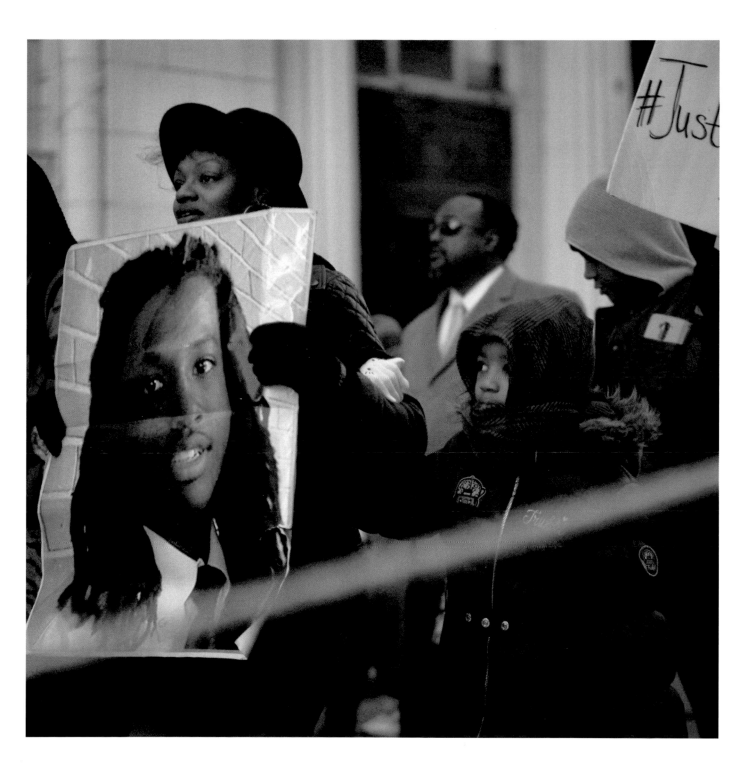

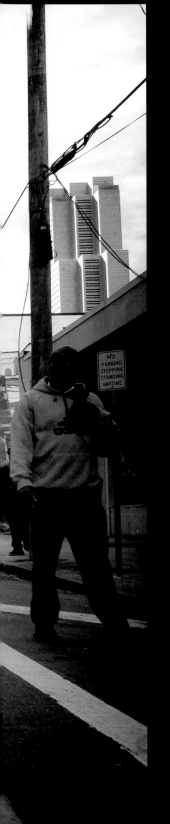

2015, #ReclaimMLKDay, Black Lives Matter disrupts MLK Day
parades across the country

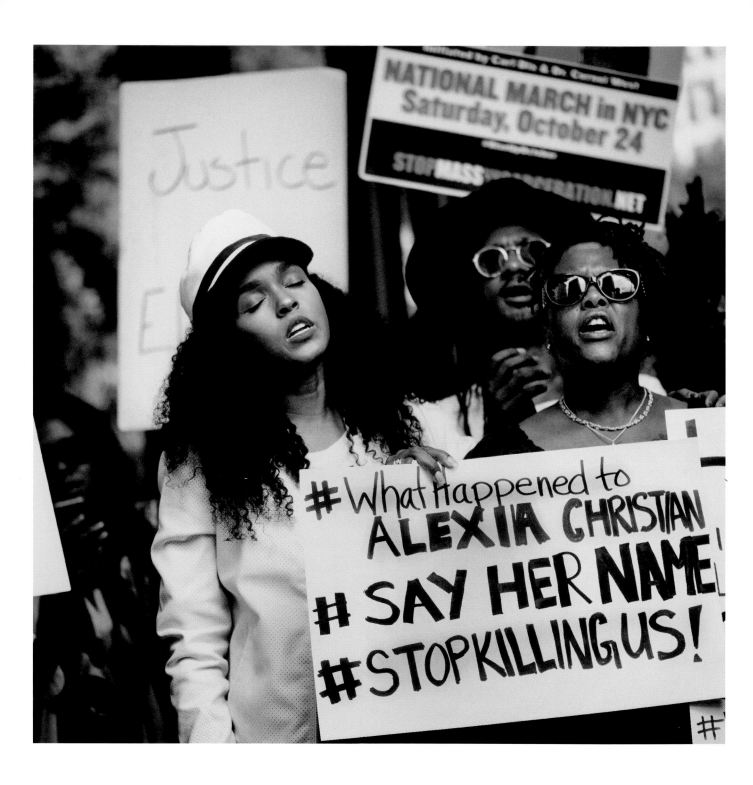

This page to page 129:

2016, "Say Her Name" protest, artist Janelle Monáe and Wondaland Records
members perform "Hell You Talmbout" protest song

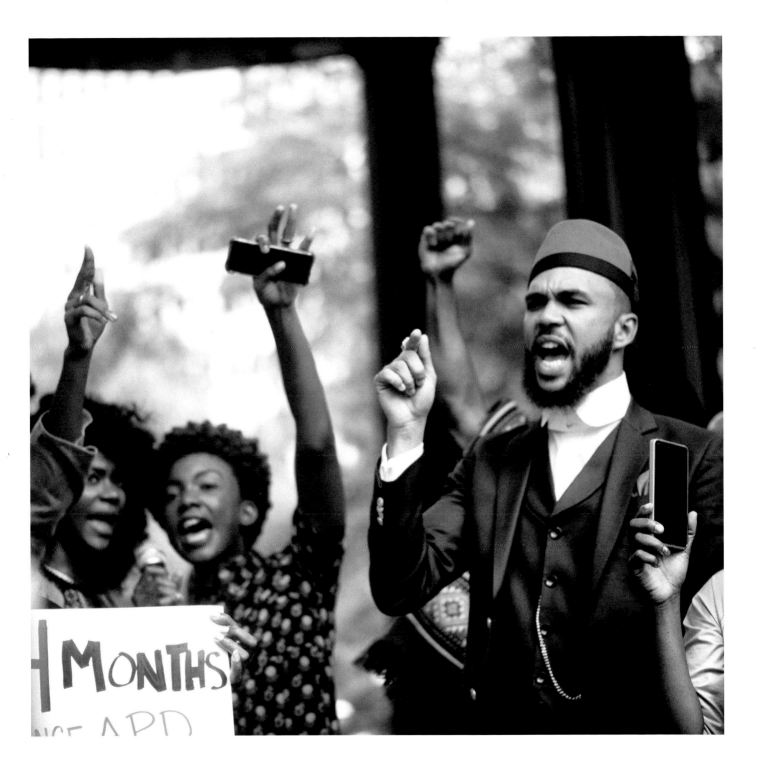

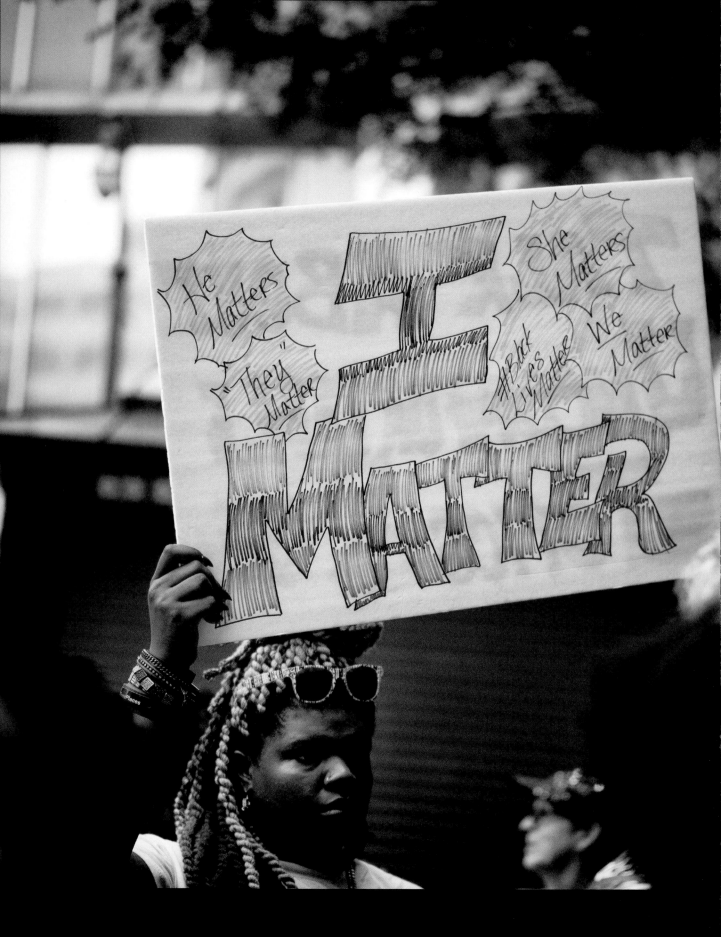

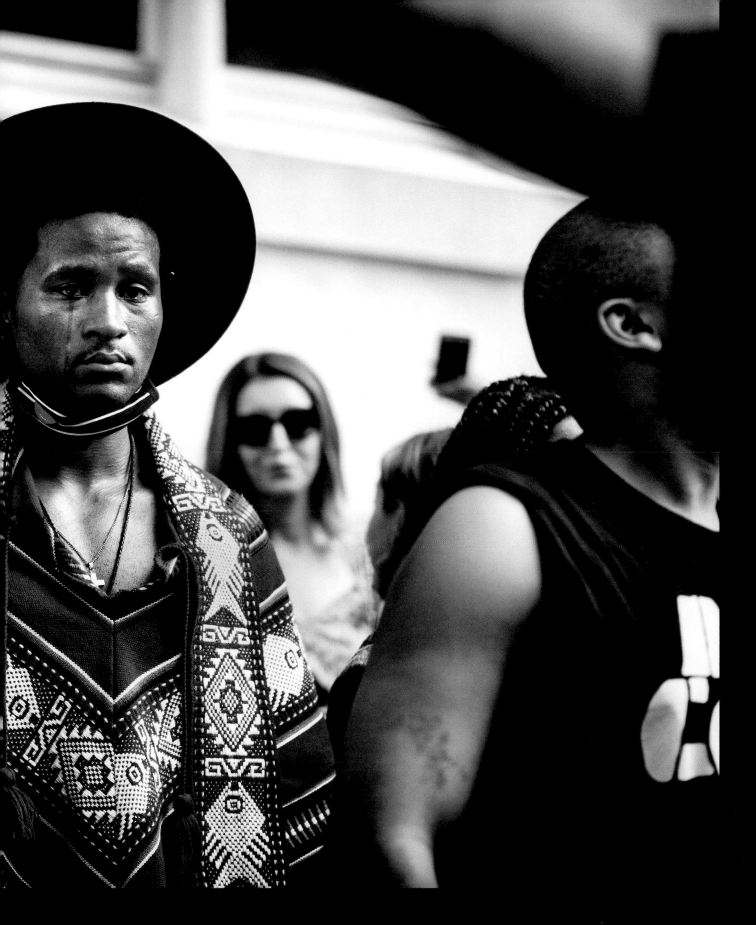

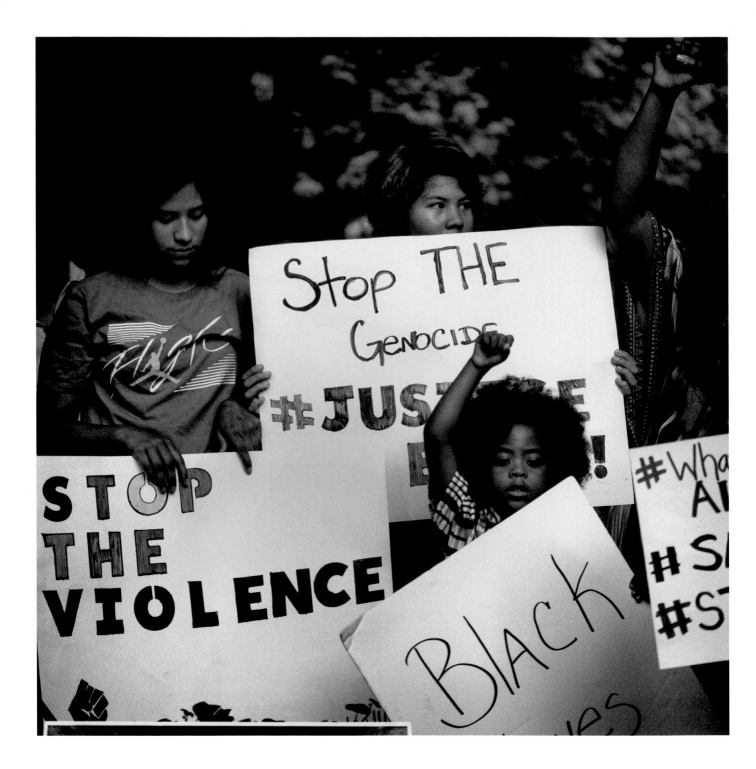

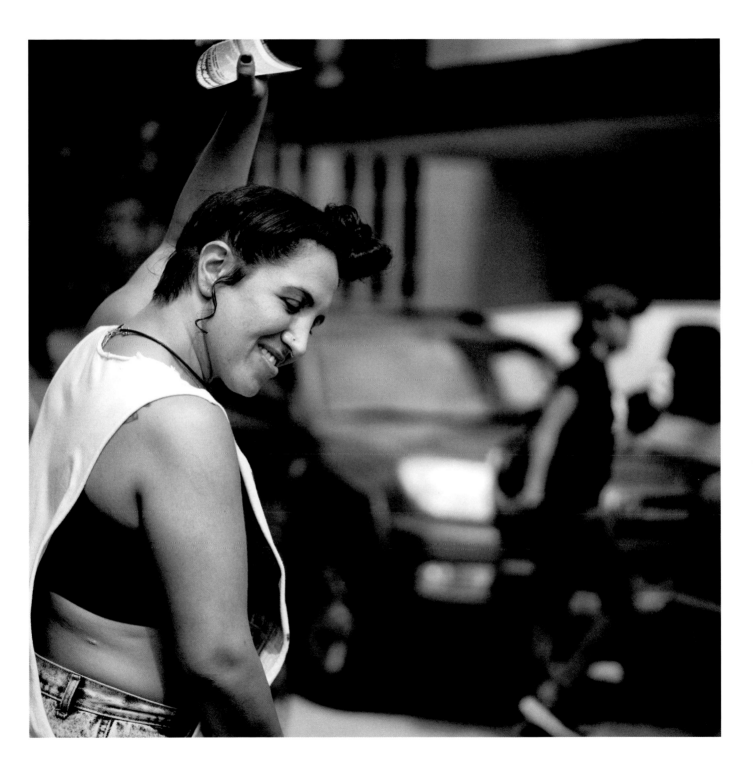

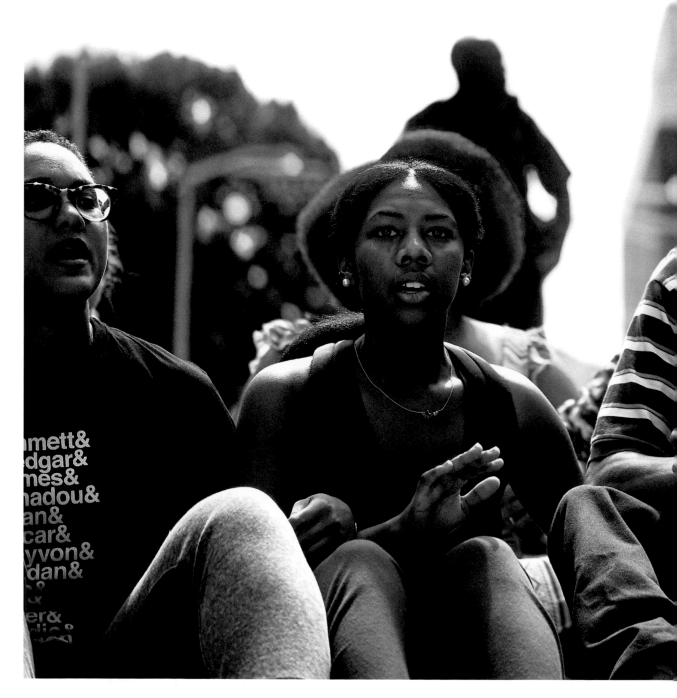

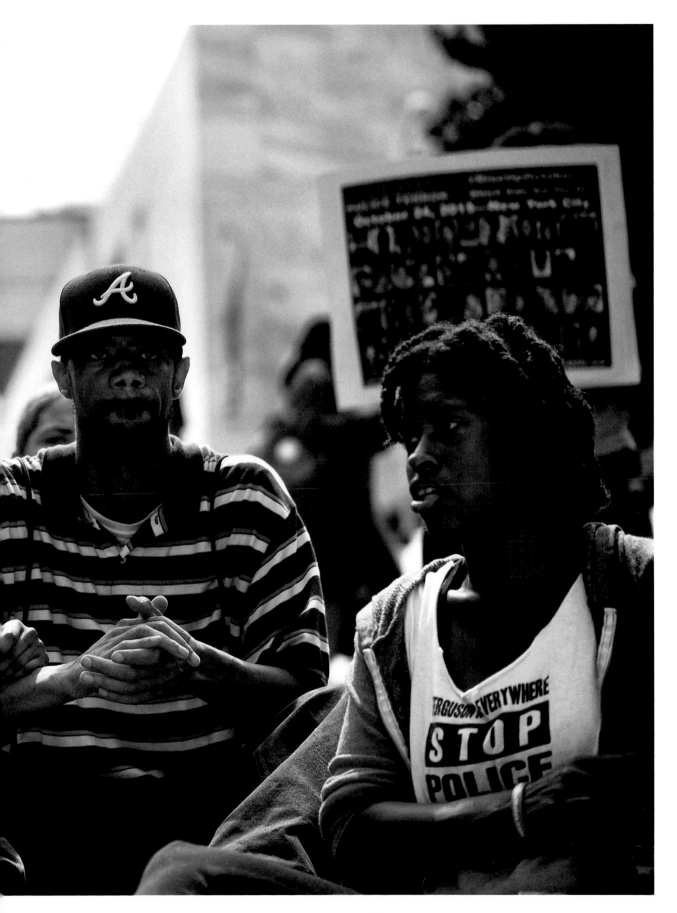

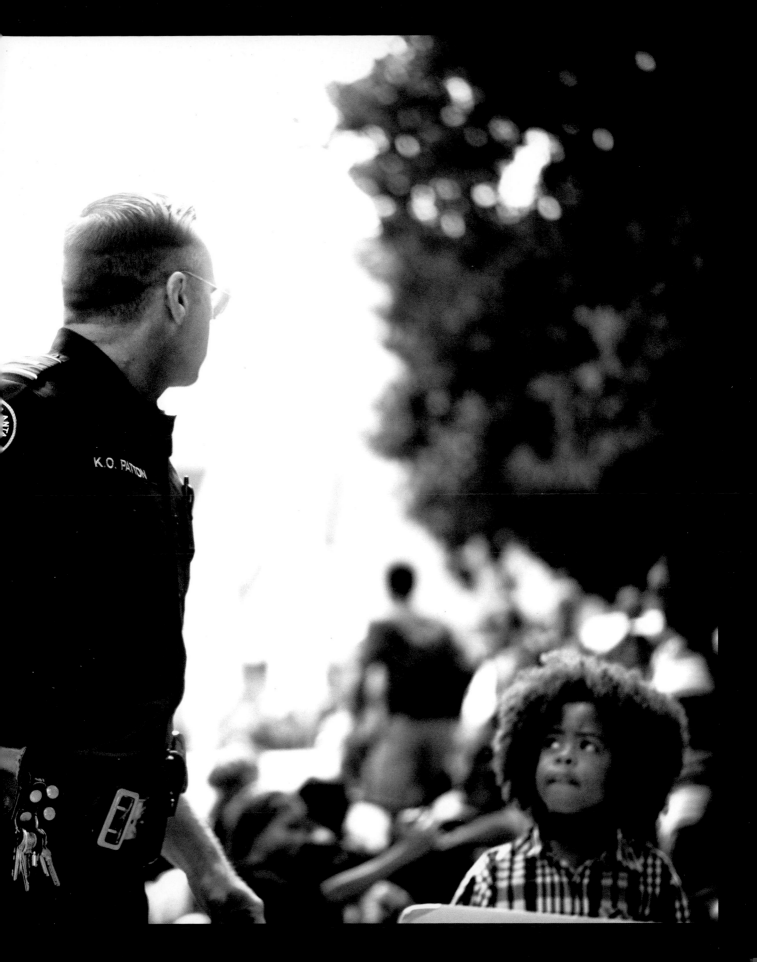

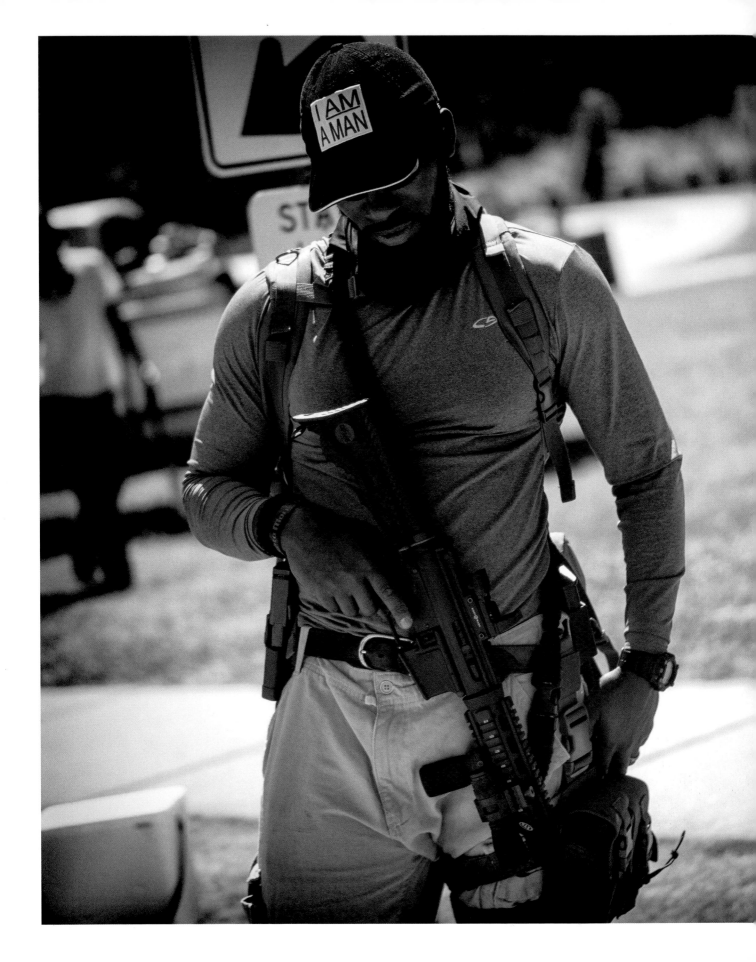

2016, protesting white nationalists at the "White Power" march in Stone Mountain Park

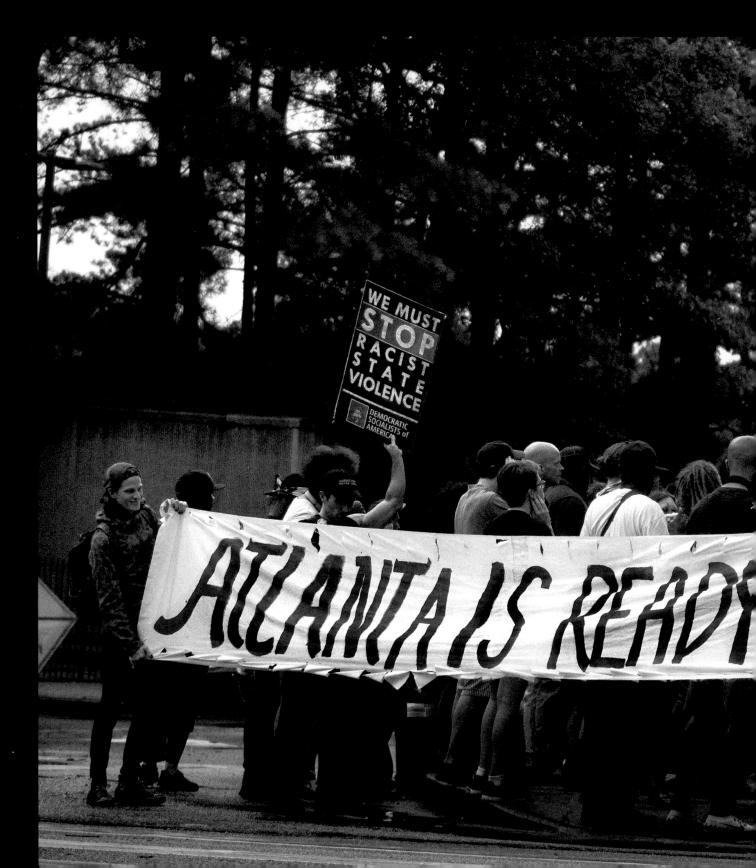

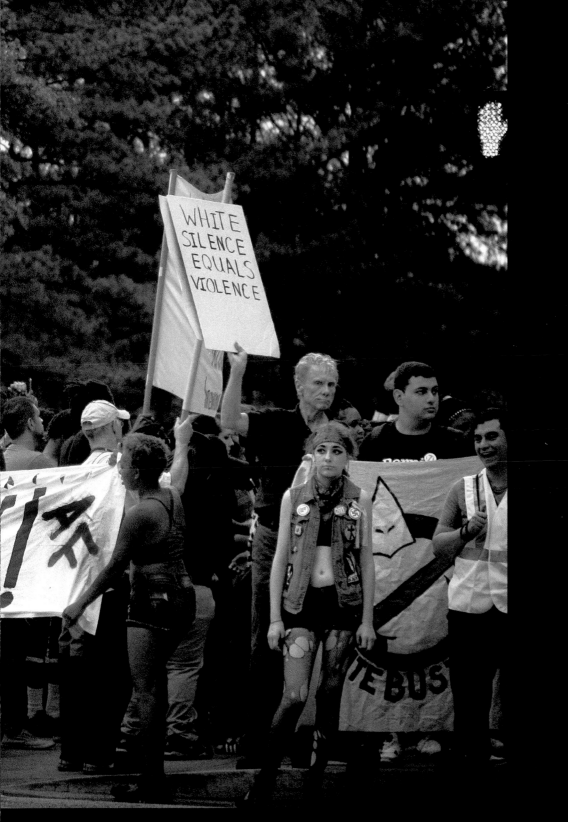

This page to page 149:

2016, #ATLisReady and Black Lives Matter Atlanta Chapter protest shootings of Philando Castile and Alton Sterling, Atlanta, Georgia

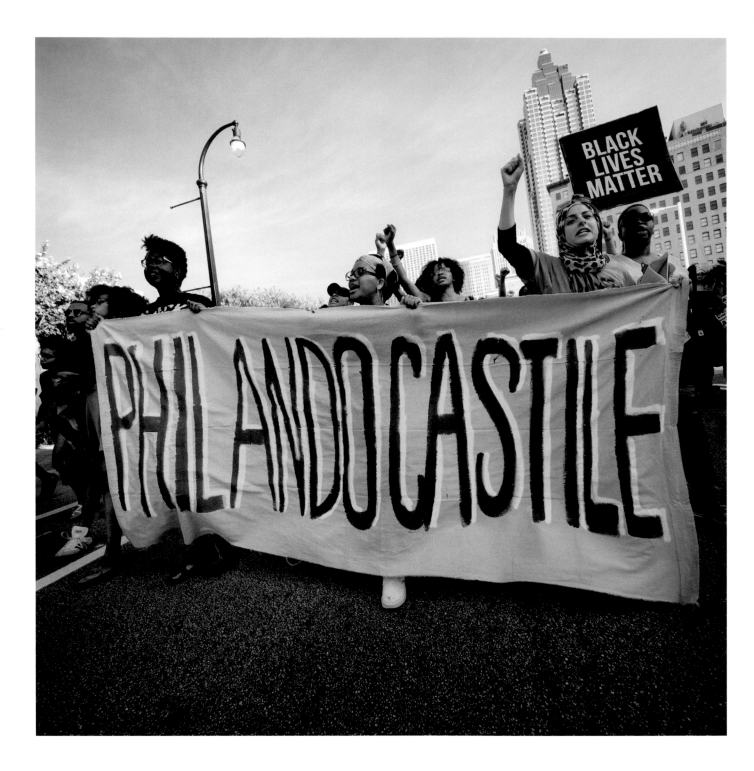

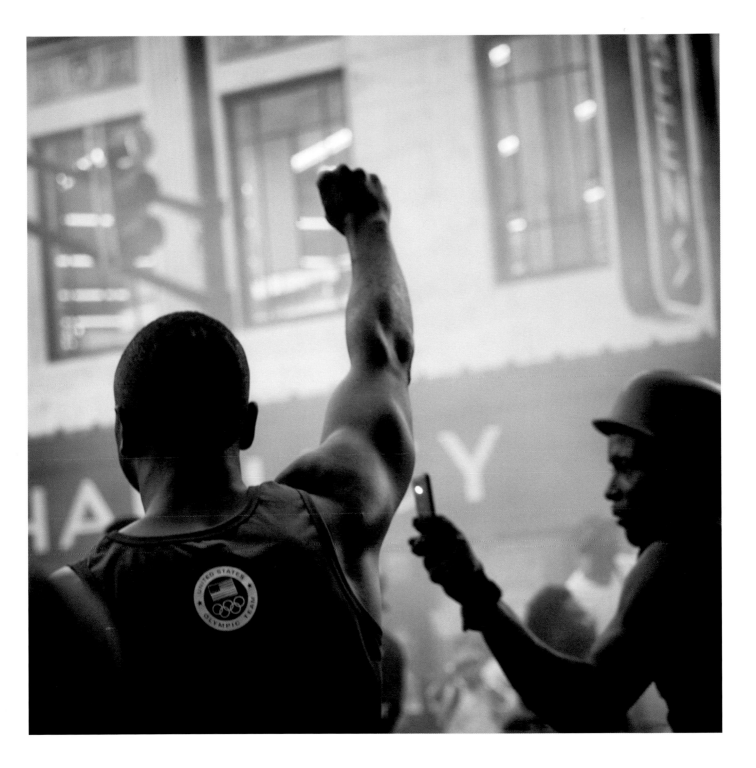

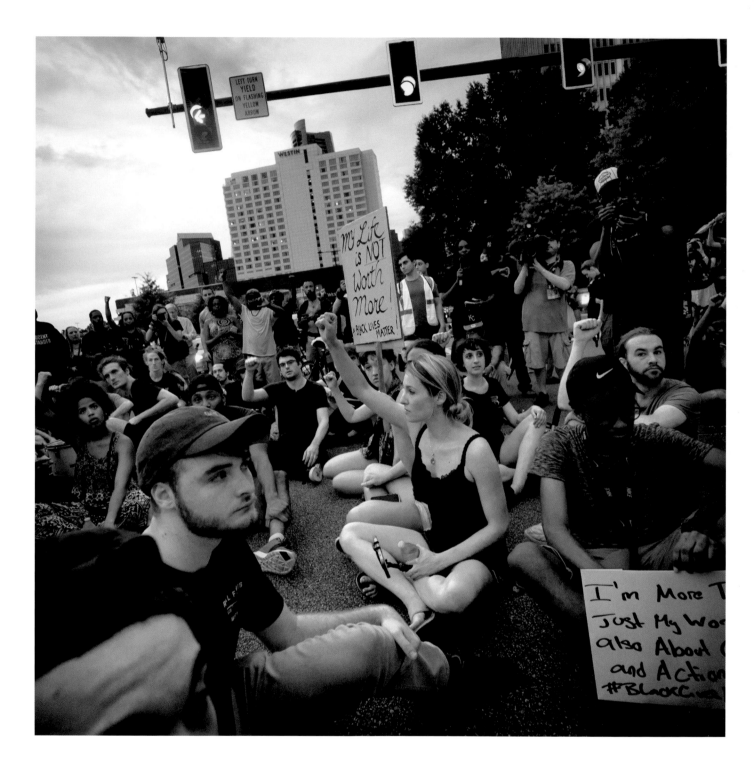

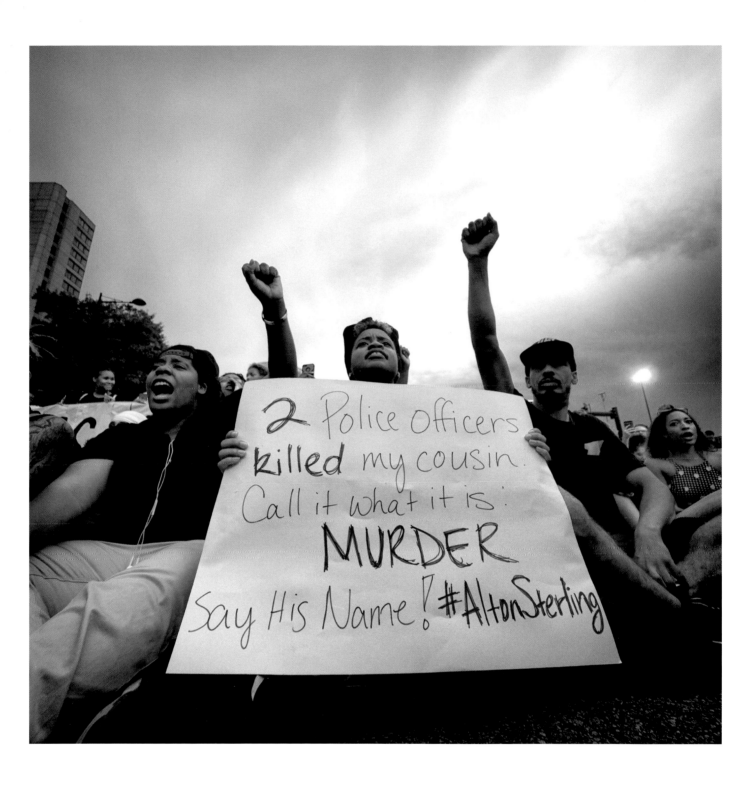

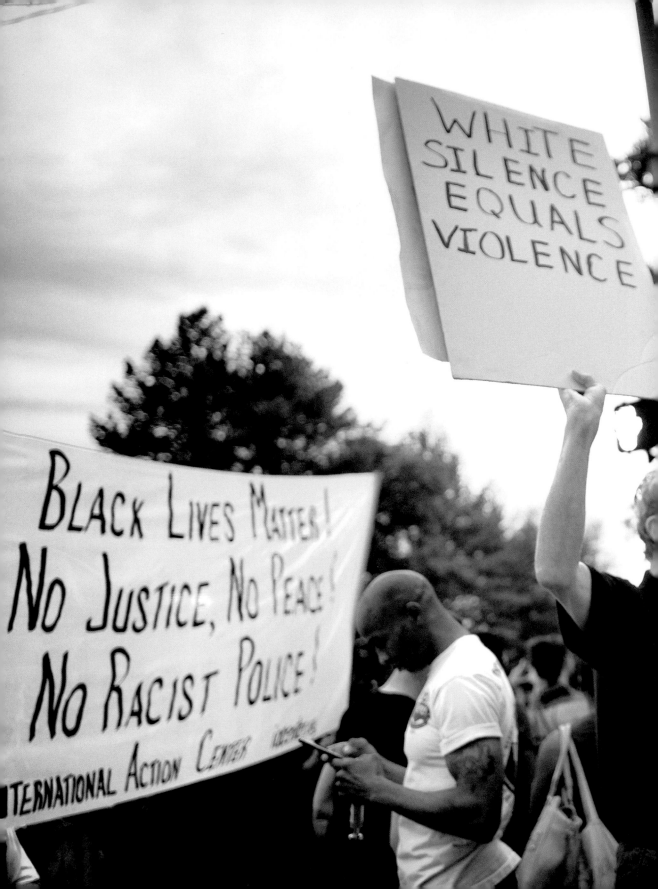

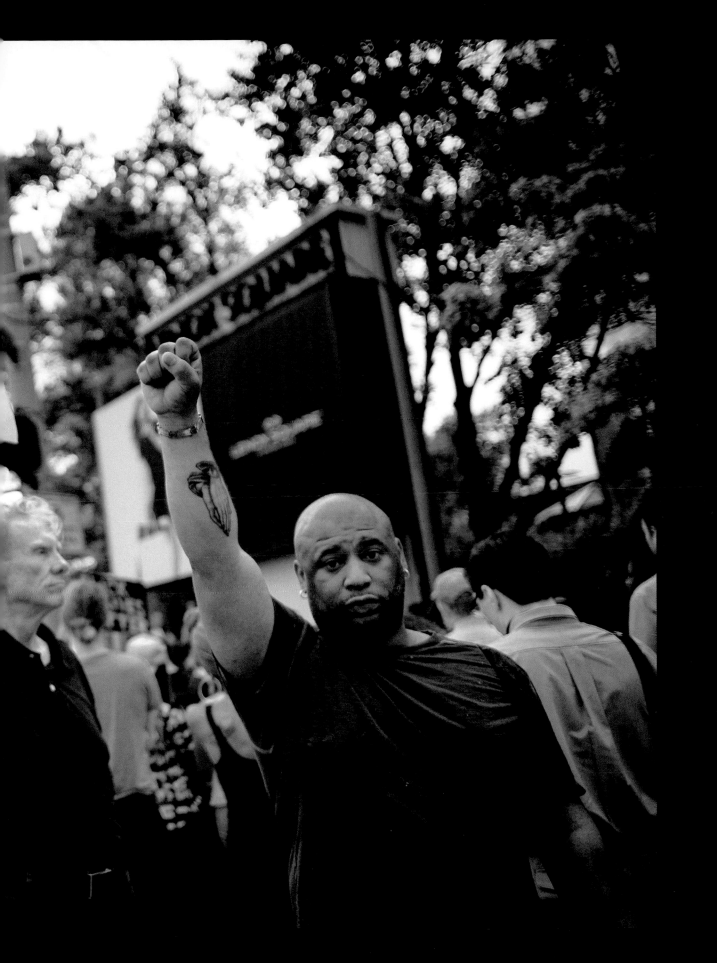

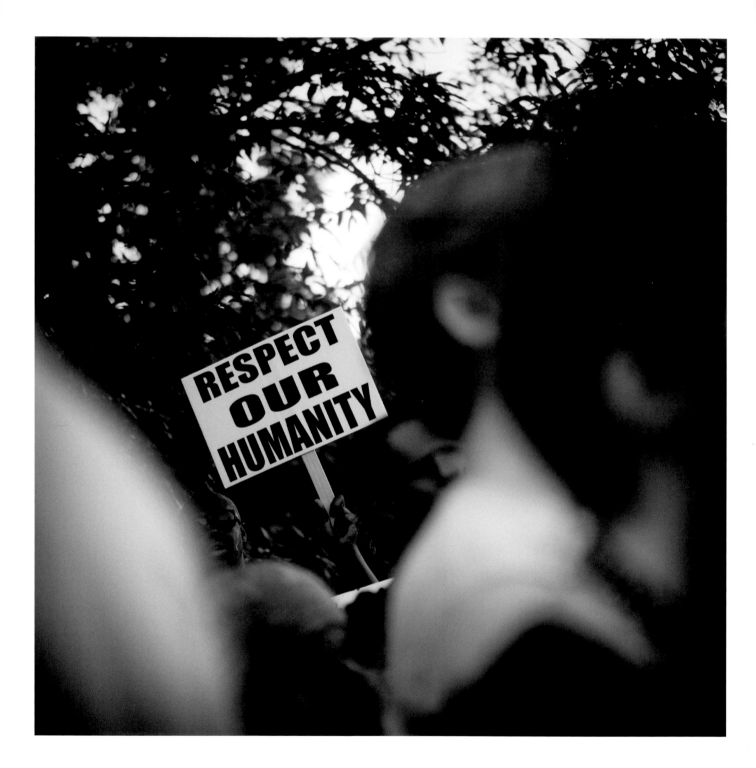

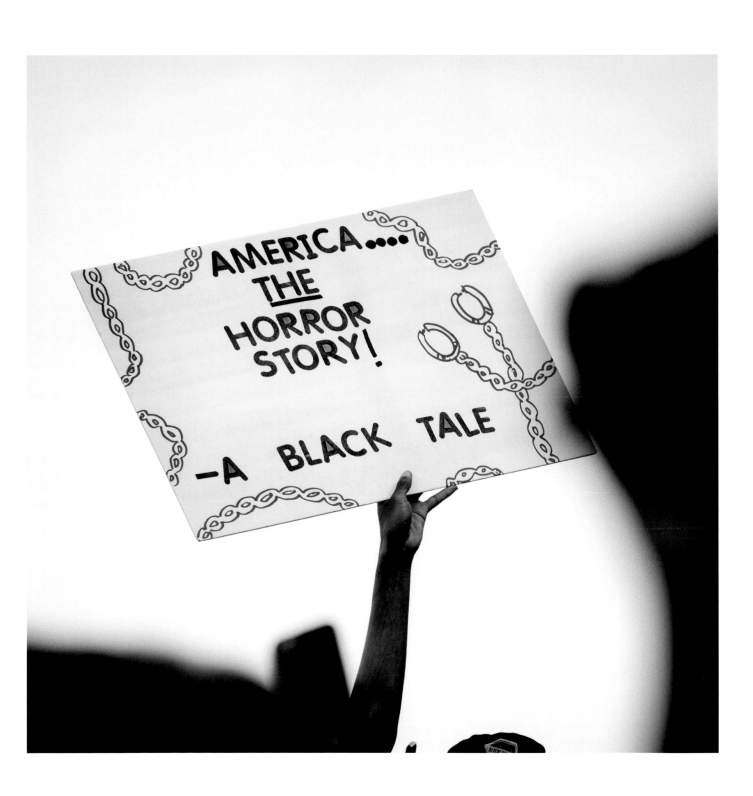

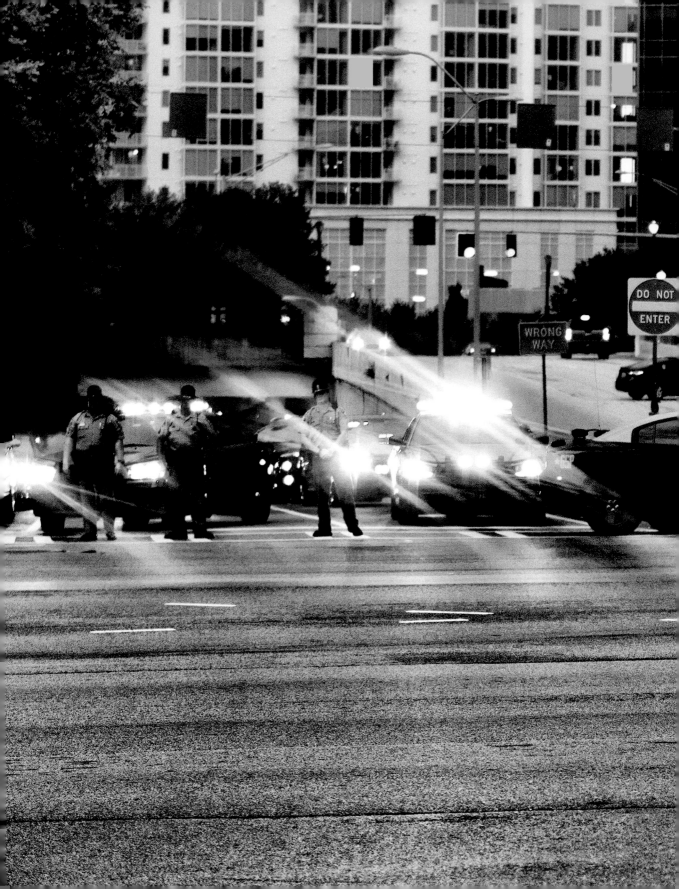

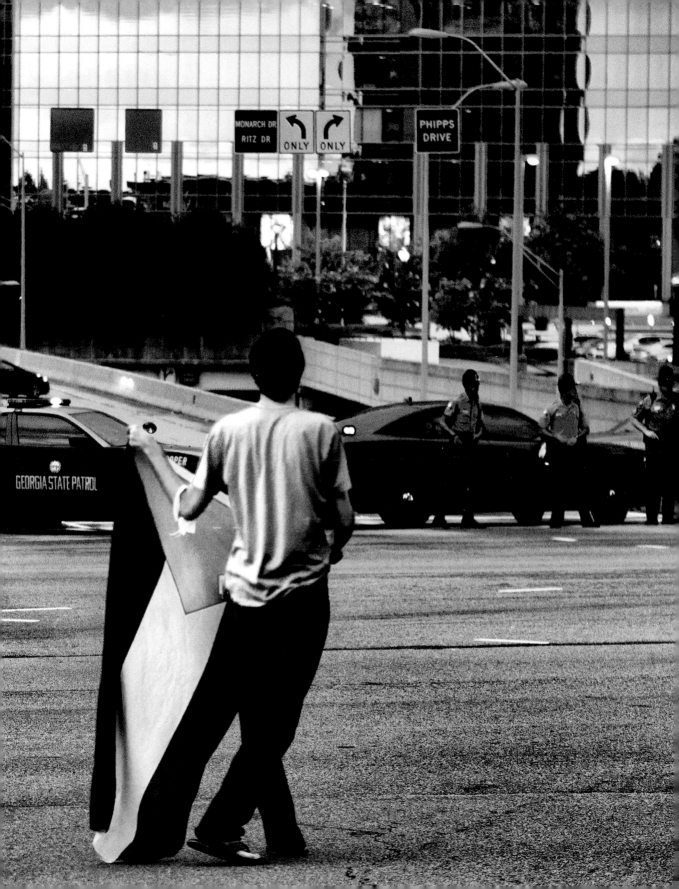

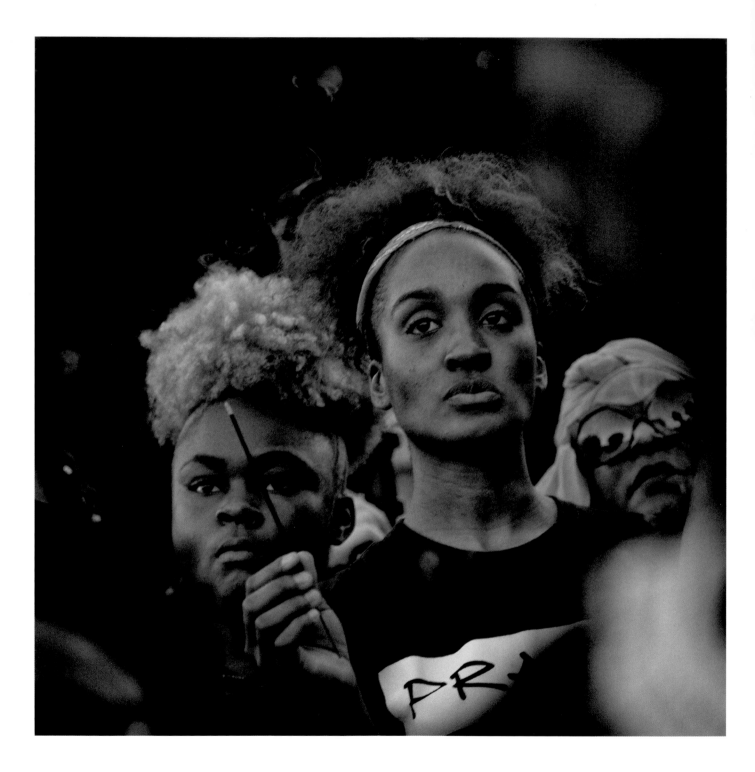

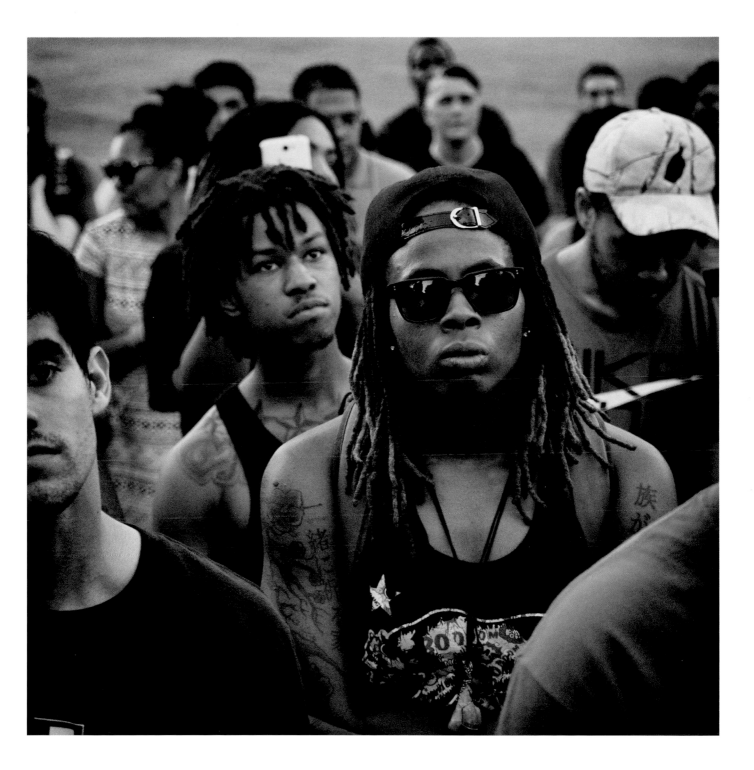

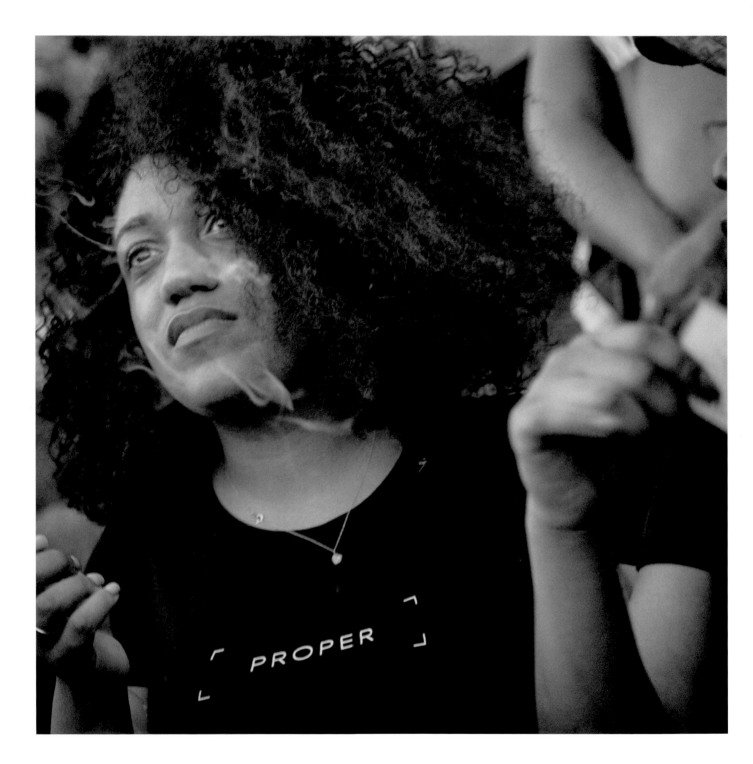

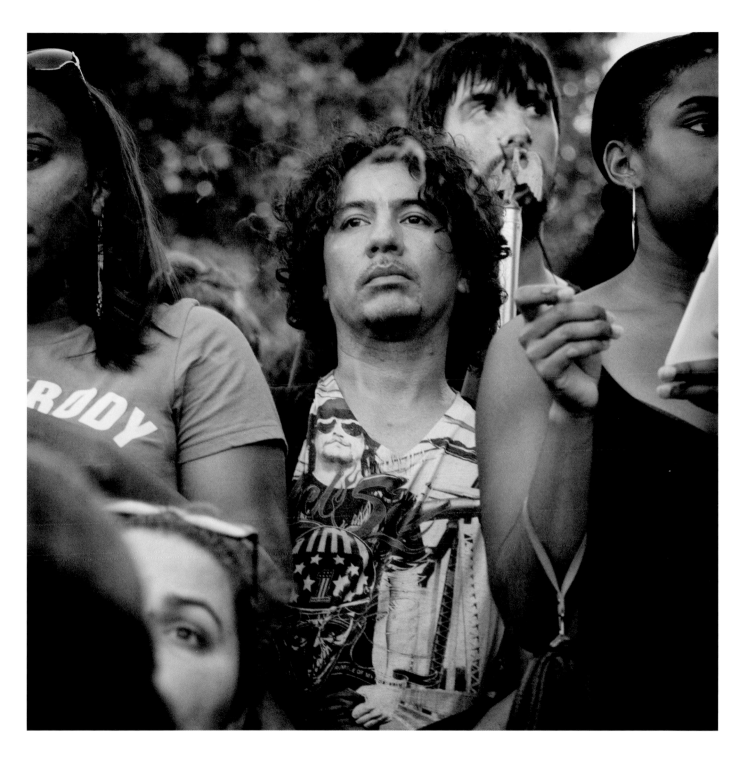

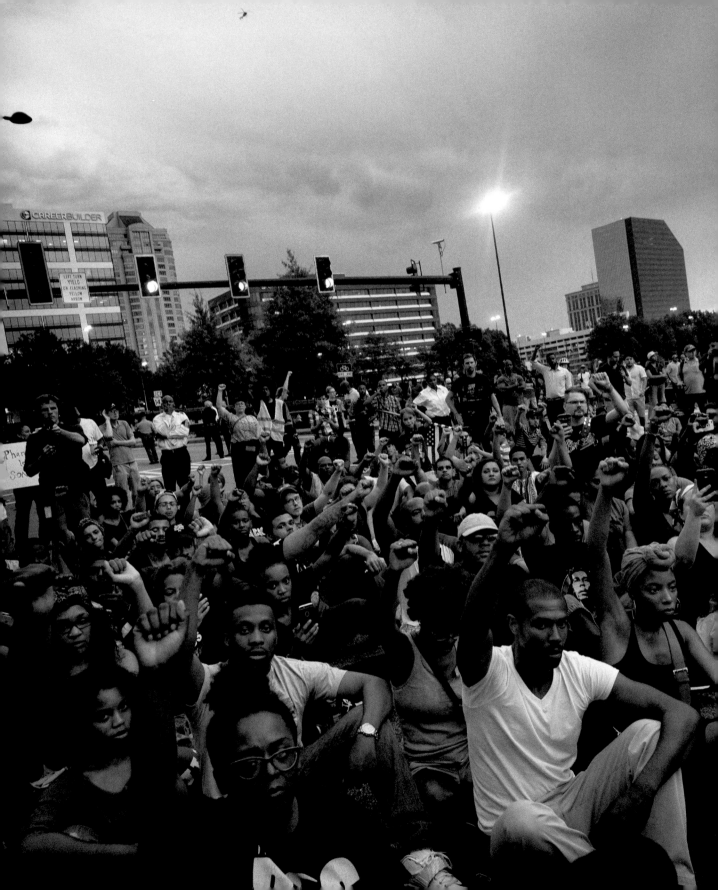

This page to page 155:

2016, Silent March

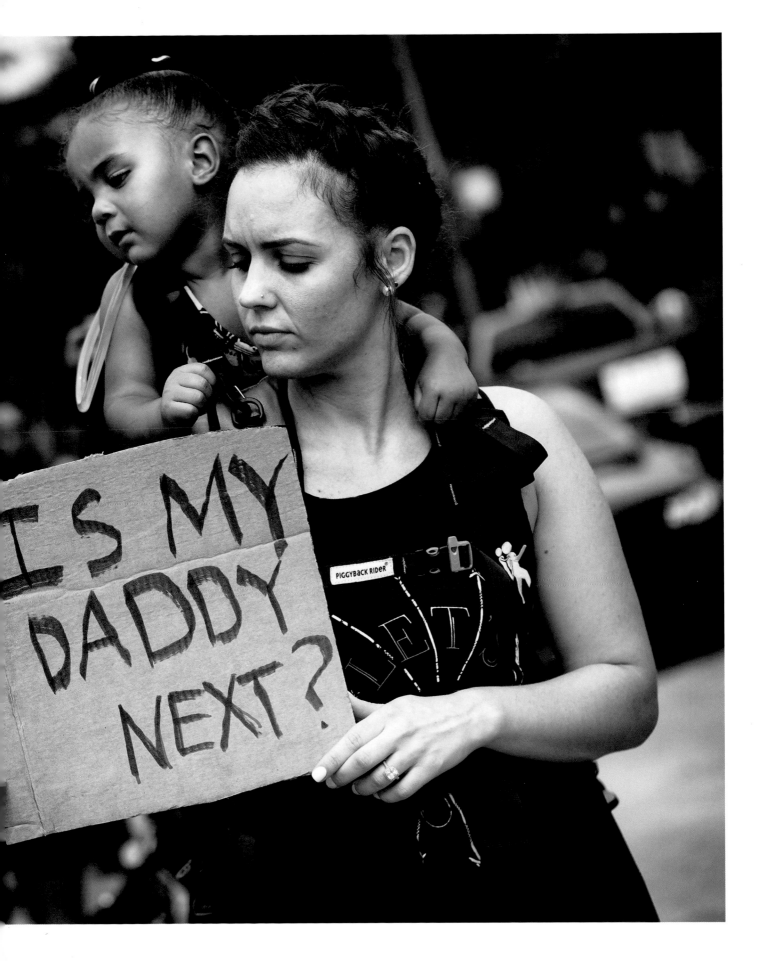

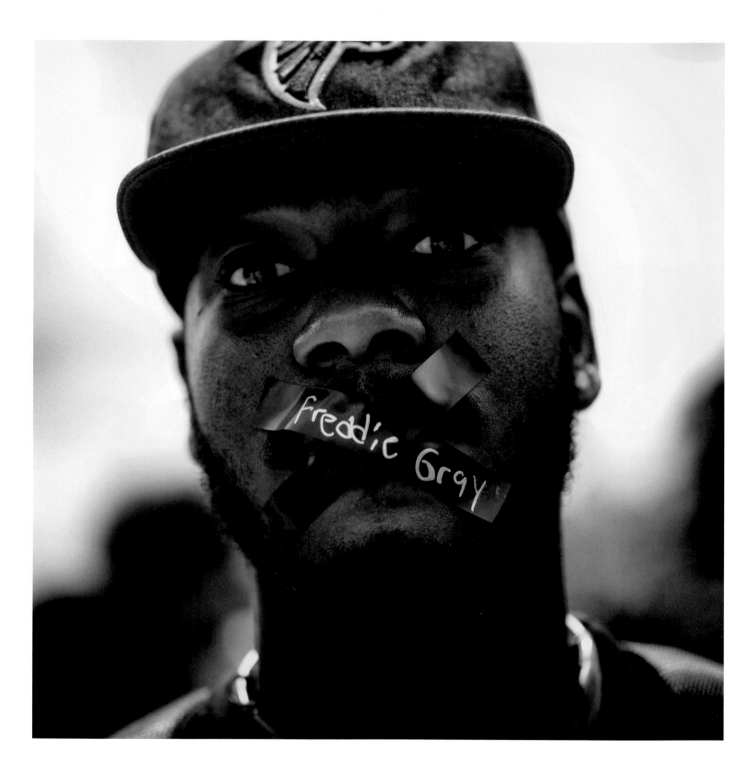

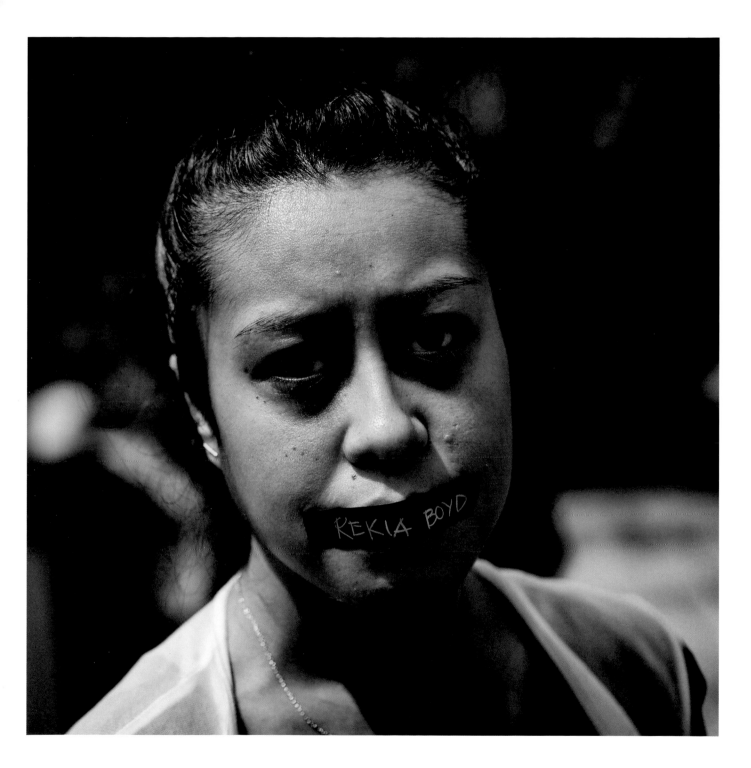

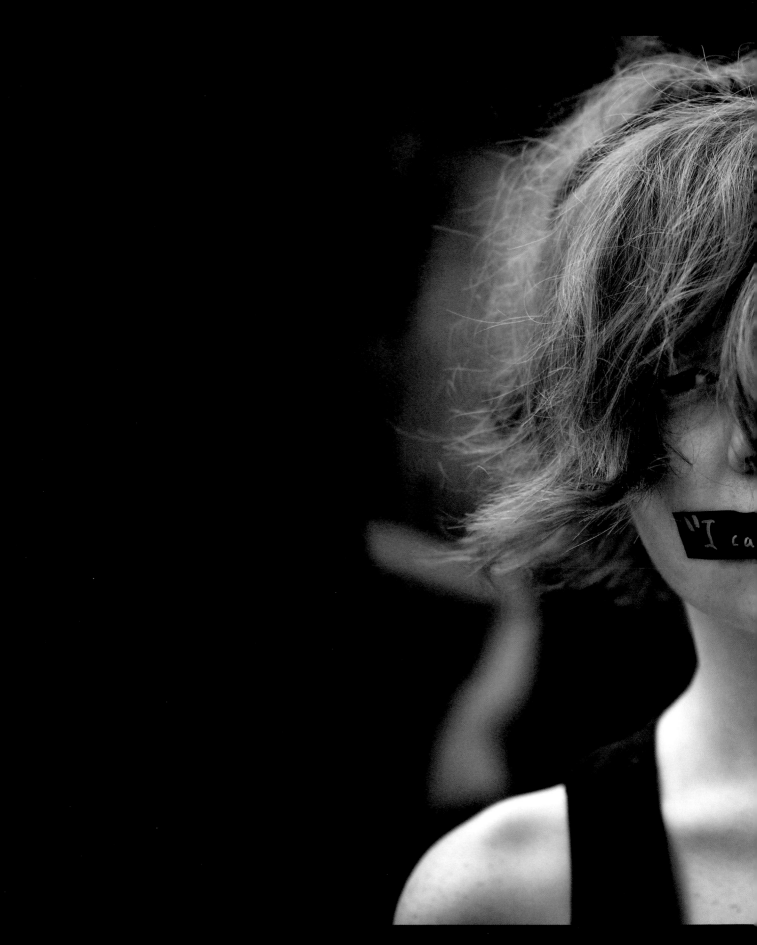

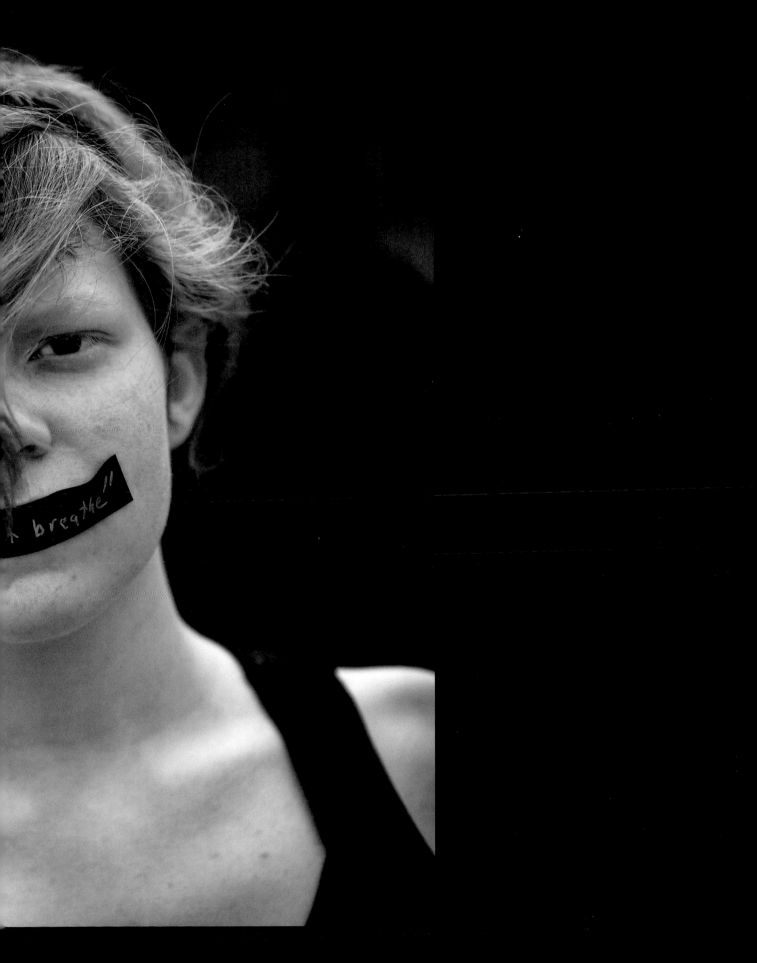

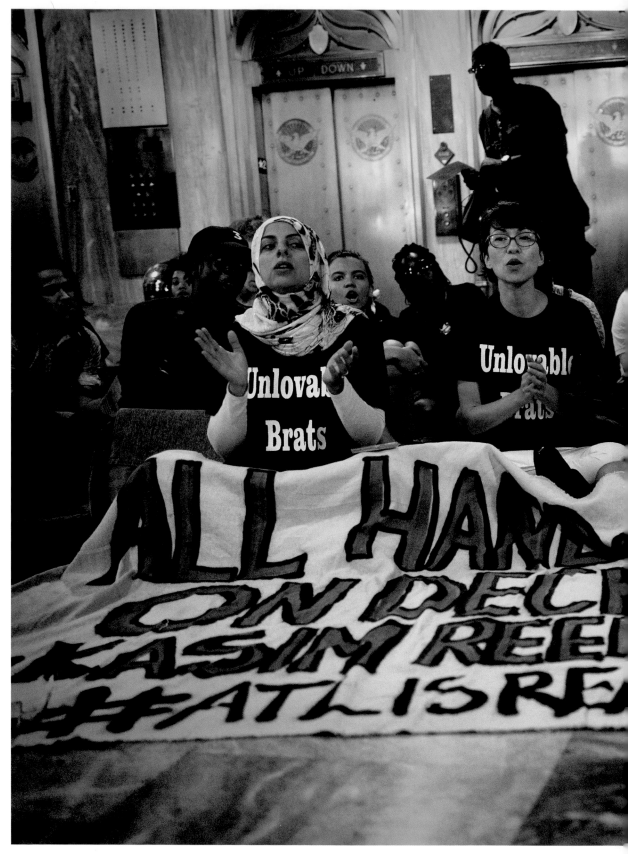

This page to page 159: 2016, #ATLisReady and Black Lives Matter Atlanta Chapter protest shootings of
Philando Castile and Alton Sterling, Atlanta, Georgia

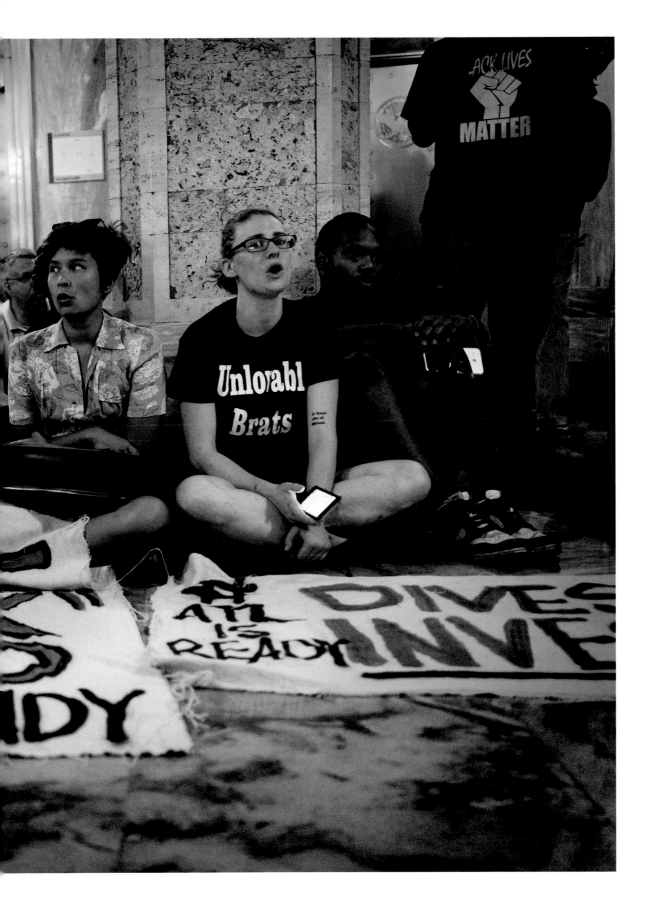

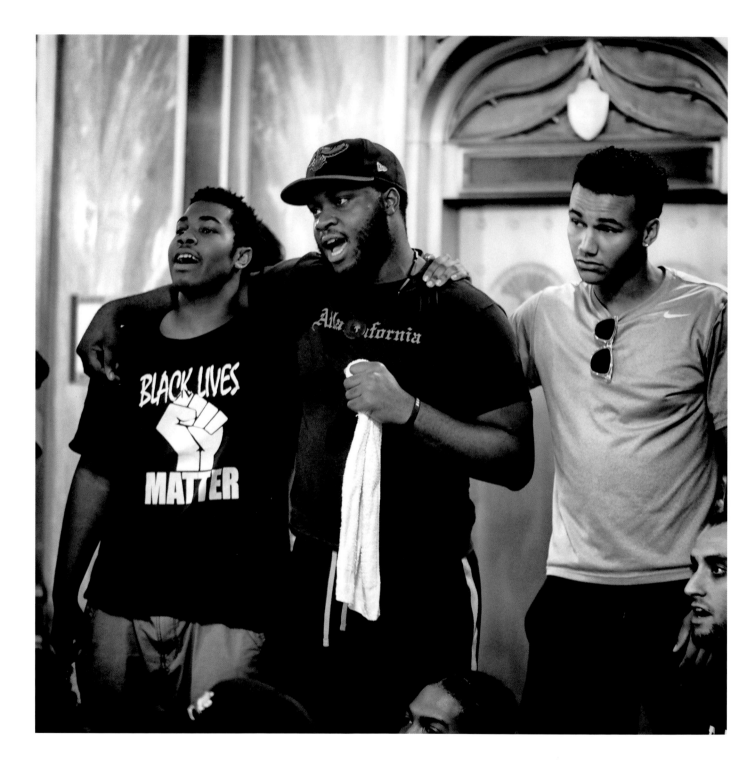

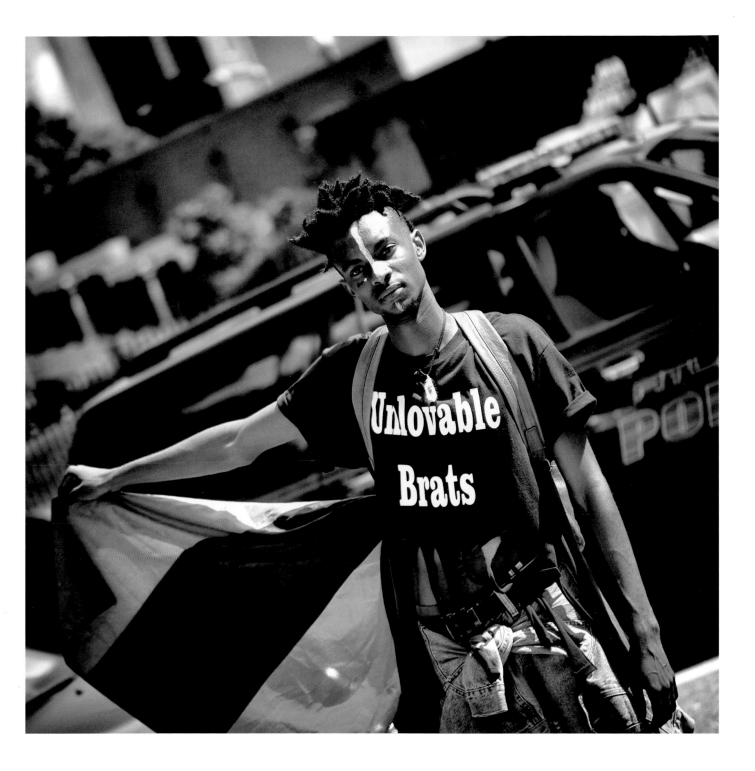

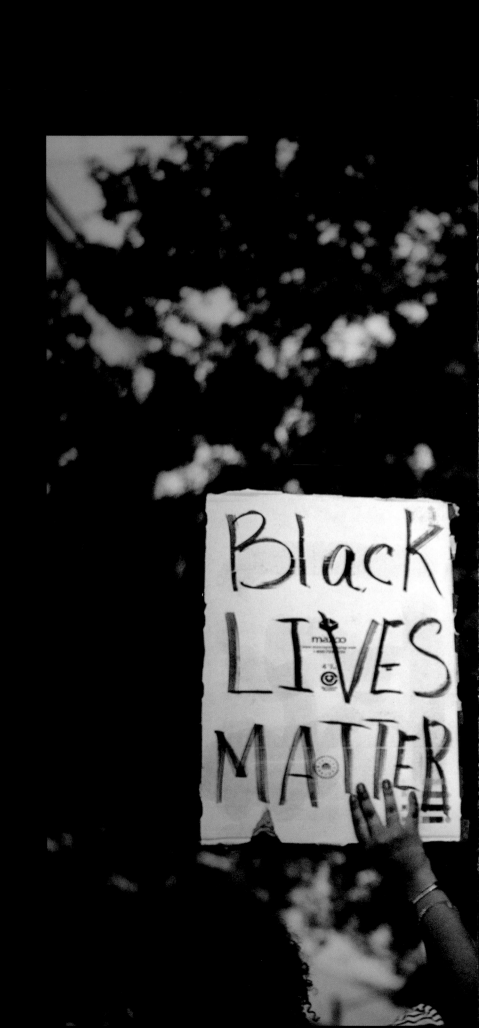

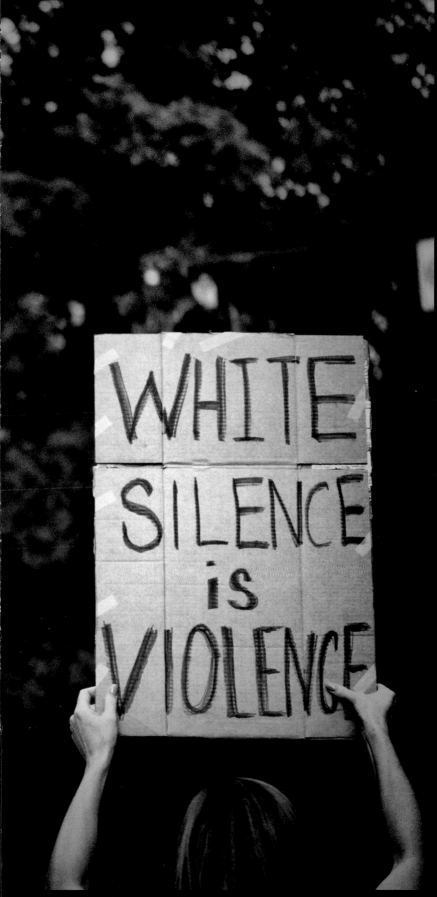

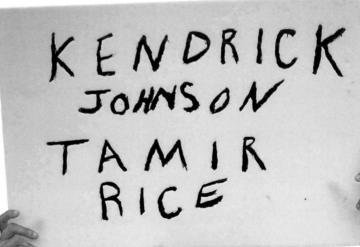

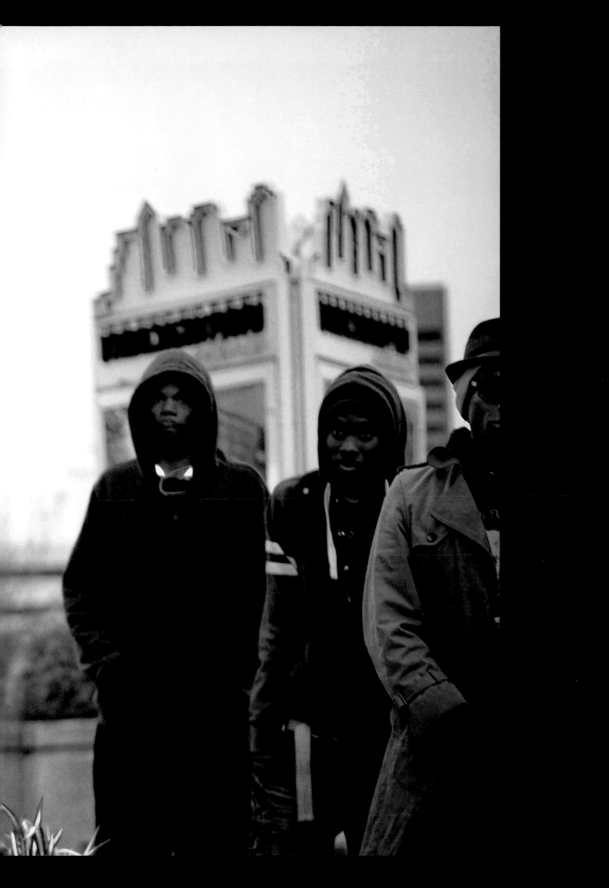

2016, Black Lives Matter Atlanta Chapter rally for Tamir Rice

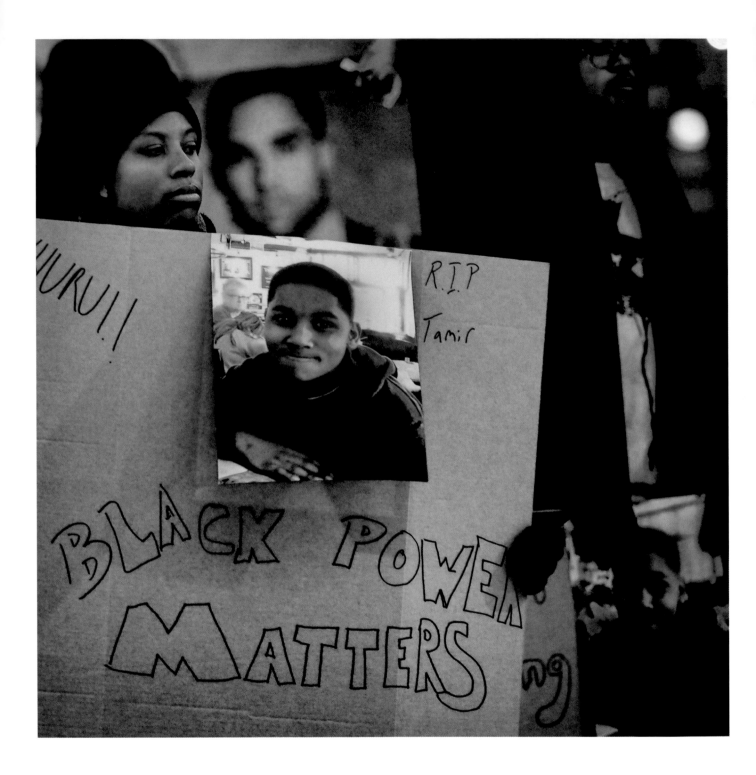

2016, Black Lives Matter Atlanta Chapter rally for Tamir Rice

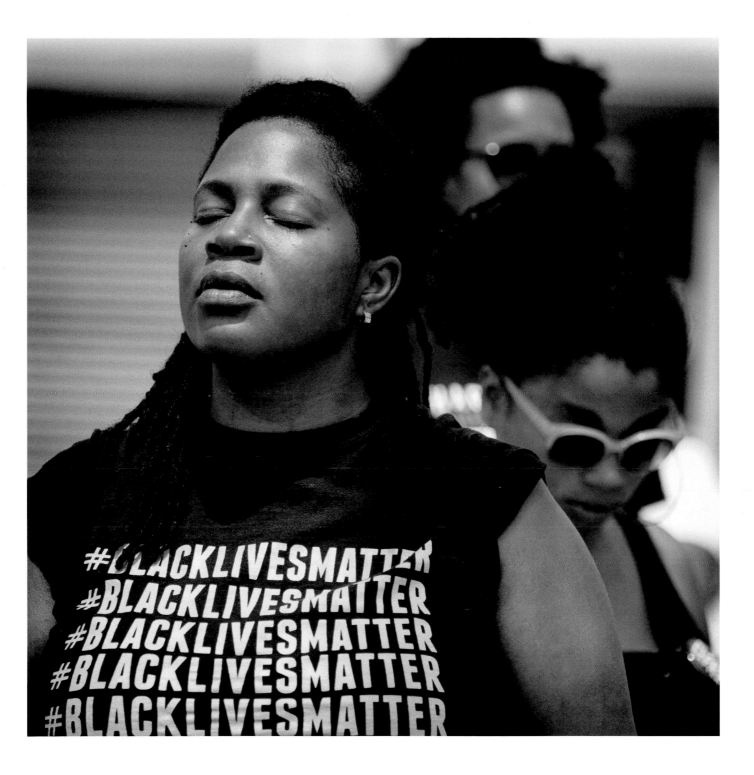

This page to page 167:

2015, Nationwide Silent Prayer to mark the anniversary
of the shooting of Mike Brown

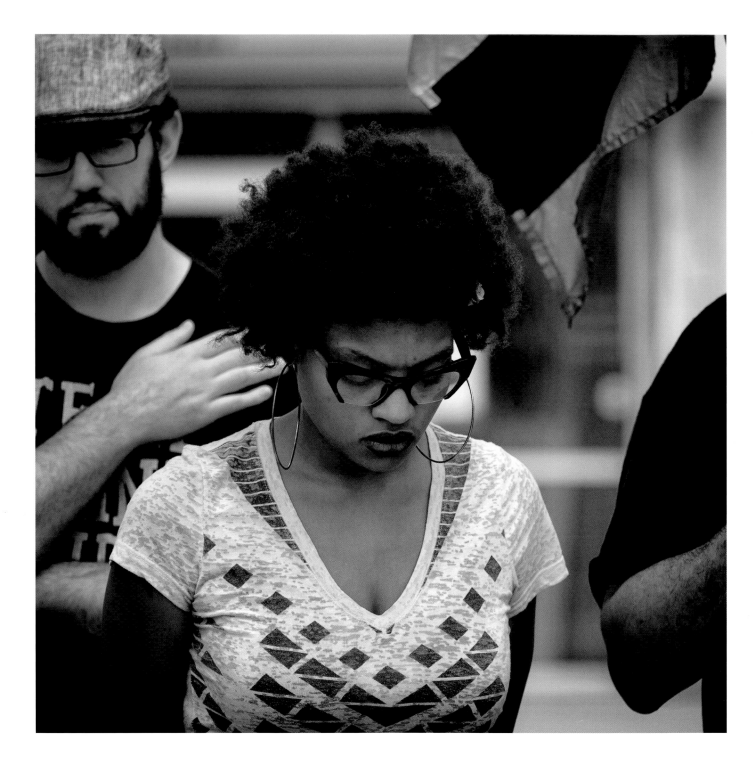

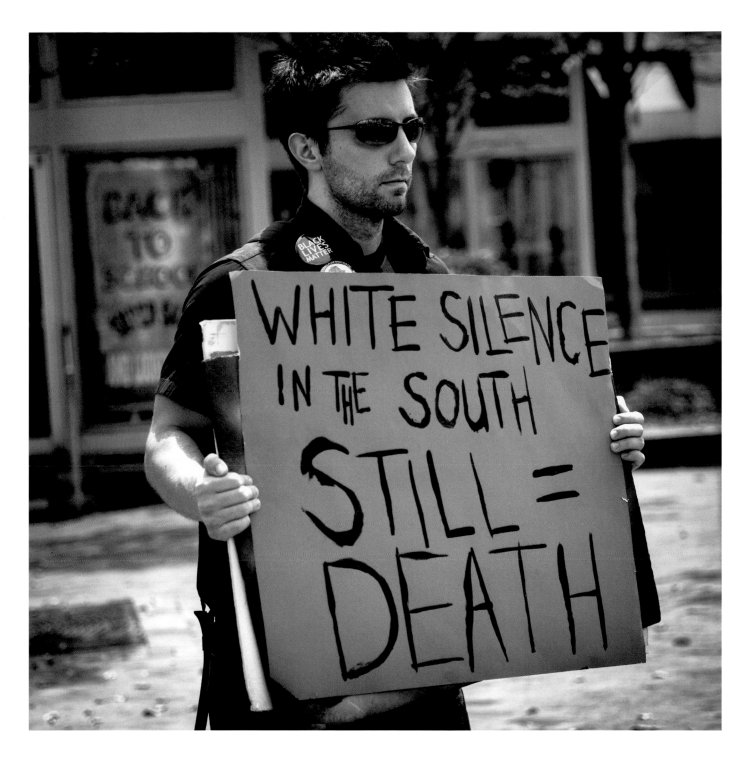

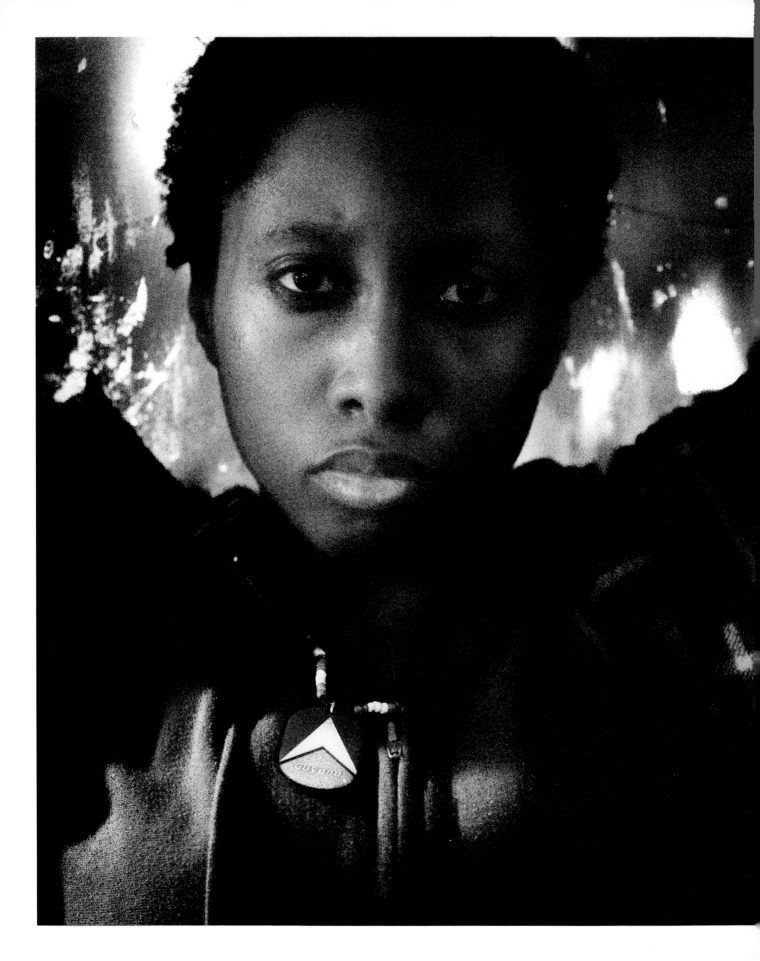

2015, Students of Historically Black Colleges and Universities stand in solidarity with students of University of Missouri, demanding the resignation of President Tim Wolfe

2016, Mother of Alexia Christian, at "Say Her Name" protest for her daughter who was shot by two Atlanta police officers

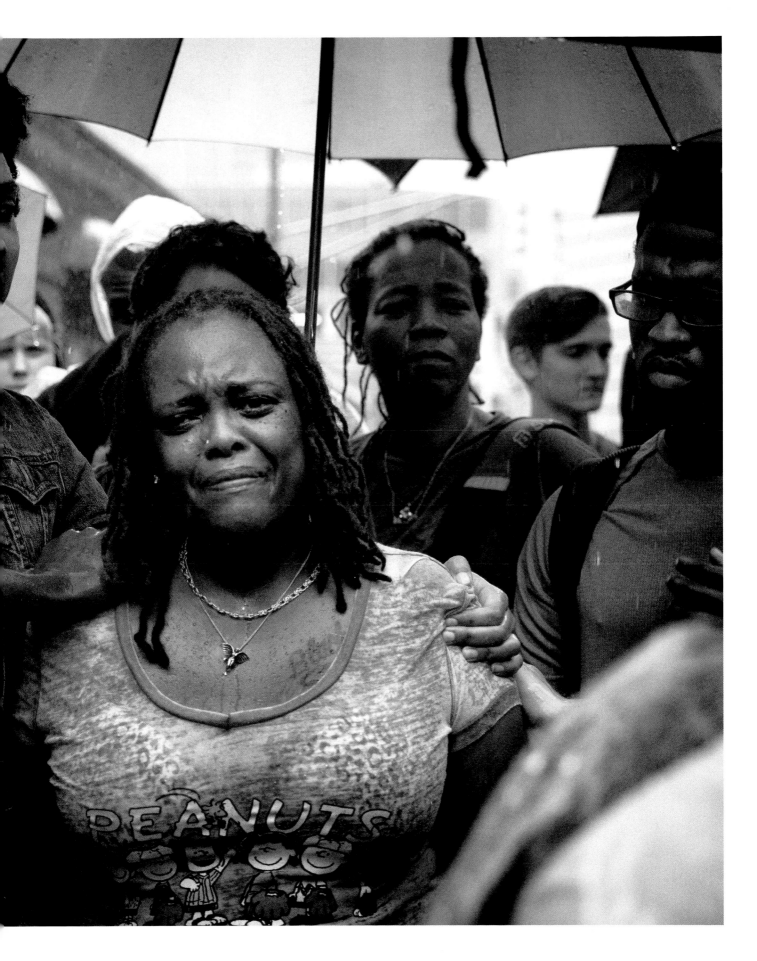

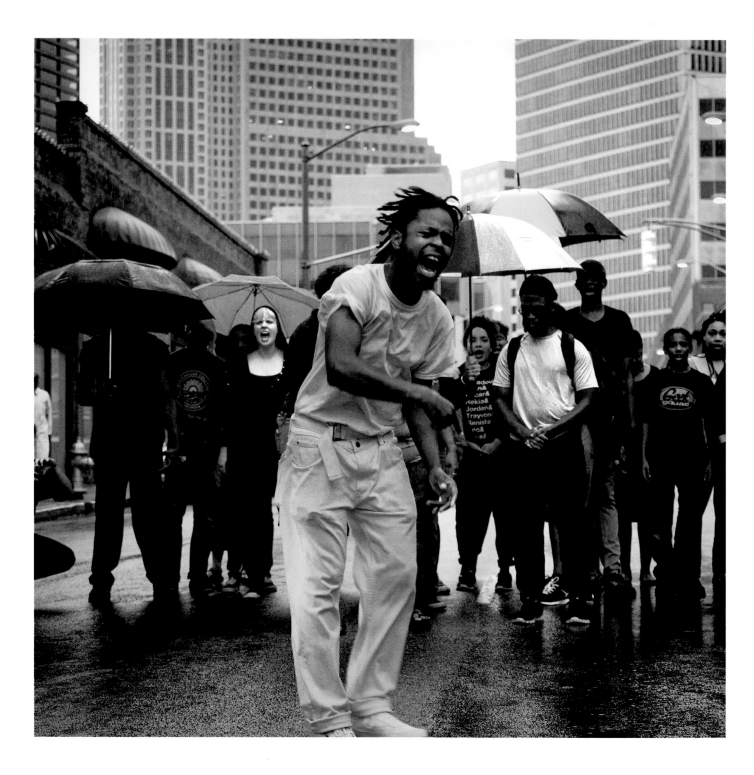

2016, "Say Her Name" protest for Alexia Christian, who
was shot by two Atlanta police officers

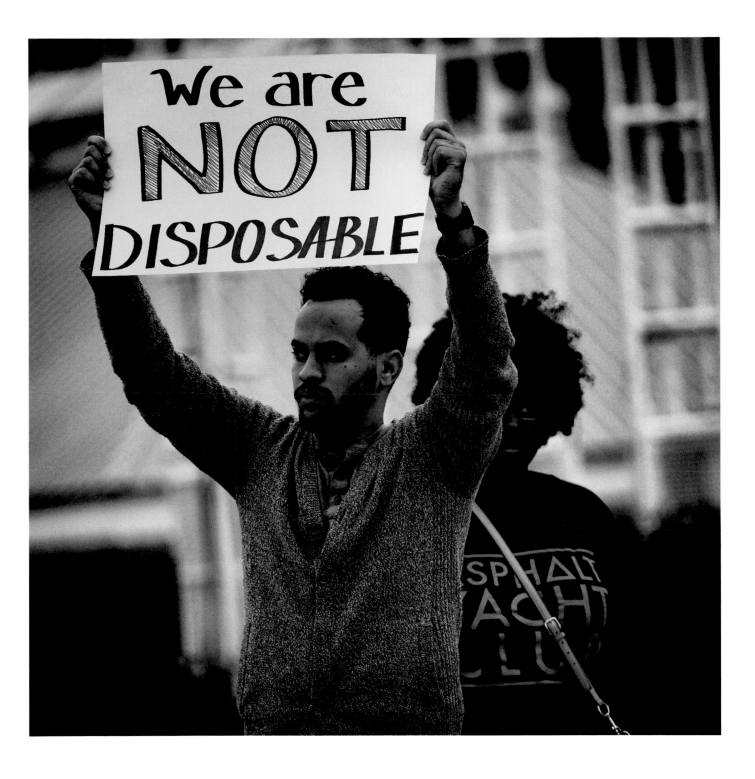

2016, Black Lives Matter Atlanta Chapter rally for Tamir Rice

This page to page 179:

2016, Rally to protest the shooting of Alton Sterling

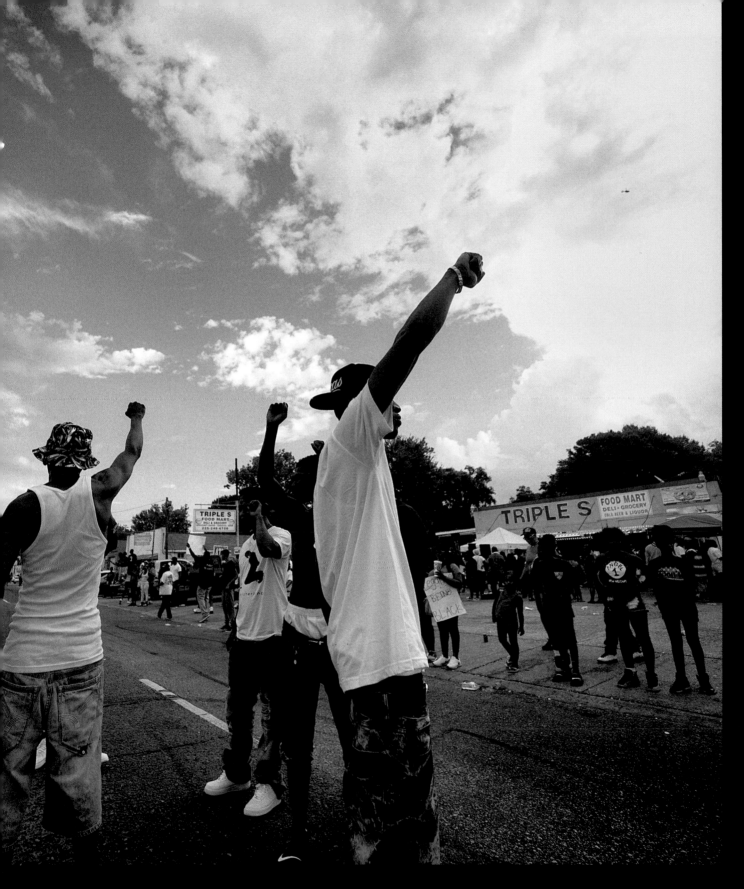

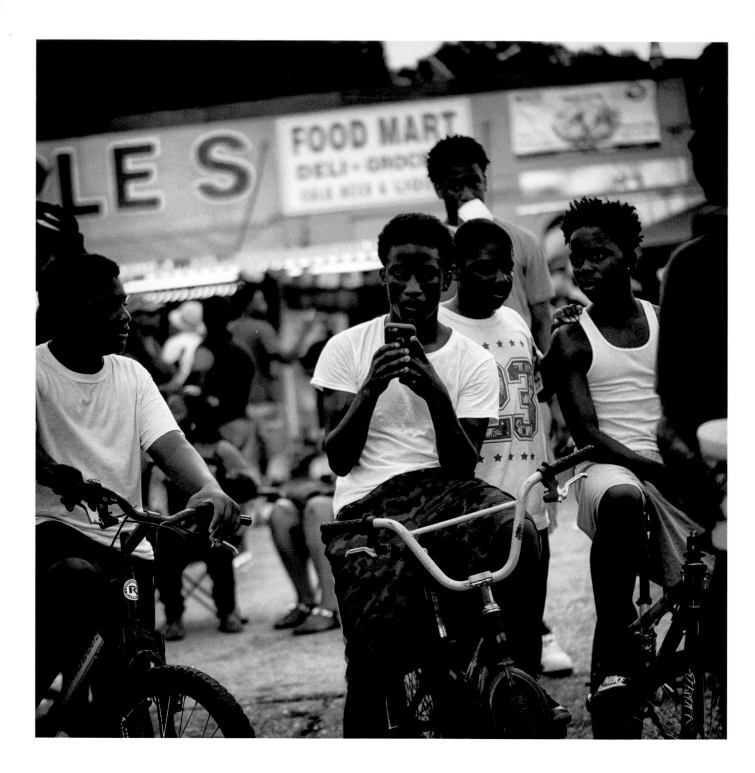

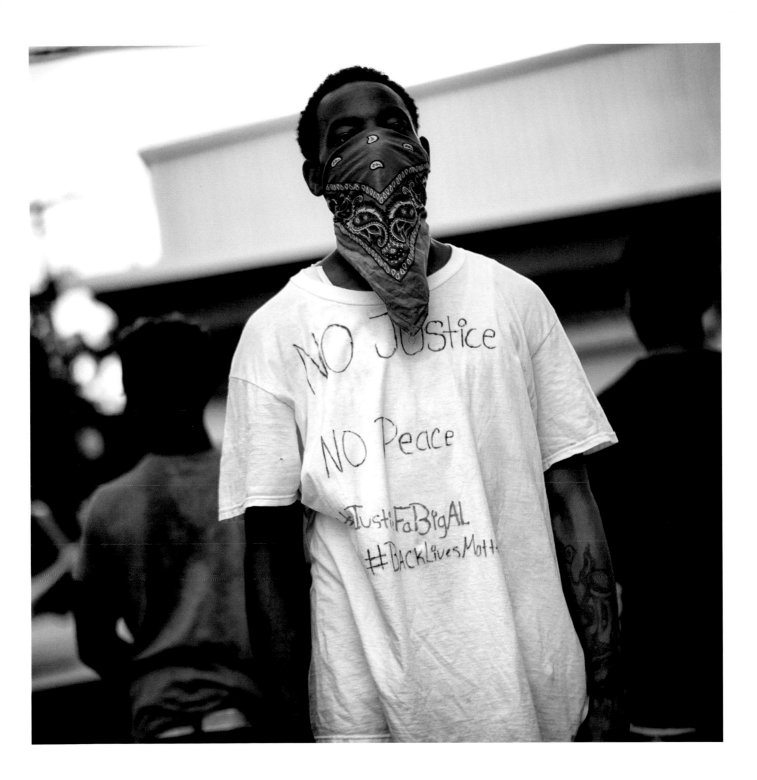

PHILADELPHIA, PA

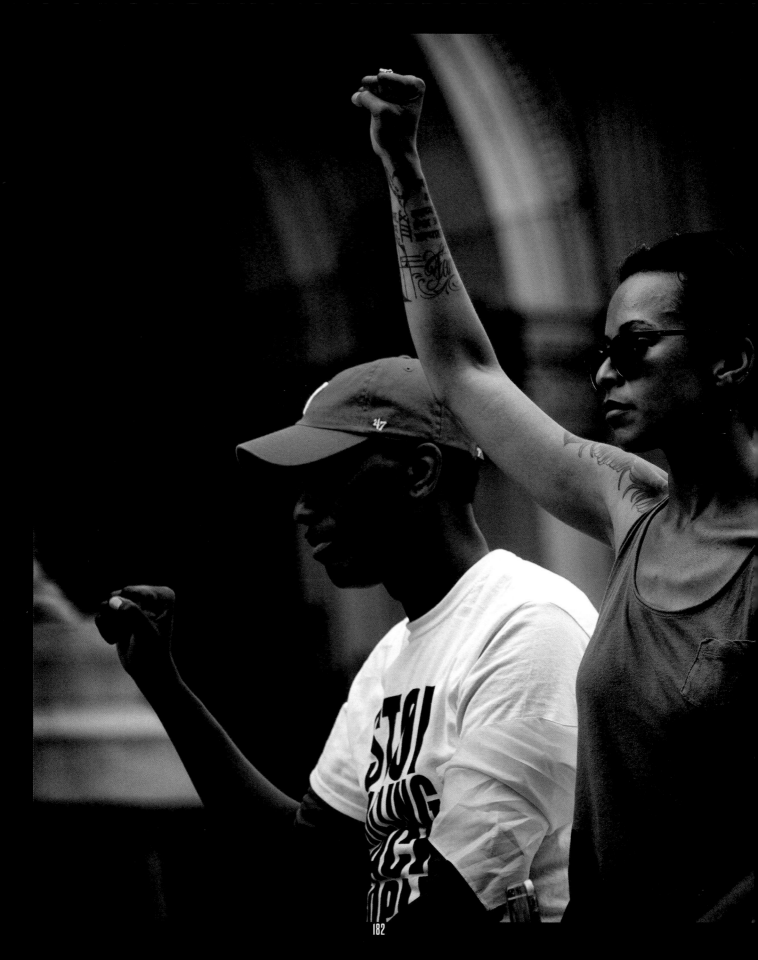

This page to page 185:

2016, "Shut Down the DNC," Black Resistance March Against
Police Terrorism & State Repression

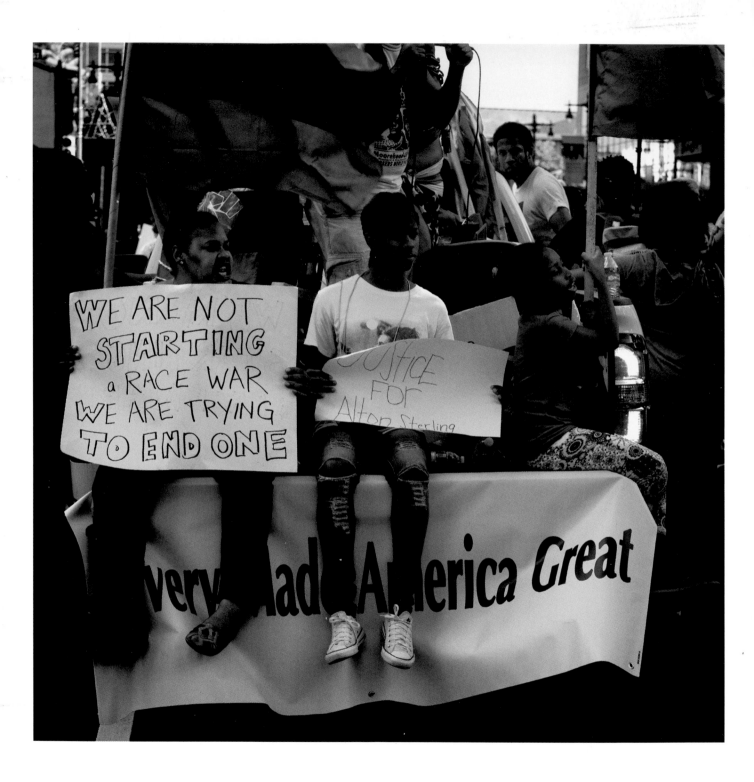

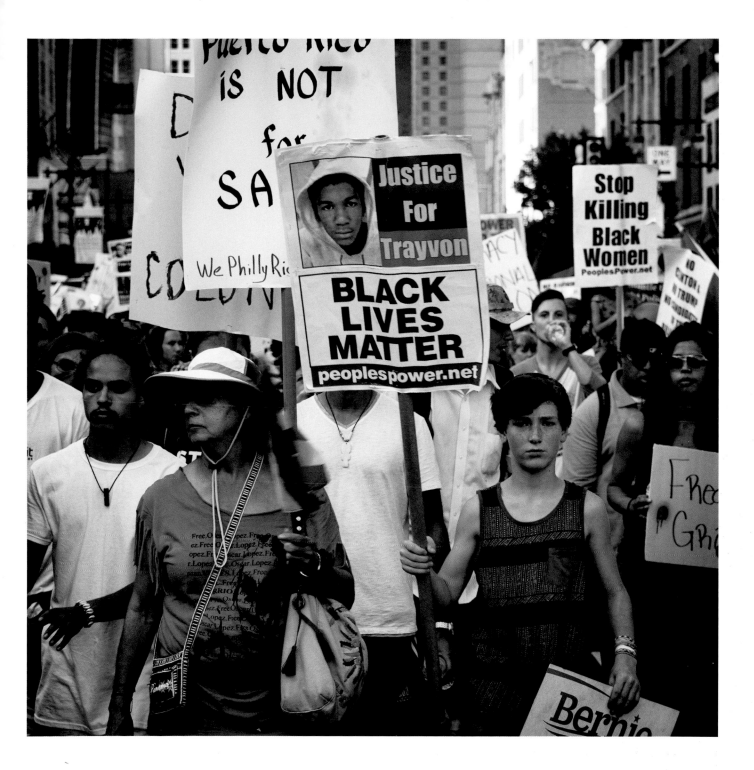

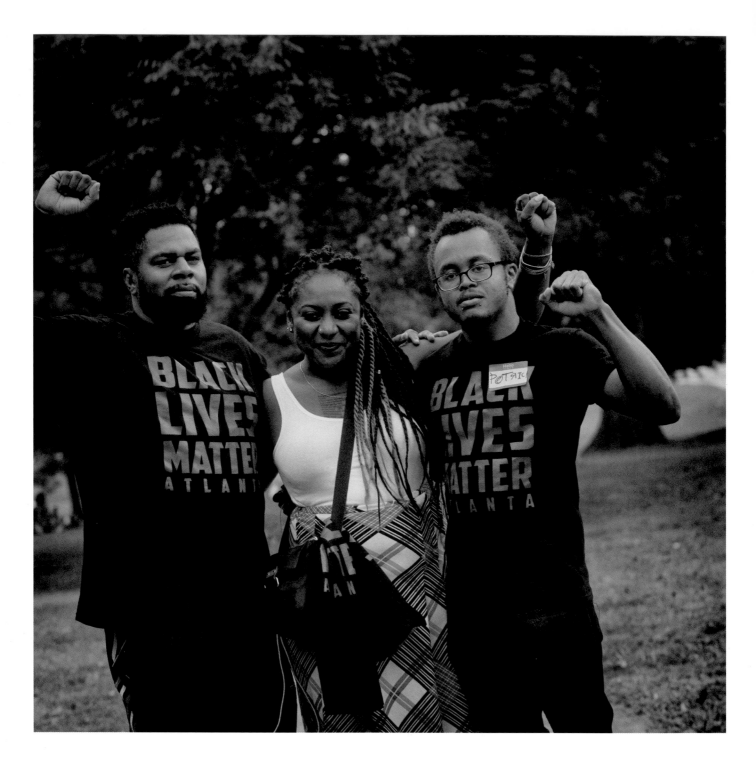

ATLANTA, GA

2016, Black Lives Matter Atlanta Chapter meeting with
cofounder Alicia Garza

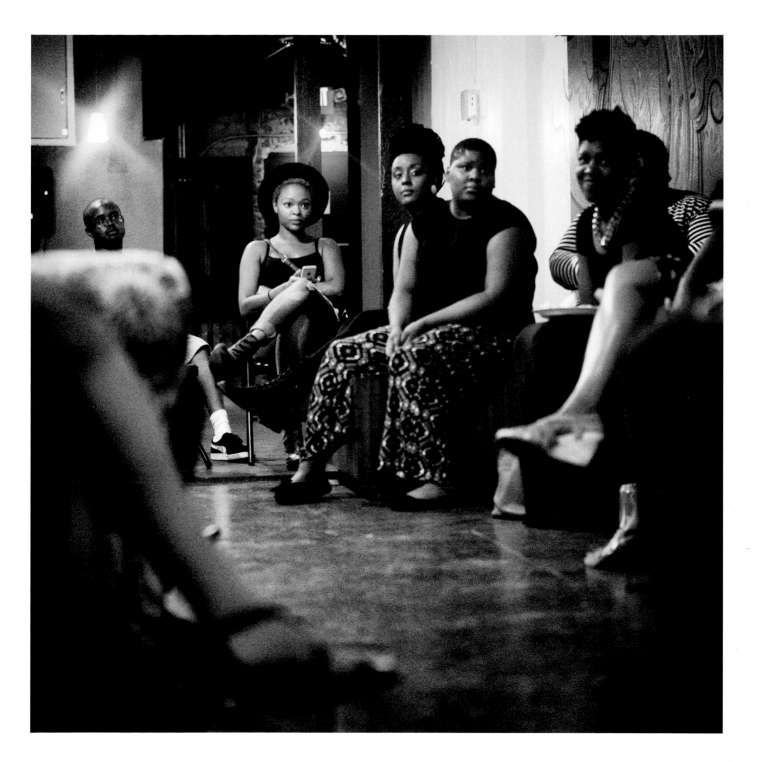

ATLANTA, GA

2016, It's Bigger Than You organization meeting

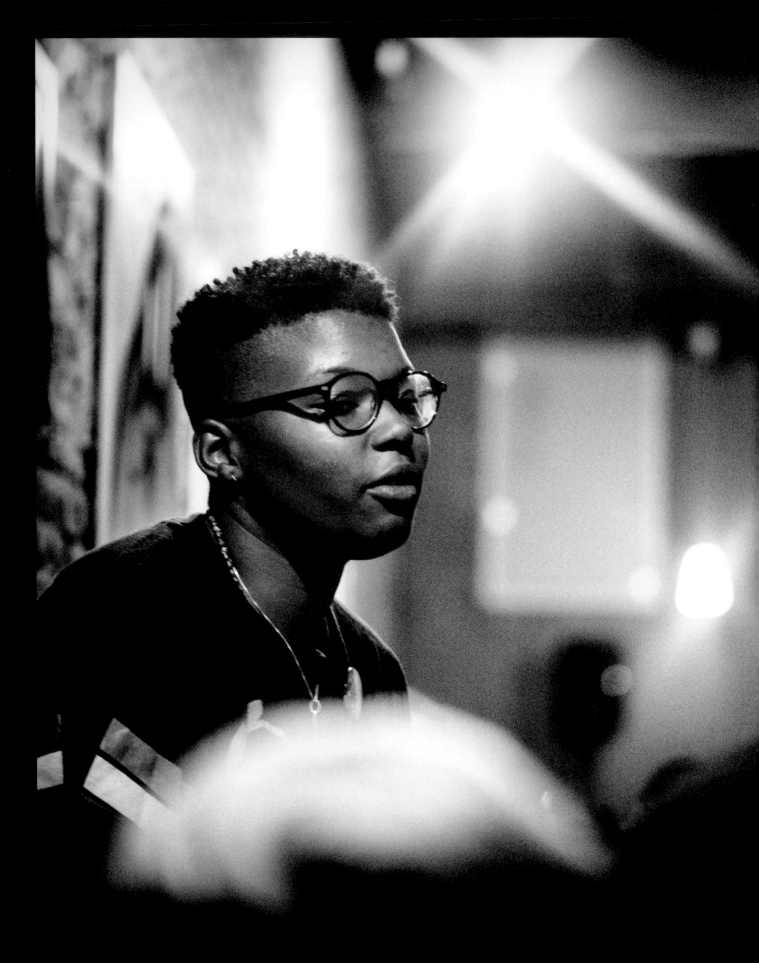

ATLANTA, GA

2016, It's Bigger Than You organization meeting

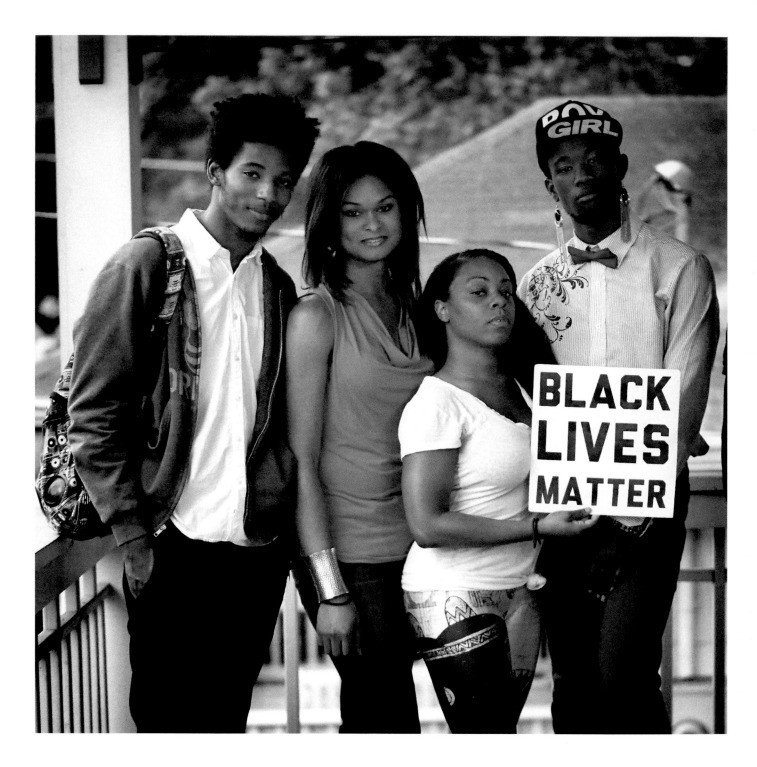

ATLANTA, GA

2015, Black Lives Matter activists Julian Plowden, Raquel Willis,
Crystal Monds, and Mickey Bee

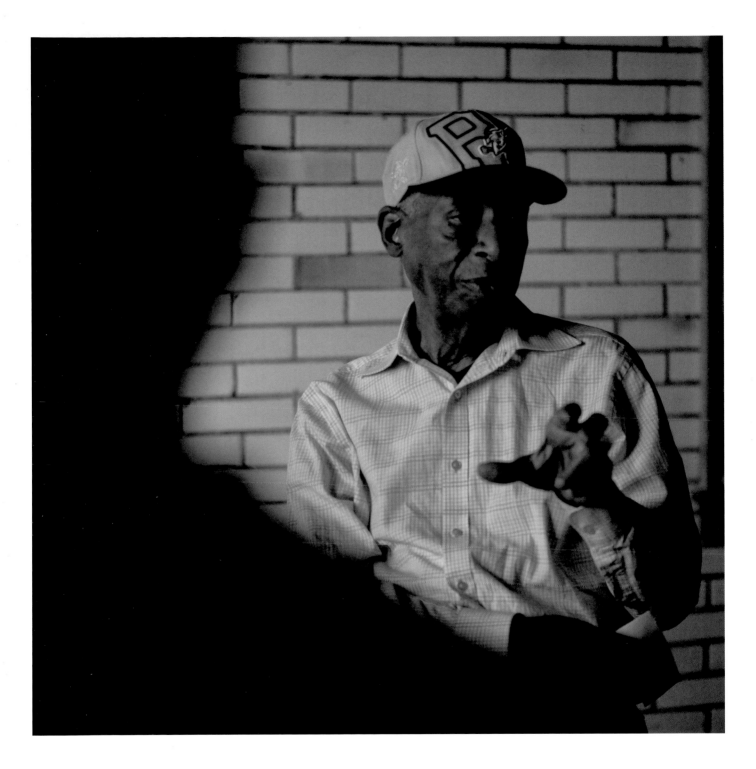

DETROIT, MI

2016, Black Lives Matter Detroit Chapter meeting

DETROIT, MI

2016, Black Lives Matter Detroit Chapter meeting

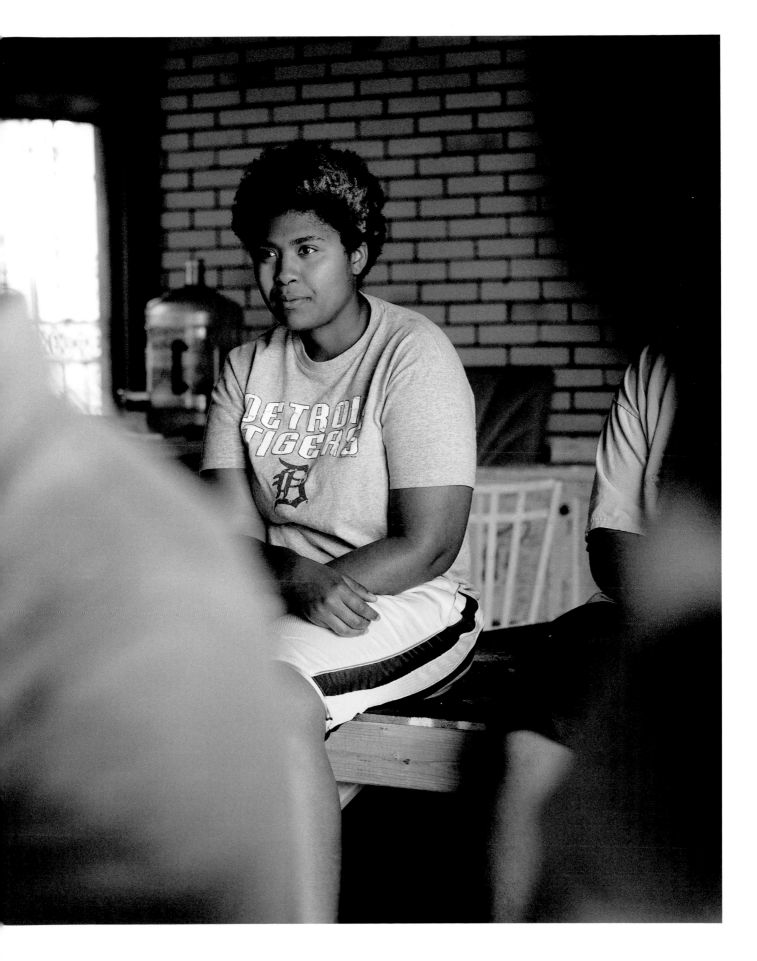

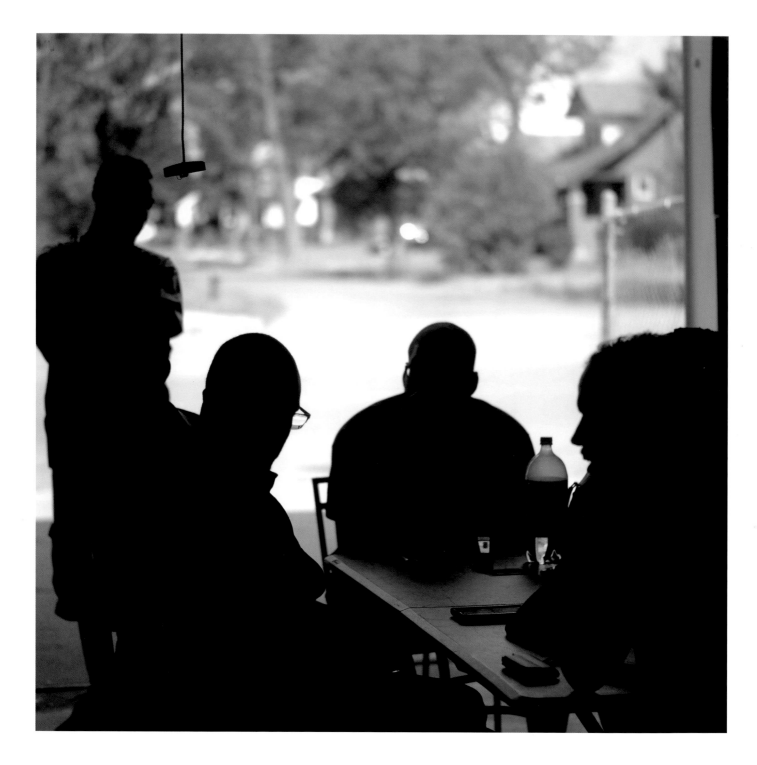

DETROIT, MI

2016, Black Lives Matter Detroit Chapter meeting

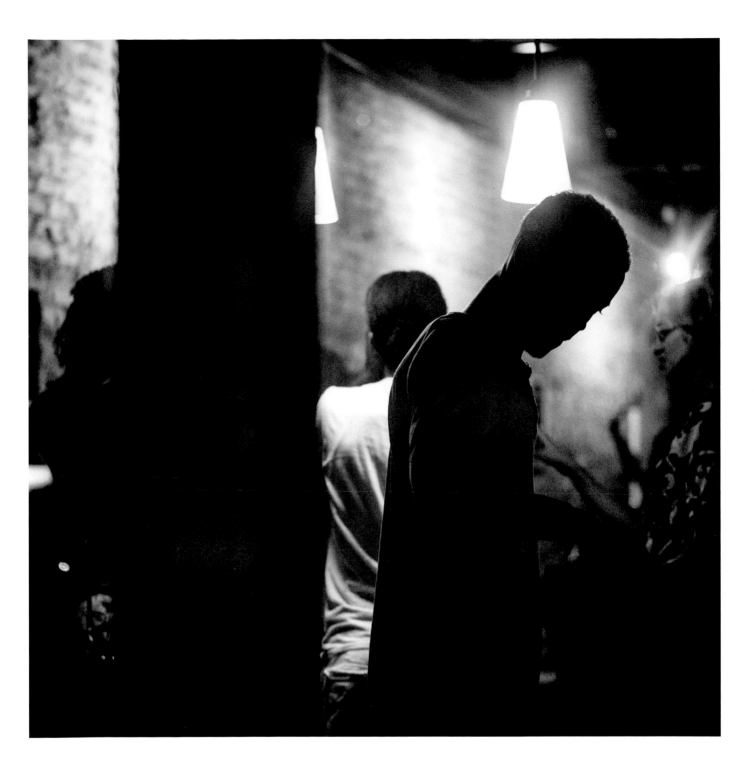

ATLANTA, GA

2016, It's Bigger Than You organization meeting

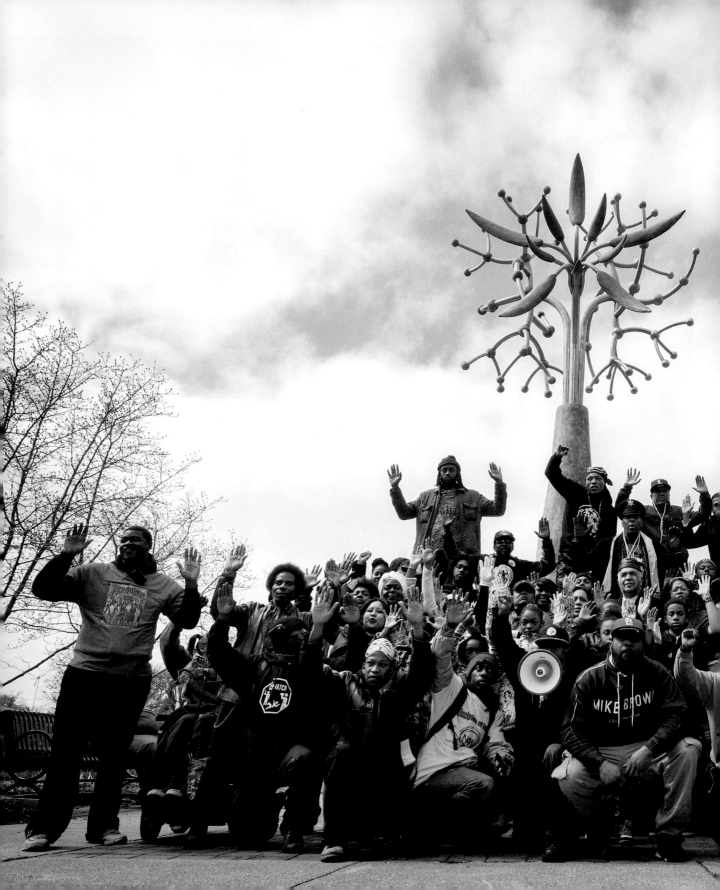

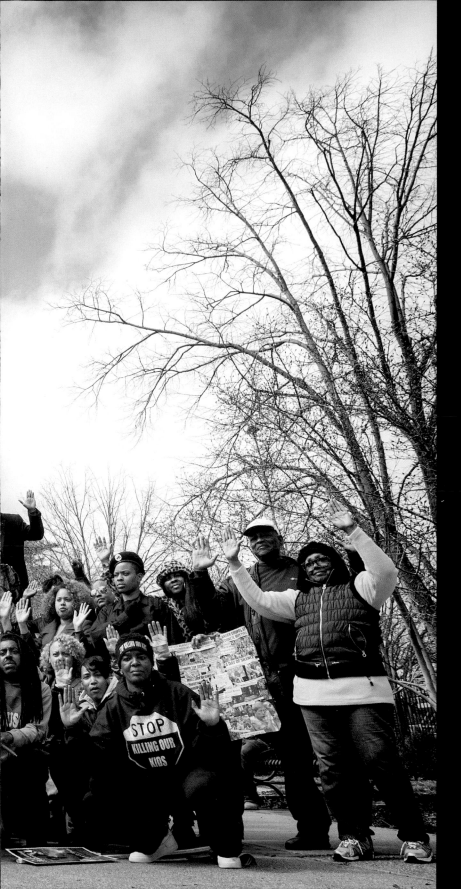

FERGUSON, MO

2015, National March on Ferguson, "We Can't Stop Now," protesting police violence and the murder of Mike Brown